ADVANCE PRAISE

"Goldbard has written a book that is vast without being superficial. Her incisive understanding of how politics, history, and culture interact and her deep appreciation of what community-minded artists contribute to society (tempered by her savvy about obstacles placed in the way) combine to produce an utterly readable book with great heart, mind, and spirit. Dazzling."

—Jan Cohen-Cruz, associate professor of drama at New York University's Tisch School of the Arts; Author of *Local Acts: Community-Based Performance in the United States*

"My hat's off to Arlene Goldbard for mapping the territory where art and democracy meet. She connects the practices, principles, theory and history of community cultural development and makes a powerful case that it is the most significant work in the arts today. No one has done this before. *New Creative Community* is an important book with the legs to last a long time."

—Nick Rabkin, Executive Director, The Center for Arts Policy, Columbia College Chicago

"A powerful description of how community-driven art can transform and improve American society. We believe that the arts are important in bringing us together across our differences and *New Creative Community* explains how and why. Important eye-opening reading for funders, civic leaders, artists and social entrepreneurs."

—Thomas Sander, Executive Director at The Saguaro Seminar: Civic Engagement in America Project, Harvard University

Arlene Goldbard's book is an inspirational breakthrough for community cultural development, starting with the term she chooses to describe the field itself. Bursting with useful examples from across the United States and beyond, Goldbard takes the reader through the work's historical, practical, political, aesthetic and moral dimensions. This brilliant book gave me insights and, especially, hope for the future of the arts in this country.

—Bill Rauch, Founding Artistic Director, Cornerstone Theater Company, Claire Trevor Professor of Drama, University of California, Irvine, and Artistic Director, Oregon Shakespeare Festival

NEW CREATIVE COMMUNITY

NEW CREATIVE COMMUNITY

The Art of Cultural Development

ARLENE GOLDBARD

Published by
New Village Press
P.O. Box 3049
Oakland, CA 94609
Orders: (510) 420-1361
press@newvillage.net
www.newvillagepress.net

New Village Press is a public-benefit, not-for-profit publishing venture of
Architects/Designers/Planners for Social Responsibility.
www.adpsr.org

Printed and bound in Canada.

Library of Congress Cataloging-in-Publication Data

Goldbard, Arlene.
 New creative community : the art of cultural development / by Arlene Goldbard. –
Updated and expanded ed.
 p. cm.
 Originally published: Creative community : the art of cultural development / by Don
Adams and Arlene Goldbard. New York, NY : Rockefeller Foundation, Creativity & Culture
Division, c2001.
 Includes bibliographical references and index.
 ISBN-13: 978-0-9766054-5-4 (pbk. : alk. paper)
 ISBN-10: 0-9766054-5-7
 1. Arts and Society–United States. 2. Community arts projects–United States. I. Adams,
Don. Creative community. II. Title.
NX180.S6G55 2006
700.1'030973–dc22
 2006027388

TABLE OF CONTENTS

11 FORWARD
13 INTRODUCTION
15 NOTES TO THE READER

17 CHAPTER ONE: UNDERSTANDING COMMUNITY CULTURAL
 DEVELOPMENT
20 Naming the Practice
22 Cultural Responses to Social Conditions
23 Global Proliferation of Mass Media
27 Mass Migrations
29 The Environment
31 Recognition of Cultural Minorities
32 "Culture Wars"
37 Development
39 Globalization and Privatization

43 CHAPTER TWO: UNIFYING PRINCIPLES
44 1) Active participation in cultural life
48 2) Diversity is a social asset
50 3) All cultures are essentially equal
52 4) Culture is an effective crucible for social transformation
54 5) Cultural expression is a means of emancipation
57 6) Culture is a dynamic, protean whole
58 7) Artists have roles as agents of transformation

61 CHAPTER THREE: A MATRIX OF PRACTICE
61 Program Models
62 Structured Learning
64 Dialogues
64 Documentation and Distribution
65 Claiming Public Space
67 Residencies
69 Themes and Methods
69 History
71 Identity
73 Cultural Infrastructure
75 Organizing
77 Boundaries and Intersections

85 CHAPTER FOUR: AN EXEMPLARY TALE
86 The Basics
87 Action Research

88 Three Action Research Projects
91 Kick-off and Project Design
94 The Map Unfolds
94 Learning from Each Other
96 Engaging the Community
100 Celebration Time

101 CHAPTER FIVE: HISTORICAL AND THEORETICAL
 UNDERPINNINGS
102 An Activism of Ideas
102 The Social Integration of the Artist
108 The Settlement House Movement
109 Popular Front and Class Consciousness
111 The New Deal
113 Arts Extension
115 Civil Rights and Identity Politics
117 Liberating Education and Theater
120 Culture and Development
123 CETA and Public Service Employment
125 People's History and Anthropology
127 Cultural Democracy and Cultural Exchange
133 Spirituality

139 CHAPTER SIX: THEORY FROM PRACTICE: ELEMENTS OF A
 THEORY OF COMMUNITY CULTURAL DEVELOPMENT
140 Definitions
142 Core Purposes
144 Response to Conditions
146 Conflict
147 Artist's Role
148 Arts Media and Approaches
148 Process versus Product
149 Expression versus Imposition
150 Responsibility for Participants
151 Legal Contract versus Moral Contract
152 Material Support
154 Indicators of Success
156 Training
158 Professionalization

163 CHAPTER SEVEN: THE STATE OF THE FIELD
163 The Role of Funding
167 From Generation to Generation
172 The New Hybridity

172 viBE Theater
175 Project Row Houses
177 Holler to the Hood
180 Glimpses of the Global Field
186 More about Money

189 CHAPTER EIGHT: THE FIELD'S DEVELOPMENTAL NEEDS
189 Public Policy and Support
192 The Scope of Cultural Policy
196 The Policy Climate for Community Cultural Development
201 Material Support
206 Suggestions for Material Support
209 Internal Infrastructure and Exchange
213 Suggestions for Internal Infrastructure and Exchange
214 Training
216 Suggestions for Training
218 Public Awareness
220 Suggestions to Expand Public Awareness

223 CHAPTER NINE: PLANNING FOR COMMUNITY CULTURAL DEVELOPMENT
224 Imagine This
226 Cultural Planning and Cultural Citizenship
228 The Basis for Cultural Planning
229 Aims and Indicators
233 Bringing It All Back Home

237 CONCLUSION: TIME TO RISE AND SHINE

241 GLOSSARY: COMMUNITY CULTURAL DEVELOPMENT

247 SELECTED BIBLIOGRAPHY: COMMUNITY CULTURAL DEVELOPMENT
247 Adult Education
247 Critical Pedagogy
248 Cultural Policy and Cultural Development
251 Intergenerational Cultural Projects
252 Oral History
253 Popular Theater and Other Performance
254 The New Deal and Antecedents
255 Other Community Arts

259 AUTHOR AND APPROACH
261 ACKNOWLEDGEMENTS
263 INDEX

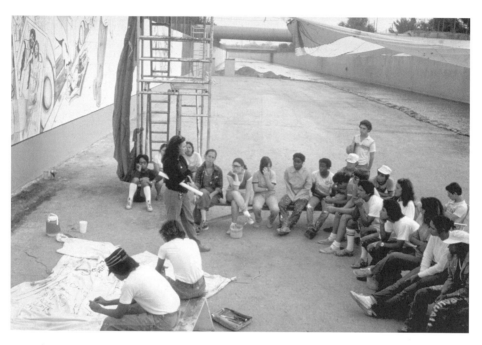

Artworkers, organized by Social & Public Art Resource Center (SPARC), meet at the Tujunga Flood con-
trol channel in Van Nuys, California, with SPARC founder Judith F. Baca, to help create the half-mile-long
Great Wall mural. Photo © SPARC 1983

FORWARD

Over the past decade I have worked with artists and cultural institutions connecting with communities in meaningful ways. Throughout the world, artists actively engage in community relationships, often facilitated by service organizations, arts centers, places of worship, schools, universities and community centers. These citizen-artists bring communities beauty and joy along with opportunities for reflection and growth.

In their creative endeavors, community-based artists value methods for building consensus, workable agreements and open and honest sharing. They strive for understanding amongst individuals with common goals, despite cultural and class differences, developing works that provoke discourse, stimulate participation and encourage action. Such artists often seek alternative ways of articulating and contextualizing issues during times of stress. They help communities know themselves more fully, and can be surprisingly successful effecting profound change, such as reconciliation, where other methods have failed.

I spent part of my spring, 2005, sabbatical studying the field of art and social justice, focusing on the efforts of visual, media and performing artists over the last thirty years. I read profiles of individual artists and cultural leaders; descriptions of mission-driven organizations, their growth, development (and occasionally their demise); manuals describing activists' techniques and methods; and essays that pose philosophical and practical questions. I also gave attention to the new generation of artists that has found power in spoken word performances, film shorts, graphics, fiction, essays, plays, street performances and the use of new technologies for rapid dissemination of images and ideas.

My studies affirmed what *New Creative Community* asserts: that this work has a long and illustrious history and an exciting expanding future. Artists serve as role models and exemplars. They use art to transform neighborhoods,

communities and societies, often establishing enduring bonds that continue long after funding for specific initiatives has ended.

The documentation of this gratifying, inspirational and catalytic work is essential. At a time of burgeoning interest in publications and media on community-based art, I welcome Arlene Goldbard's new book for its value in defining and sustaining community cultural development. It will benefit students, scholars and practitioners now and in the future.

Claudine K. Brown, Director
Arts and Culture Program
Nathan Cummings Foundation

INTRODUCTION

What can art do?

During the War in Vietnam, I was both an activist and an artist. I worked as a draft counselor, helping young men navigate the byways and alternate routes of the Selective Service System. Many applied for status as conscientious objectors, enabling them to perform civilian service in place of going to war. When I wasn't doing that work, I made paintings in a little studio I'd carved out of my apartment's spare room.

One morning in 1968, I awoke feeling exhilarated. During the night, I'd dreamed of painting a picture that ended the war. I woke up trying to memorize the shapes and colors suffusing my dream, but they instantly began to evaporate. Desperate to retain them, I ran to my studio. By the time I stood in front of my easel, my dream image had disappeared. I felt helpless and frustrated, standing stalled before a canvas smeared with incoherent reds and blues.

I was reminded of this experience in the fall of 2005 as I read news bulletins from the race riots that seized France that season. For instance, Alan Riding had an article in the *New York Times* on 24 November entitled "In France, Artists Have Sounded the Warning Bells for Years." He interviewed filmmakers and musicians who long ago warned of explosive social conditions in the *banlieues* (literally "suburbs," this word has come to signify impoverished immigrant neighborhoods dominated by high-rise public housing). Quoting lyrics and citing films, Riding pointed out that in contrast to artists, who felt the pulse of the times, consistently predicting what was to come, newspapers and politicians "have variously expressed shock and surprise, as if the riots were as unpredictable as a natural disaster."

Whether in dreams or daylight, many artists hope our work will awaken conscience and awareness. My 1968 dream was a form of magical thinking,

of course; so far as I know, a painting has never possessed the power to move political worlds. But two more modest hopes are in the minds of many artists and organizers like those described in this volume.

First is the expectation that people facing social exclusion, when given the opportunity to express their individual truths in the language of their own creative imaginations, will become aware of their common concerns and common capacity to take action in their own interests and may even join together to actualize that awareness. Art is a compelling vehicle for self-awareness and self-declaration. To pick a single example, consider how music of social protest has flourished everywhere under conditions of poverty and oppression, galvanizing young people to act out their hopes or frustrations, depending on the receptivity of the larger society.

Second is the wish that gatekeepers and others who wield power will be reached by such expressions, will be moved to respond constructively. Often this wish is frustrated. After surveying French rap lyrics portraying with unmistakable clarity the *banlieues'* frustration, Riding concluded that such artists "have been mirroring the life and mood of France's immigrant underclass. The problem is that, in the corridors of power in Central Paris, no one was paying heed."

I write at a moment marked by passionate desires and deep despair. In my own country, many of us have become cynical about what can be accomplished with conventional methods of promoting social change. In such a climate, community-based arts work holds great promise because people can bring all they are and all they value to the work: their minds and bodies, their histories and relationships, their deepest meanings and beliefs. Someone taking part in a collaborative theater project, for instance, is able to share a very full and rich experience of citizenship: to be one among many whose ideas and efforts are welcomed equally, who pursue common aims in a climate of respect and affection, who together make something meaningful to themselves and to the whole community. Even in a dark time, this experience foreshadows true democracy and full, vibrant citizenship.

What can art do? One artist's dream can't end a war, but when enough people dream together—when enough people have a taste of wide-awake dreaming to create critical mass—who knows what might happen?

Arlene Goldbard
Richmond, California
March 2006

NOTES TO THE READER

The bulk of examples in this volume are drawn from experiences within the United States, the community cultural development milieu I know best. Nevertheless, throughout this book, I have tried to hint at the breadth and depth of the global movement, drawing on international examples, influences and resources to the best of my ability. While it is impossible for one person to truly comprehend the ground-level realities of every world region, I have learned enough to feel confident that practitioners around the world will agree there are more commonalities than differences, more reasons to feel connected than not. I am confident that mutually supportive relationships will grow across all boundaries, that despite very real obstacles such as distance, we are working together to heal the world.

This volume incorporates information from several research and planning projects, including quotations from interviews with community cultural development practitioners. Interviewees took part on condition of anonymity, so wherever unattributed quotations appear, these confidential interviews are their source.

The kernel of this book is a shorter, earlier volume published by the Rockefeller Foundation, *Creative Community: The Art of Cultural Development*, co-authored with Don Adams. I heard the phrases "cultural policy," "cultural development" and "cultural democracy" for the first time in conversations with Don in the mid-1970s. I am grateful for his imprint and influence, which appear on every page of the present volume. (Needless to say, any mistakes are my own.) Many people contributed to this work; their names appear in the acknowledgements at the end. But Don's contributions were paramount, for which I will always be more grateful than I can say.

A children's workshop led by the Liz Lerman Dance Exchange at Jacob's Pillow Dance Festival.
Photo © Michael Van Sleen 2000

CHAPTER 1
Understanding Community Cultural Development

> I worked in a lot of different places during my life. I've got to know this country pretty well. I can name every creek crossing between Robinson River and the Queensland border, and I know both the language name and the English name. When I went back to Robinson River after about 35 years I still knew the country better than anyone living there now. That's one of the things about working as a drover and a stockman. You know a lot about a lot of places.

The speaker is Joe Clark, an Aboriginal Australian born in Australia's northern territory. Since the 1980s he has lived in Dajarra in North West Queensland, one of the chief sites of work for Feral Arts, a community cultural development group based in Brisbane. Images and first-person accounts from his life are preserved at <www.placestories.org>, an online repository for digital stories made by people whose stories have been omitted from the official histories of the places where they live. Their narratives are linked to maps and other online tools, and are made public or private depending on the wishes of their creators.

Halfway across the world, in Richmond, California, where skyrocketing homicide rates have thrust the community into fear and panic, a group called Mothers Against Senseless Killing (MASK) was formed to mourn the loss

of children to gun violence and to begin addressing the causes. San Francisco-based artist Isis Rodriguez trained and led a dozen Richmond teenagers in producing a double-panel mural depicting residents of the Iron Triangle neighborhood (where Latino and Southeast Asian populations have in recent years joined the longstanding African American population). The mural portrays a vision of healing put forward by those taking part in community planning meetings for the project: "We should be burying our guns, not our neighbors." Richmond closed many of its community centers to accommodate a budget crisis, but the Nevin Community Center was reopened with the installation of this mural in April 2005.

Meanwhile, in eastern Kentucky coal country, a community coalition that grew out of classes at Southeast Kentucky Community and Technical College initiated a three-year project throughout Harlan County, famous for its long and violent 1973 coal miners' strike. An array of artists and arts-related groups worked with more than 2,000 local residents to explore the social, economic and environmental conditions putting the community at risk. Changes in coal mining over recent decades triggered a chain reaction that reduced county population from 80,000 in the 1940s to 30,000 today, with an estimated real unemployment rate of 30 percent. A specific project focus was the prescription drug abuse exacerbated by these conditions, especially OxyContin, which has been called "poor man's heroin" because it is so addictive, so destructive, and so widely available in rural regions. The highest abuse rate is in Appalachia.

Participants launched the project by collecting nearly 200 oral histories and involving local residents in art projects intended to nurture trust and bring

Tile mosaic mural at the Appalachian Center of Southeast Kentucky Community and Technical College, designed and built with participation by more than 100 community members. Photo by Graphicbliss.com/Malcolm J. Wilson, © Southeast Kentucky Community and Technical College

people together to work on something positive. The people who took part in art-making and story-collecting formed a base of active concern and hope for the community. Building on their involvement, a team of 60 local residents conducted the Harlan County Listening Project, carrying out 400 confidential interviews with fellow residents from many walks of life. Interviewers were trained in Listening Project methods devised by Rural Southern Voices for Peace <www.listeningproject.info>, widely employed in community organizing and in situations of conflict. Using material from oral histories, working with playwright Jo Carson and a team of theater artists assembled by director Jerry Stropnicky, the group produced and performed a play, *Higher Ground*, with a cast of 75 ranging in age from 2 to 80. The group also mounted community photography exhibits and created tile mosaic murals in public spaces. At this writing, the coalition behind this project is moving forward, engaging the community in creating new works.

In our Information Age, with its default tone of exaggerated self-importance—colossal, revolutionary, humongous!—human-scale phenomena are often dwarfed by energetically marketed trivialities. So it is with community cultural development practice, a powerful, ground-level approach to community and culture that struggles for visibility in a market-driven world. The three examples mentioned above suggest only a fraction of the interest, power and diversity of work in the field.

NAMING THE PRACTICE

"Community cultural development" describes the work of artist-organizers and other community members collaborating to express identity, concerns and aspirations through the arts and communications media. It is a process that simultaneously builds individual mastery and collective cultural capacity while contributing to positive social change. Many examples are described and discussed in this volume.

The community cultural development field is global, with a decades-long history of practice, discourse, learning and impact. In Europe and much of the developing world, the work of the field has long been recognized by cultural authorities, development agencies and funders as a meaningful way to assist communities coping with the forces of modernization. As the phenomenon of globalization accelerates, trailing protest in its wake, community cultural development practice has become more and more widely respected by activists and their supporters as a powerful means of awakening and mobilizing resistance to imposed cultural values.

However, public attention and resources have not been commensurate with the intrinsic merit of this work. Conditions vary from nation to nation, but nowhere has this been so clear as in the United States, where an active community cultural development field has been nearly invisible to those not directly involved. There has been little sustained support for community cultural development per se in the United States, forcing practitioners to struggle for legitimation. Because community cultural development employs the same art forms as conventional arts disciplines (e.g., dance, painting, video), work in the field has mostly been treated as a marginal manifestation of mainstream arts activities—for instance, as "community-based theater projects" competing for a tiny fraction of theater-oriented funding; or as "audience development" initiatives valued for their role in expanding conventional arts audiences by bringing new people into contact with arts work.

The result is a U.S. field that consistently appears atomized and dispersed, with no clear, easily grasped identity. Constantly reinventing arguments to convince funders of the value of their efforts, constantly reframing their work to fit the guidelines of social-service or conventional arts-discipline funders, community artists have been unable to develop adequate infrastructure of the type that legitimates a profession—its own widely accepted standards, journals of theory and practice, training initiatives and funding sources.

Indeed, people in the United States don't even know what to call this category of social action. Around the world, many different names are in simultaneous use. Here are a few of the most common:

Community arts. This is the common term in Britain and most other Anglophone countries. In U.S. English, it is also sometimes used to describe conventional arts activity based in a municipality, such as "the Anytown Arts Council, a community arts agency." While I use the term "community artists" to describe individuals engaged in this work, to avoid such confusion, I have chosen not to employ the collective term "community arts" to describe the whole enterprise.

Community animation, from the French *animation socio-culturelle*, is the common term in Francophone countries. There, community artists are known as *animateurs*. This term was used in much international discussion of such work in the 1970s and sometimes appears in English accounts of the work.

Community-based arts is preferred by some practitioners, who find it sensible to scoop both participatory projects and conventional arts projects about community issues into a single category, united by their common social and political aims. Mat Schwarzman's definition in his and Keith Knight's *Beginner's Guide to Community-Based Arts* reads this way: "Any form or work of art that emerges from a community and consciously seeks to increase the social, economic and political power of that community."

Cultural work, a term with roots in panprogressive Popular Front organizing of the 1930s, emphasizes the socially conscious nature of the practice, stressing the role of the artist as cultural worker, countering the tendency to see art-making as a frivolous occupation, a pastime as opposed to important labor.

Participatory arts projects "community residencies," "artist/community collaborations"—the list of labels is very long. Even though it is a mouthful, I prefer "**community cultural development**" because it encapsulates the salient characteristics of the work:

• **Community** acknowledges its participatory nature, which emphasizes collaboration between artists and other community members;

• **Cultural** indicates the generous concept of culture (rather than, more narrowly, art) and the broad range of tools and forms in use in the field, from aspects of traditional visual- and performing-arts practice to oral-history approaches usually associated with historical research and social studies, to use of high-tech communications media, to elements of activism and community organizing typically seen as part of non-arts social-change campaigns; and

• **Development** suggests the dynamic nature of cultural action, with its ambitions of conscientization (see Glossary) and empowerment, linking it to other enlightened community development practices, especially those in-

corporating principles of self-development rather than development imposed from above.

In 1987, "community cultural development" became the official label in Australia (generally abbreviated "CCD"). The Australia Arts Council was seen until recently as the national cultural policymaker most committed to community cultural development. But in 2005 and early 2006, the Council recommended cutbacks and other disturbing changes in national funding programs, triggering the formation of an advocacy group, the National Arts and Cultural Alliance <www.naca.org.au>. NACA has had considerable success in mobilizing community artists and their supporters, securing the continuation of community cultural development funding for 2006. At this writing, the Australia Council is conducting a study of the CCD sector (using a new rubric, "creative communities") as the basis for its future funding, so the longer-term outcome is still uncertain.

Except in Australia, no term has become official or universal. "Community cultural development" is preferred by those who wish to acknowledge the wider meaning and impact of the practice. But whether one says "community-based arts," "community arts" or "community cultural development," someone is sure to respond with a question: "What is that?"

The answer can be complicated. Within the community cultural development field, there is a tremendous range of approach, style, outcome—every aspect of the work. New forms and applications are constantly being invented, so while nothing fixed between two covers could ever be fully inclusive, the balance of this volume provides a more complete description.

CULTURAL RESPONSES TO SOCIAL CONDITIONS

Community cultural development work inevitably responds to current social conditions: the work is grounded in social critique and social imagination. The precise nature of this response always shifts as social circumstances change. As Brazilian educational theorist Paulo Freire wrote in *Pedagogy of the Oppressed*, every epoch is characterized by "a complex of ideas, concepts, hopes, doubts, values and challenges in dialectical interaction with their opposites. ..."[1] This complex forms our "thematic universe," to which contemporary community cultural development work responds.

1 Paulo Freire, *Pedagogy of the Oppressed*, Continuum, 1982, p. 91–92.

In the period since the 1960s—the decades that have shaped the current field—these contending forces have been, as Machiavelli put it so elegantly half a millennium ago, "like the hectic fever which, as the doctors tell us, at first is easy to cure though hard to recognize, but in time, if it has not been diagnosed and treated, becomes easy to recognize and hard to cure."[2] Indeed, the issues discussed in this chapter often feel overwhelming to contemplate.

While this complex of issues can be broken into segments to facilitate examination, as I have done below, considering contemporary Western culture as a whole exposes two overarching and countervailing truths addressed by community cultural development. The more complex and commercial the society, the more people experience a loss of agency, a decline in spontaneous connection, a tendency for consumer activities to supplant other social relationships and a strong pull toward isolated pursuits. Yet as these tendencies have come to light, the will to resist them has grown stronger, expressed in countless ways, such as the locally based "slow food" movement, remarkable growth in the popularity of do-it-yourself approaches, burgeoning interest in craft and other traditional cultural practices and a great awakening of the impulse to seek spiritual meaning. The feelings that animate this growing refusal to succumb to corporate values also enspirit those who work for community cultural development.

Global Proliferation of Mass Media

Since the advent of radio, motion pictures and television, penetration of commercial mass-media products around the globe has proceeded at a pace unparalleled in history. In its wake have arisen several disturbing social trends:
- the weakening of traditional multidirectional means of cultural transmission and preservation (e.g., person-to-person sharing of stories) in favor of the unidirectional transmission of mass-produced cultural products such as film, television and recorded music;
- the creation of a global youth market that has broken longstanding patterns of transmission for traditional cultural heritage, often alienating youth from cultural roots and substituting products for an immaterial legacy; and
- the pervasive passivity of consumer culture overtaking live, in-person activities that bring people into the commons and into direct contact with each other, with an attendant decline in the vitality of civil society.

2 Niccolò Machiavelli, *The Prince*, written 1513, translated by Thomas G. Bergin, Appleton-Century-Crofts Educational Division, 1947, p. 6.

I do not mean to suggest a simple dichotomy here: commercial culture, bad; traditional culture, good. Social and individual impacts can be quite different. For instance, the United States consumes a quarter of the world's energy, which keeps me warm and cozy in the winter, but from an environmental perspective, the costs are great. Despite the concerns listed above, I welcome the way technology has brought me easier access to the literature and music of the world, which seems to me an entirely good thing—that we should know more about each other, that we should appreciate each other's creations. In fact, when it comes to mass media, in the social as in the personal sphere the results have been mixed. Along with the products they exist to sell, commercial cultural industries have indeed sometimes spread liberatory ideas of individual choice and social mobility. As Robert McChesney has pointed out:

> Global conglomerates can at times have a progressive impact on culture, especially when they enter nations that had been tightly controlled by corrupt media crony systems (as in much of Latin America) or nations that had significant state censorship over media (as in parts of Asia).[3]

Markets don't respect traditions, which can be both good and bad for culture. Because commercial media have one imperative—to increase profits through expansion of their clientele—their operators view constraints such as cronyism and state control merely as temporary obstacles, glitches in a larger marketing plan. When such obstacles are overcome, the net result is to expose populations to a broader range of news, a wider spectrum of programming suggesting new life possibilities—as well as virtually unlimited opportunity to arouse new needs that can be fed in the marketplace. But the progressive impact of global conglomerates does not extend so far as to incite political change, since transnational corporations, in media as in other fields, are intrinsically conservative, always preferring a stable climate rather than the volatility that leads to rebellion or revolution.

The advent of new media has also softened the distinction between consumption and participation. When I sit in front of a computer interacting with other computer users, am I an active participant in the life of a particular (albeit virtual) community? Or have I merely succumbed to the enchantment of seeing my own words on television? The predominant use of the Internet is for commerce; in comparison, political speech occupies very little space on the World Wide Web. Personally, I have enjoyed being in easy touch with friends and colleagues around the world via the Internet. But whether such personal pleasures will suffice to counteract the soporific social effects of unidirectional

3 Robert W. McChesney, "The New Global Media," *The Nation*, Nov. 29, 1999, p.13.

communication will remain unknown for some time. I am skeptical that the impetus for democratic cultural development will naturally flow from television or computers. Without dismissing the genuine cause for hope represented by newer technologies' democratic potential, any provisional judgment should be based on mass media's impacts to date, not their unrealized possibilities. If advocates of free cyberspace prevail, the trend may be reversed; but until then, the channeling of cultural energy into consumer choices is the primary effect of current arrangements. Everything else is a minority interest.

The formidable challenge lies in allowing people a larger, more meaningful choice in relation to commercial culture, as articulated by Amadou Mahtar M'Bow, former Director-General of UNESCO (the United Nations Educational, Scientific and Cultural Organization):

> The only pertinent question facing us today is not only of choosing between an outdated past and imitation of the foreign but of making original selections between cultural values which it is vital to safeguard and develop—because they contain the deep-lying secrets of our collective dynamism—and the elements which it is henceforth necessary to abandon—because they put a brake on our facility for critical reflection and innovation. In the same way we must sort out the progressive elements offered by industrial societies, so as only to use those which are adapted to the society of our choice which we are capable of taking over and developing gradually by ourselves and for ourselves. [4]

Because American consumer cultural industries are the main generators of commercial cultural products, many other nations have mobilized to protect themselves from this onslaught from Hollywood. For instance, they have enacted legislation mandating a certain percentage of domestic content on their own airwaves or taxed American product to finance indigenous media development. The imbalance has been remarkable. In part to address it, in October 2005, member states of UNESCO adopted a "Convention on the Protection and Promotion of the Diversity of Cultural Expressions." In describing the need for such a convention, France's cultural minister, Renaud Donnedieu de Vabres, was quoted by the BBC as saying: "Hollywood movies account for 85 percent of movie tickets sold around the world. In the United States, only one percent of shown movies come from outside the United States." The eighth of the Convention's nine objectives speaks directly to this issue: "to reaffirm the sovereign rights of States to maintain, adopt and implement policies and measures that they deem appropriate for the protection and promotion of the diversity of cultural expressions in their territory…"

4 Amadou Mahtar M'Bow, "Opening of Leo Frobenius Seminar," *Cultures*, 6, No. 2, 1979, p. 144.

The United States is the point of origin for most of the cultural products that crowd the world's screens and storefronts. But the same imbalances exist within this country, where there has been only minimal regulation of commercial exploitation of broadcast media and other cultural industries and no organized effort has succeeded in highlighting the need to protect living cultures from the deadening effects of a surfeit of mass media. To the contrary, the U.S. leads a small but vociferous opposition to such protection. For instance among the 191 member states of the United Nations, there were two votes against UNESCO's 2005 Convention on the Protection and Promotion of the Diversity of Cultural Expressions, the U.S. and Israel, as well as four abstentions, Australia, Nicaragua, Honduras and Liberia.

This is not a new position for the United States. The U.S. role in international discourse concerning the problem of imbalance between American cultural industries and other countries' has consistently been to dismiss it as no problem at all. The U.S. government waited until 2003 to reverse Ronald Reagan's 1984 decision to leave UNESCO, the primary international forum for such dialogue. For the nearly two decades the U.S. sat out, official policy was simply to refuse to engage.

On those pre-1984 occasions when an official American voice joined the UNESCO dialogue, it was to reject any "internationally imposed cultural standards or norms limiting, in any way, the rights of individuals. ... Our cultural policy is a policy of freedom," as articulated by Jean Gerard, United States Ambassador to UNESCO, at the organization's global cultural policies conference in Mexico City, August 1982. The classic interpretation of this language was provided by French cultural minister Jack Lang at that same conference: "Cultural and artistic creation is today victim of a system of multinational financial domination against which it is necessary to get organized. ... Yes to liberty, but which liberty? The liberty ... of the fox in the henhouse which can devour the defenseless chickens at his pleasure?"

Since these positions were put forward more than two decades ago, global saturation of American commercial media has reached undreamed-of levels, a core component of the complex now referred to as globalization. Again, the phenomenon is also at work within the United States: recognizing that media portrayals will be many people's chief experience of individuals and communities remarkably different from themselves, rural residents, people of color and members of other cultural minorities consistently complain of their misrepresentation within the mainstream media.

In 2001, Don Adams and I co-edited an anthology of essays on community cultural development by practitioners from around the world. The editorial group for *Community, Culture and Globalization* included one member each

from the Philippines, South Africa, India and Mexico. Several had never before visited New York City, the site of our editorial meetings. Our work session was planned in the spring, well before the horrific events of September 11th. Even then, people had been extremely anxious about their security: would they be safe from thieves and attackers? Should they take special precautions? "NYPD Blue" occupied space in our visitors' minds, in the slot where "gritty realism" meets "reality show." In the event, everyone survived unscathed. But as we walked the streets, our visitors stayed close, replaying the familiar scenes of fear on their inner TV screens.

How many stories have we seen since 9/11 detailing arrests of people whose complexions matched a bystander's mental profile of "terrorist," and thus whose innocent overheard phone call or personal conversation seemed to warrant alerting Homeland Security? Across the U.S., how many citizens have had direct, positive experiences with persons of Arab descent sufficient to balance their ubiquitous media portrayals as terrorists?

I would never say that media reality supplants direct experience, but often it creates a context that influences interpretation and experience. As global media penetration increases, that influence grows.

Mass Migrations

The social upheavals and violent conflicts of the last century produced an unprecedented flood of refugees and exiles. Certain situations are familiar to consumers of news. For example, the visibility of the Dalai Lama and his celebrity supporters has brought attention to the way Chinese domination has endangered traditional Tibetan culture and to the massive emigration of Tibetans from their homeland. Many less visible crises have contributed to the primary flow of refugees from global South to North. At the beginning of 2005, the United Nations High Commission on Refugees recognized over nine million refugees and more than 19 million "persons of concern" from Darfur to Pakistan, in every world region. The problem has become so monumental and desperate that evacuees from New Orleans after 2005's Hurricane Katrina protested, "We aren't refugees, we're survivors," fearing that the very word "refugee" carried a fatal charge of indifference.

It is possible to maintain a degree of cultural continuity in diaspora, but eventually, being forcibly uprooted from one's homeland leads to cultural deracination. My immigrant parents were sent to study Yiddish at the end of each school day, equipping them for fluent conversation with their elders; most of my generation knows few words beyond the common terms that have made their way into the larger culture, such as *kvetch* and *schlep*. I see the same story

Chinese and Vietnamese families and among Haitian friends who know only a few words of their parents' Creole. Some grow new roots, but for many, the path of rootlessness leads to anomie, reflected in violence and dropout rates among the young, as this community artist described:

> This latest project is the biggest challenge ever.... These newer [Southeast Asian] immigrants—most are refugees and they have a different mind-set [than previous immigrant groups], ... youth violence, high failure rates and a real void in leadership from these communities. So we're trying partnerships with emerging organizations and social-service agencies and trying to find strategies for program development; but all of this is very complex. It raises many issues. It takes work, care, negotiation, leadership skills. Amazing stuff comes out and healing. But I'm putting out fires all the time.

Within the United States, forced internal exile has generated a similar dynamic, especially during the 1960s and 1970s, when urban renewal projects (known to those they displaced as "urban removal") banked on ending poverty and urban blight by demolishing inner-city neighborhoods, forcing the inhabitants to relocate, thus eliminating both the material and immaterial networks that previously sustained local culture. These internal migrations have been further complicated by ongoing transformation of the American cultural landscape through immigration, leading to a resurgent backlash of anti-immigrant feeling.

Around the globe, the last decade has seen an unprecedented upsurge in economic exile in the form of migration, often temporary, from impoverished countries to nations seeking low-cost labor. A friend who recently visited her retired parents in Israel recounted how well these aging friends and family members were cared for by legions of Filipina nurses and maids. In 2001, when I visited Italy for the meeting that originated *Community, Culture and Globalization*, a Filipina friend and I took an excursion to Como on a free afternoon. After a week of pasta, my friend had a yen for rice. She stood in the town square for a few minutes, scanning for faces that reminded her of home. Looking through her eyes, I saw dozens of young women whose glossy black hair and eyes, whose high cheekbones and flat noses stood out among the Italians doing their weekend shopping. My friend approached one young woman, exchanged a few words in Tagalog, then led us through a chain of alleys to a market stand serving homestyle chicken and rice.

A couple of years later, I was invited to a community cultural development conference in Hong Kong. There too, on Sunday the public park was thronged with young Filipinas. Maids' day off, I thought, remembering Como, but as

it turned out, on that particular Sunday they were using their scarce leisure time to protest wage cuts imposed on foreign domestics by Hong Kong's government. More than half of the estimated 250,000 foreign maids working in Hong Kong in 2005 were from the Philippines, the rest from south and southeast Asia. It is estimated that nearly one in ten Filipinos works abroad, often at low-paying domestic jobs that nevertheless channel aggregate billions of dollars into families back home. As Sheila S. Coronel wrote in her spring 2005 report on the subject for the Philippine Center for Investigative Journalism,

> [O]verseas work is the country's main source of foreign exchange and is a major driver of the local economy.
>
> The social cost of this in terms of separated families, especially a whole generation of children growing up without their mothers, is also well known; it has even been immortalized in popular culture through films like the heart-rending Anak (Child). The loneliness and homesickness that migrants suffer, not to mention the discrimination and prejudice they often encounter, cannot be quantified in monetary terms. Neither can anyone convert in any currency the pain, longing, and neglect that scar motherless children.[5]

This is globalization at its starkest: cultural continuity and family values are treated as expendable as compared to economic benefits in the form of salary savings to privileged societies employing low-paid foreign workers and, ironically, to overseas workers' own societies in the form of wages they send home.

The Environment

While land, air and water are part of the birthright of every human being, often they are seen less as universal heritage or public trust than as assets to be managed to the advantage of specific interests (and thus to the disadvantage of others).

Often the brunt of environmental risk is borne by communities under great cultural pressure. For example, the Environmental Justice Movement was conceived at the beginning of the 1990s to address the pervasive practice of imposing the costs of environmental despoliation on low-income communities of color: channeling toxic runoff from mining and manufacturing into the rivers and creeks of their neighborhoods; situating toxic waste dumps near their homes; spraying the fields where they tend crops, heedless of the resulting birth defects and incidence of illness; allowing lead paint to persist

5 Sheila S. Coronel, "A Nation of Nannies," *iReport*, Issue No. 2 April–June 2005; available at <http://pcij.org/i-report/2/yaya.html>.

in urban housing despite its effects on children's health; and much, much more. The terrible consequences of 2005's Hurricane Katrina on the poorest of New Orleans demonstrates official indifference to the well-being of poor communities.

In these times, the issue is usually framed as economy versus environment. Cultural considerations—what it means to be tied to the land, how language, customs and spiritual grounding are shaped by that connection, the harm it may do to sever such ties—by and large, these concerns have not been heard. Instead, people are asked to consider how much quality of life and health they are willing to sacrifice to keep their jobs or homes. Corporations assert that forcing clean-ups will drive industry away, that environmental regulation's impact on profits will be too dire to be borne. Communities are deeply split by such controversies, with the added irony that often, the debate quickly becomes moot: by the time the dust has settled, the corporate polluter has moved on, leaving its formerly loyal supporters without employment. Mustering the courage and the arsenal of information and skills needed to stand up to such threats often requires a monumental investment of time and resources, pitting David communities against Goliath corporations and government agencies.

One hard-fought and highly visible campaign has focused on India's Narmada River. A people's organization known as Narmada Bachao Andola has organized mass protests against the Indian government's program to dam the river and its tributaries to produce electricity, flooding countless traditional villages and agricultural areas in the process. Civil disobedience has been massive; some protestors drowned as the waters rose, choosing death over leaving their traditional homes. Economic arguments are primary for the dams' advocates, but cultural concerns loom just as large for the people directly affected, as writer Jai Sen recounted in a 2000 essay on the impact of the dams on the tribal peoples affected,

> [P]erhaps most profound of all has been their being uprooted and torn away from their forests and from their river itself, and from the spirits of their ancestors, each of which are key elements of their culture, and then being scattered like this in a virtually treeless and riverless environment, far away from where their spirits dwell. There are some things in life that can never be recovered except by returning, which is what many have now done, to live if necessary higher up on the slopes of their hills the lower reaches of which have now been submerged.[6]

Similarly, communities that have traditionally been sustained by agriculture or resource extraction—mining, timber, fishing—have been hard-hit by

6 For "Development projects and the Adivasi: What kind of country do we want India to be?" see the Friends of Narmada website, <www.narmada.org/articles/JAI_SEN/whatkind.html>.

the restructuring of those industries. For example, as forests in the global North are logged out by companies with no commitment to sustainable practices, timber harvesting has moved South, where low wages and even weaker environmental regulations ensure greater short-term profit. What becomes of those left behind, whose histories, cultures and identities are tied to the land along with their livelihoods? The conflict between land as life and land as commodity is one of the strongest dichotomies of our thematic universe.

Recognition of Cultural Minorities

Though the consequences have sometimes been troubling, the fact of human diversity and its recognition have transformed our times.

In the United States, recognition of minority cultures as distinct and different in character has grown, reflected in better textbook histories and school curricula, in increased availability of ethnic foods, dress, literature and music and in the proliferation of culturally distinct celebrations, festivals and observances. But at the same time, oppositional feeling and the incidence of persecution—synagogue fires, anti-immigrant legislation, anti-Arab violence, organized white supremacist activity—have become more visible through media exposure.

Recently, domestic reports of persecution have declined. The FBI's reported domestic hate crimes for the most recent available years dropped overall from a peak of 9,730 in 2001 to 7,649 in 2004. (It is widely accepted that such crimes are underreported, so no one claims that these figures represent all hate crimes, merely the total of those reported to law enforcement agencies.) Crimes against African Americans consistently account for two-thirds of all racially motivated crimes. Within the overall drop were certain contrary trends, such as a nine percent increase in crimes based on race. In its *Annual Audit of Anti-Semitic Incidents* released in April 2005, the Anti-Defamation League also reported a 17 percent upturn in anti-Semitic incidents in 2004 after several years of relatively flat numbers. Many recent hate incidents resulted from increasingly aggressive campaigning by white supremacist groups. As diversity increases, scapegoating escalates.

Everywhere, as pointed out by the World Commission on Culture and Development, "people turn to culture as a means of self-definition and mobilization and assert their local cultural values. For the poorest among them, their own values are often the only thing that they can assert."[7] The cultures of major European and American cities have become immeasurably more vibrant, diverse and lively as a result of such assertions. In many other parts of

7 *Our Creative Diversity: Report of the World Commission on Culture and Development,* Second Edition, UNESCO Publishing, 1996, p. 28.

the world, the result has been more mixed, leading simultaneously to greater overall autonomy—as in the key part Islamic culture played in overturning the Shah of Iran—and a corresponding lessening of freedom for individuals who diverge from the presumed cultural consensus—as for those Iranians who resisted adopting the lifeways of fundamentalist Shiite Islam under the Ayatollah Khomeini.

This is a confusing time, offering enough contradictory evidence to feed almost any theory about cultural identity. The embrace of particularism is widening: in the developed world, many people have sought fresh connection with cultural roots that previous generations tried to prune. Johns and Janes are giving birth to Juans and Juanitas, Kwames and Imanis, Yaacovs and Yaels. In developing countries, indigenous voices are claiming their ways of life, even attaining the highest offices, as with the 2005 election of Aymara coca farmer Evo Morales as president of Bolivia. Increasingly, cultural rights are deemed essential to human rights, a trend that shows no signs of stopping.

Yet even as immigration increases diversity in the global North, it heightens the anxiety of those who wish to preserve the dominance of their own groups. For example, in 2004 and 2005, some American retailers replaced the traditional December greeting of "Merry Christmas" with the more neutral "Happy Holidays" so as not to offend non-Christian shoppers. They became the target of Reverend Jerry Falwell's "Friend or Foe Christmas Campaign" and the American Family Association's parallel retail boycott. As William Donohue, president of the Catholic League for Religious and Civil Rights, said (citing highly questionable statistics), "Ninety-six percent of Americans celebrate Christmas. Spare me the diversity lecture."

Growing recognition of cultural minorities is a chief characteristic of these times. Indeed, ours has been an era of cultural particularization, marked by what the Mexican writer Carlos Fuentes has called "the emergence of cultures as protagonists of history."[8] The question of whether they are protagonists in a tragedy or triumph is not settled.

"Culture Wars"

Our thematic universe has been shaped by extreme polarization of cultural values. The two main contending camps have been fundamentalism and liberal humanism: on one side has been the desire to eliminate cultural expression that offends received religious and social beliefs; on the other, to promote

8 Carlos Fuentes, *Latin America: At War With The Past*, Massey Lectures, 23rd Series, CBC Enterprises, 1985, p. 71.

free expression of divergent views.

We have seen countless manifestations, from the burning of books in revolutionary Iran to the hue and outcry over witchcraft in the Harry Potter series of children's stories. In the United States, there has been an unending stream of controversy over works of art that are perceived as dangerous when viewed from the fundamentalist camp: Robert Mapplethorpe's sexual images, Andres Serrano's and Chris Ofili's religious ones, Marlon Riggs' challenging transgressions of racial and sexual taboos. In 2005, a main U.S. battlefield was the debate between those who wish to teach "Intelligent Design" (i.e., creationism) in schools as an equivalent to the study of evolution, a campaign supported by religious fundamentalists and just as vigorously opposed by liberal humanists. By now, such controversies seem to be fixtures of the zeitgeist: wherever expressive freedom is asserted, a counter-assertion of disapproval is sure to claim a higher authority.

In the community cultural development field, skirmishes in the "culture wars" (Pat Buchanan's rubric from a 1992 speech has become the label of choice across the political spectrum) have most often arisen around works of public art. Consider Los Angeles' Social and Public Art Resource Center (SPARC), one of the oldest and most accomplished community mural groups in the United States. SPARC has repeatedly mobilized its allies to protect its work, often with success. For instance, former Los Angeles Mayor Riordan's "zero tolerance" crime-fighting campaign of in the late 1990s led police to demand the obliteration of alternative history murals in communities of color. Claiming that portrayals of past rebellion would inspire fresh revolt, police singled out such images as a Black Panther and a mestizo from the Mexican Revolution.

In 2005, "Save Our State" (SOS), a group opposing illegal immigration, demanded the alteration of *Danzas Indigenas* ("Indigenous Dances"), a Metro station monument in Baldwin Park created thirteen years earlier by SPARC's director Judith F. Baca, using an extensive process of public dialogue with the support and approval of the City. SOS condemned multilingual, multicultural messages from local residents that were part of the monument. As Baca described it in her May 2005 artist's statement,

> The work is not a work of a lone artist working without relationship to the community, but rather a representation of community sensibilities and sentiment of the time. While this group has cast the artwork as part of a "Reconquista movement," it is in fact neither advocating for the return of California to Mexico, nor wishing that Anglos had never come to this land. This statement [incorporated into the monument] "it was better before they came" was

deliberately ambiguous. About which "they" is the anonymous voice speaking? The statement was made by an Anglo local resident who was speaking about Mexicans. The ambiguity of the statement was the point, and is designed to say more about the reader than the speaker—and so it has.

Once again, SPARC launched a counter-campaign that drew passionate opposition to SOS, preserving the monument intact. But each victory requires a fresh mobilization, a huge investment of time and energy merely to protect what already exists.

Even when individual artworks are not especially controversial, there can be an underlying conflict between the assertion of protected public space which is intrinsic to the idea of public art (which Baca has called "sites of public memory") and encroaching commercialization of public space. In 1998, for instance, an advertising company (subsequently bought out by the huge advertising corporation Clear Channel, which has a virtual monopoly on billboards) won a court ruling that it was unconstitutional for the city of Portland, Oregon, to regulate billboards but not murals, erasing the legal distinction between art and signage. This effectively amounted to a six-year moratorium on exterior murals.

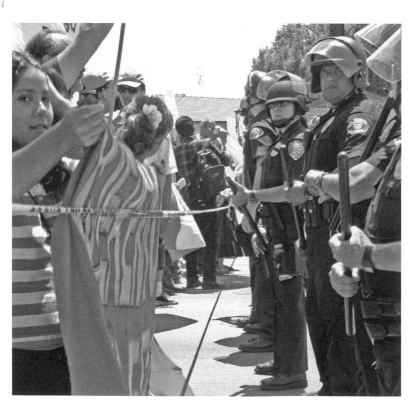

Right:
SPARC's Baldwin Park
monument "Danzas
Indigenas."
Photo © SPARC 2005

Left:
Community members
protest anti-immigrant
group's attempt to
censor SPARC's
Baldwin Park
monument "Danzas
Indigenas."
Photo © SPARC 2005

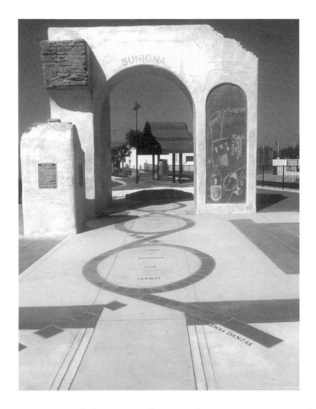

The City tried to wire around the court decision by creating a special status for public art whereby the owners of buildings receiving murals would in effect deed the works to the City of Portland, exempting them from sign ordinances. But property owners who don't want to enter into such a relationship blocked several community murals from the start. Clear Channel, calling the City's compromise part of a "jihad" against sign companies, pushed its case hard, arguing that local muralists should have no voice in the court proceedings, but in December 2005, muralist Joe Cotter was granted the right to participate in the trial as a "non-aligned third party." At this writing, the legal outcome is uncertain. But there could hardly be a clearer expression of the conflict between community cultural development values and the rampant commercialization of absolutely everything—a different type of culture war, one that protected public space seems to be losing.

Meanwhile, yet another category of cultural conflict has been surfacing. Looming over issues involving freedom of expression since 2001 has been the United States government's and its allies' "War on Terror," deploying weapons such as the USA Patriot Act to expand government surveillance and otherwise curtail civil liberties. This too has been framed as a "culture war." In his speeches, President Bush has explained such measures as necessary to op-

pose "Islamic radicalism, militant Jihadism, or Islamo-fascism," while civil libertarians counter with alarm at the threat of censorship. For example, the American Library Association and other library and bookstore associations have protested against provisions allowing the government unrestricted access to readers' records (including secret monitoring of library Internet use). Some librarians have taken to shredding records rather than keeping them on hand and available for FBI review. Meanwhile, citizens have repeatedly been cautioned by members of the Bush administration that expressing criticism of the motives and methods of the War in Iraq lends comfort to America's enemies.

This culture war too is global. Britain responded to terrorist bombings in 2005 by passing new legislation that put much stricter limits on speech, making it a crime to publish anything that "glorifies the commission or preparation (whether in the past, in the future or generally)" of terrorist acts, including "matter from which ... members of the public could reasonably be expected to infer that what is being glorified is being glorified as conduct that should be emulated in existing circumstances." In March 2005, surveying recent developments worldwide, the International Federation of Journalists and the human rights organization Statewatch co-published *Journalism, Civil Liberties and the War on Terrorism*, concluding that:

> Having considered the current state of policymaking at national and international level, it is impossible not to conclude that the war on terrorism amounts to a devastating challenge to the global culture of human rights and civil liberties established almost 60 years ago. ... [T]he war on terrorism is undermining more than half of the minimum standards in the 1948 UN Universal Declaration on Human Rights.[9]

For an art exhibit leading up to the 2004 presidential election—"Elect This!"—SPARC asked artists to examine the state of American democracy, speaking through their art to the issues raised in the election. At a discussion held in conjunction with the exhibit, SPARC's director told the assembled that she had been cautioned against sponsoring such an exhibit: in the midst of the War on Terror, friends feared it might endanger her nonprofit organization. In this climate, the risk of self-censorship is perhaps greater than that imposed by the state. That it is being counseled so vigorously and also vigorously resisted are both characteristic of our thematic universe.

9 Aidan White and Ben Hayes, *Journalism, Civil Liberties and The War on Terrorism*, International Federation of Journalists, 2005, p. 56.

Development

"Development" is a prickly concept. In the 1960s, the rubric "underdevelopment" came into use to describe regions suffering the after-effects of colonial domination: poor infrastructure, inadequate economic opportunity, weak educational systems. Colonial powers had used countries in Africa, Asia and Latin America as repositories for raw materials and low-cost labor, extracting their vital natural and human resources to sustain colonizers' own standing in world trade and politics. The pejorative cast of this term led to a change in nomenclature from "underdeveloped" to "developed" and "developing" nations, hopefully marking the poorest nations less as left behind than as works in progress. But not all have been helped or allowed to progress, and in recent years, "least-developed countries" has come into use as a more accurate designation for some nations.

No matter what terms are used, the underlying questions are still the same: what does development mean? How is it judged and measured? Who decides? For most of the 20th century, the primary yardstick was economic, and the standard toward which nations were developing was that of the industrialized countries of North America and Europe. To develop meant to acquire manufacturing capacity, including the needed telecommunications and energy apparatus, to produce the needed skilled workers, to establish markets for manufactured goods and thus to map out a trajectory of ongoing, self-sustaining economic growth. As progress was made toward these aims, social development would also rise, reflected in higher literacy rates, life span and household income.

The United Nations uses a "Human Development Index" to rank nations' position on a matrix involving Gross Domestic Product per capita, life expectancy and several indicators of literacy and education. Its 2005 report indicated that the Index continues to rise in most regions while falling in sub-Saharan Africa and the former Soviet regions. The ten lowest ranked on the Index are former colonies in Africa; nine of the ten highest are in Europe and North America (the tenth is Australia).

For decades, the principal actors financing development—agencies like the World Bank and the International Monetary Fund—promoted a highly economistic definition of development, with results decidedly mixed for those nations and regions perceived to be developing. Assistance often came in the form of loans that could never be repaid, sometimes because the funds were misspent by corrupt authorities, sometimes because investment was insufficient to reverse crushing poverty. In the 1980s, lending agencies began to

impose "structural adjustment programs" calling for huge cuts in public welfare spending, stressing export and resource extraction (which did nothing to strengthen local economic capacity) and requiring initiatives to attract multinational investors. Thus programs that were ostensibly devised to stimulate positive development exacerbated underdevelopment. The classic illustration depicts farmers who used to raise their families' food facing a terrible dilemma: cashing out the coffee or sugar they now grow for export to buy expensive imported food for their own tables, a net loss in so many ways.

There are signs of change. In June 2005, G8 finance ministers (i.e., Canada, France, Germany, Italy, Japan, Russia, the United Kingdom and the United States) agreed to forgive US$40 billion of debt owed by 18 countries to the World Bank, the International Monetary Fund and the African Development Fund. Other international bodies have responded as well. UNESCO's current position on development asserts the critical, central role of culture in changing notions of development:

> Development models produced since the 1970s have clearly failed, despite constant revision, to live up to the expectations they raised. Some would claim that this is because development has itself been defined far too exclusively in terms of tangibles, such as dams, factories, houses, food and water, although these are undeniably vital goods. UNESCO defends the case of indivisibility of culture and development, understood not simply in terms of economic growth, but also as a means of achieving a satisfactory intellectual, emotional, moral and spiritual existence. This development may be defined as that set of capacities that allows groups, communities and nations to define their futures in an integrated manner.[10]

Precisely the same integral view—that tangible development and cultural development are integral and inseparable—pertains to community development within nations. As Dee Davis, Executive director of the Center for Rural Strategies in Whitesburg, Kentucky, observed in his essay "Why no 'Marshall Plan' for America's rural areas?":

> Of the 250 poorest counties in the United States, 244 are rural. Rural households average 27 percent less in earnings than their metropolitan counterparts, and the poverty rate is 21 percent higher. The suicide rate for males over 15 is 80 percent higher, and the rate of alcohol and drug abuse is significantly higher among rural young people. Rural eighth-graders are 104 percent like-

10 From the introduction to UNESCO's Culture and Development portal: go to <http://portal.unesco.org/culture> and click on "Culture and Development."

lier to use amphetamines and 83 percent likelier to use crack cocaine than their peers in metropolitan areas.

Rural residents are more likely to be victims of violence than urban Americans. Rural areas have just half the number of physicians per capita, and rural school spending is 25 percent less per pupil. Forty percent of the rural population has no access to public transportation, even though half of the rural poor do not have automobiles to get them to work or to the doctor.

These conditions exist for a significant number of Americans. There are more rural Americans than Iraqis. The 56 million people who live in rural America, if counted separately, would rank as the world's 23rd largest nation, just behind France, Italy and Great Britain. Yet as a nation, we find difficulty acknowledging that the challenges rural Americans face are national challenges, let alone national priorities on a par with rebuilding the infrastructure in Iraq.[11]

In rural communities and depressed inner cities, domestic community development programs have given as little consideration to culture as the World Bank at its worst. As UNESCO's policy statement implies, the driving question is self-determination. When integrated development is properly understood as "that set of capacities that allows groups, communities and nations to define their futures in an integrated manner," it becomes inarguable that development must grow from dialogue and collaboration. The clash between those who desire this collaboration and those who see their own interests as coming first is one of the sharpest in our thematic universe.

Globalization and Privatization

Many of these conditions can be understood as phenomena of globalization, the increasing irrelevance of national boundaries and interdependence of worldwide trade, capital and population. While some have gained from the forces of globalization, many have lost:

Over a billion poor people have been largely bypassed by the globalization of cultural processes. Involuntary poverty and exclusion are unmitigated evils. ... [A]ll too often in the process of development, it is the poor who shoulder the heaviest burden. It is economic growth itself that interferes with human and cultural development. In the transition from subsistence-oriented agriculture to commercial agriculture, poor women and children are sometimes hit hardest. In the transition from a traditional society, in which the extended

11 On the Center's website at: <www.ruralstrategies.org/issues/marshallplan.html>

family takes care of its members who suffer misfortunes, to a market society, in which the community has not yet taken on responsibility for the victims of the competitive struggle, the fate of these victims can be cruel. In the transition from rural patron-client relationships to relations based on the cash nexus, the poor suffer by losing one type of support without gaining another. In the transition from an agricultural to an industrial society, the majority of rural people are neglected by the public authorities in favour of the urban population. In the transitions that we are now witnessing from centrally planned to market-oriented economies and from autocracies to democracies, inflation, mass unemployment, growing poverty, alienation and new crimes have to be confronted. ...

As a result of accelerated change, the impact of Western culture, mass communications, rapid population growth, urbanization, the break-up of the traditional village and of the extended family, traditional cultures (often orally transmitted) have been disrupted. Cultures are not monolithic and the elite culture, often geared to global culture, tends to exclude the poor and powerless.[12]

Globalization's most obvious impacts have limited the ability of the poor and excluded to earn decent livelihoods. But advanced development thinkers such as the economist Amartya Sen have made it clear that impoverishment and exclusion are not matters merely of economic power.[13] It is well-established, for instance, that life expectancy and health do not correlate neatly with per capita income: the citizens of Kerala, in India, have higher literacy rates and longer life expectancies than inner-city African-American men, whose average income is substantially higher. Sen's Nobel Prize–winning work on the causes of famine demonstrated that free access to communications media is a most effective way to prevent such human disasters, because an informed population will be able to learn and therefore address the causes of food shortage, almost always a problem of distribution (i.e., caused by political corruption or market abuses) rather than one of supply.

Yet the forces driving globalization are preeminently, almost exclusively, economic: the push to open new markets and to consolidate and dominate those that have been established. Every element of globalization has this dual aspect: while new information technologies hold great promise to increase communication around the globe and thus expand cooperation toward greater freedom, for instance, their distribution is determined largely by market forces, creating a growing digital divide between haves and have-nots.

12 *Our Creative Diversity*, p. 30.

13 See, for example, Sen's book *Development as Freedom*, Knopf, 1999.

In this climate of inequality, the question of how to distribute social goods so as to advance the aims of global inclusion—among them, freedom of expression and association and the right to culture, with all it implies—are not on the agendas of transnational corporations. Indeed, the global trend is toward privatization, with formerly public responsibilities devolving to the private sector, following the American model. As the late C. Wright Mills pointed out, the problem is treating the "public issues of social structure" as if they were "personal troubles of milieu." Every day we see public issues treated as personal troubles, as when young people struggling with urban poverty slip into illegal activity to help support their families and society's response is to condemn them for criminality and throw away the key. For those who benefit from the status quo, dismissing public issues as private troubles has been a winning strategy with intractable consequences for the rest of us. As Mills wrote forty years ago in *The Sociological Imagination*:

> In so far as an economy is so arranged that slumps occur, the problem of unemployment becomes incapable of personal solution. In so far as war is inherent in the nation-state system and in the uneven industrialization of the world, the ordinary individual in his restricted milieu will be power-less—with or without psychiatric aid—to solve the troubles this system or lack of system imposes upon him. In so far as the family as an institution turns women into darling little slaves and men into their chief providers and unweaned dependents, the problem of a satisfactory marriage remains inca-pable of purely private solution. In so far as the overdeveloped megalopolis and the overdeveloped automobile are built-in features of the overdeveloped society, the issues of urban living will not be solved by personal ingenuity and private wealth.[14]

Weakened public sectors seldom demonstrate the will or ability to effec-tively address problems of social inclusion, despite considerable popular sen-timent in favor, as demonstrated by the vocal opposition to globalization-as-usual that surfaced with the November 1999 World Trade Organization meeting in Seattle and has continued with each subsequent meeting around the world. In large part, it has been left to the third sector of non-governmen-tal organizations (NGOs), religious organizations, foundations and unions to seek a balance between the private pursuit of profit and the public good. Yet the complex point is frequently made that the transnational anti-globalization alliances that have become so visible in recent years would not be so strong and vibrant—would perhaps not exist—without the globalization of communications.

14 C. Wright Mills, *The Sociological Imagination*, Oxford University Press, 1959, p. 10.

It appears that globalization cannot be stopped nor, given its positive effects, do many people wish the increasing interrelatedness of the world's people could be undone. Whatever else it is reputed to breed, familiarity seems to engender awareness and often, caring. Yet we have no indication that globalization will somehow bring about the reversal of its own destructive effects or even the amelioration of such effects. Rather, this would require us to exert powerful countervailing pressure, demanding pluralism, participation and equity. As Indian writer and activist Arundhati Roy has said, the response to globalization begins with awareness:

> Mass resistance movements, individual activists, journalists, artists, and film makers have come together to strip Empire of its sheen. They have connected the dots, turned cash-flow charts and boardroom speeches into real stories about real people and real despair. They have shown how the neo-liberal project has cost people their homes, their land, their jobs, their liberty, their dignity. They have made the intangible tangible. The once seemingly incorporeal enemy is now corporeal.
>
> This is a huge victory. It was forged by the coming together of disparate political groups, with a variety of strategies. But they all recognized that the target of their anger, their activism, and their doggedness is the same. This was the beginning of real globalization. The globalization of dissent.[15]

Community cultural development efforts constitute one such response, making democratic counterforces of many of the same arts and media tools elsewhere used to promote global saturation of commercial culture.

15 Arundhati Roy, "Public Power in the Age of Empire," 24 August, 2004, speech; text at <www.countercurrents.org/us-roy240804.htm>.

CHAPTER 2
Unifying Principles

Over time, practitioners of community cultural development have adopted certain key principles to guide their work. There is no universal declaration or manifesto. Rather, each of these seven points has been given a multitude of different expressions in practice.

1: Active participation in cultural life is an essential goal of community cultural development.

2: Diversity is a social asset, part of the cultural commonwealth, requiring protection and nourishment.

3: All cultures are essentially equal and society should not promote any one as superior to the others.

4: Culture is an effective crucible for social transformation, one that can be less polarizing and create deeper connections than other social-change arenas.

5: Cultural expression is a means of emancipation, not the primary end in itself; the process is as important as the product.

6: Culture is a dynamic, protean whole and there is no value in creating artificial boundaries within it.

7: Artists have roles as agents of transformation that are more socially valuable than mainstream art world roles—and certainly equal in legitimacy.

1) Active participation in cultural life is an essential goal of community cultural development.

Authentic citizenship requires action: social intercourse, forthright exchanges on the subjects that matter most to us and to our societies, satisfying experiences of working together to make things happen. I am convinced that active participation in the life of one's society is a self-evident social and individual good, one that ought to guide every culture that values democracy. But vast numbers of my fellow citizens have opted out, and so I find it necessary to justify this principle.

My own conviction was formed in the 1960s through reading writers like Paul Goodman who took citizenship seriously. This is from the preface to his 1962 book of essays, *Utopian Essays and Practical Proposals*:

> The idea of Jeffersonian democracy is to educate its people to govern by giving them initiative to run things, by multiplying sources of responsibility, by encouraging dissent. This has the beautiful moral advantage that a man can be excellent in his own way without feeling special, can rule without ambition and follow without inferiority. Through the decades, it should have been the effort of our institutions to adapt this idea to ever-changing technical and social conditions. Instead, as if by dark design, our present institutions conspire to make people inexpert, mystified, and slavish.[1]

What would Goodman make of Americans' pervasive sense of being overwhelmed by events and information? Of the widespread desire, as one friend described it to me, "to stick my fingers in my ears and sing la-la-la until it all stops"? I imagine he'd describe it much as he did forty years ago in his essay "The Psychology of Being Powerless," which first appeared in the *New York Review of Books* in 1966:

> People believe that the great background conditions of modern life are beyond our power to influence. The proliferation of technology is autonomous and cannot be checked. The galloping urbanization is going to gallop on. Our over-centralized administration, both of things and men, is impossibly cumbersome and costly, but we cannot cut it down to size. These are inevitable tendencies of history. More dramatic inevitabilities are the explosions, the scientific explosion, and the population explosion. And there are more literal explosions, the dynamite accumulating in the slums of a thousand cities and

1 Paul Goodman, *Utopian Essays and Practical Proposals*, Vintage, 1962, pp. xvi–xvii.

the accumulating stockpiles of nuclear bombs in nations great and small. The psychology, in brief, is that history is out of control.

But the degree to which the phenomenon has deepened over four decades might be hard for Goodman to credit. He wrote about television, but he did not know, as we do now, that the logical end-point of consumer culture is the "couch potato," the individual who has succumbed to the virtual existence available via remote-controlled television, eschewing the flesh-and-blood contact of social intercourse and direct participation in community life. By definition, mass media substitute vicarious exposure for actual experience: instead of sitting in the bleachers, you watch the instant replay in the comfort of your own living room, cheering your team and heaping abuse on an inch-high unhearing referee on the other side of your TV screen. Instead of sorting through the multiple layers of information one derives from real-life encounters, deciding for oneself what to treat as figure and what as ground, the couch potato orders from a limited menu cooked up by TV programmers and advertisers, with all information predigested for ease of consumption.

Could Goodman have imagined the now-ubiquitous sight of a child hunched over a small box, jabbing his thumbs at it hour after concentrated hour? Since Goodman's time, a limited type of interactivity has been built into entertainment media to keep consumers engaged past the point they might have grown bored with merely watching. Among the most common problems addressed by child development specialists and other advice-givers in the industrialized world today is how to cure kids' addiction to video games. "I can't get him to look at me or talk to me," the parent complains, "he doesn't do his homework or play outside anymore. He just presses those keys all day." The National Institute on Media and The Family website <www.mediafamily.org> lists these symptoms of video game addiction:

For children:

- Most of non-school hours are spent on the computer or playing video games.
- Falling asleep in school.
- Not keeping up with assignments.
- Worsening grades.
- Lying about computer or video game use.
- Choosing to use the computer or play video games, rather than see friends.
- Dropping out of other social groups (clubs or sports).
- Irritable when not playing a video game or on the computer.

For adults:

- Computer or video game use is characterized by intense feelings of pleasure and guilt.
- Obsessing and pre-occupied about being on the computer, even when not connected.
- Hours playing video games or on the computer increasing, seriously disrupting family, social or even work life.
- Lying about computer or video game use.
- Experience feelings of withdrawal, anger, or depression when not on the computer or involved with their video game.
- May incur large phone or credit bills for on-line services.
- Can't control computer or video game use.
- Fantasy life on-line replaces emotional life with partner.

Entertainment is a fine thing, necessary and delightful leavening for existence. But a core point of critique in the community cultural development field is that an excess of such passivity is antithetical to civil society. The muscles of cultural participation atrophy with chronic underuse, leaving a population in thrall to urgent-sounding messages beamed over the airwaves.

Viewed globally, it makes no difference whether such social passivity is promoted in aid of selling products or inculcating an official worldview. As Hans Magnus Enzensberger has written, it

> ...is essentially the same all over the world, no matter how the industry is operated. ... The mind industry's main business and concern is not to sell its product; it is to "sell" the existing order, to perpetuate the prevailing pattern of man's domination by man, no matter who runs the society and no matter by what means.[2]

But however diligently the mind industry husbands its crop of couch potatoes, the harvest is always smaller than hoped. Human resilience and ingenuity cannot be undone by television broadcasts, as demonstrated by the many ways artists and activists have employed television imagery to subvert the aims of advertising. Indeed, computer-based media have begun to blur the boundary between passive consumption and active participation.

There is already an impressive body of evidence hinting at the interactive potential of such technologies, from their use by insurgent movements like the Zapatistas to the sort of interactive portrait of a people typified by the "place

2 Hans Magnus Enzensberger, "The Industrialization of the Mind," *Critical Essays*, Continuum, 1982, p. 10.

for collective memory and cultural exchange" of the Kurds created by photographer Susan Meiselas at her website <www.akakurdistan.com>, to the way minority cultures have used computers to maintain a sense of present-time community in diaspora, as demonstrated, for example, by the Overseas Filipino Workers Online website <www.theofwonline.com>, each page headed by the slogan, "Bridging the gap to bring us all closer."

Still, there is a huge chasm between these technologies' potential for interactive, multidirectional communication and the massive and dulling social impacts of the actual existing broadcast media. More than seventy years ago, with newborn awareness of the power of electronic communications media, Bertolt Brecht wrote:

> Radio must be changed from a means of distribution to a means of communication. Radio would be the most wonderful means of communications imaginable in public life ... if it were capable not only of transmitting but of receiving, of allowing the listener not only to hear but to speak and did not isolate him but brought him into contact.[3]

Enzensberger makes the point that this presents not a technical difficulty, but a failure of social will:

> [E]very transistor radio is, by the nature of its construction, at the same time a potential transmitter; it can interact with other receivers by circuit reversal. The development from a mere distribution medium to a communications medium is technically not a problem. It is consciously prevented for understandable political reasons.[4]

With computers' interactivity, we now have the means for communication rather than mere distribution, and for some people, this has opened the floodgates of social imagination and democratic creativity. Yet considered as a whole, most of the Internet is used to distribute commercial messages, and most of its interactivity consists of clicking "Buy now!" The remarkable democratizing potential of the media is so little developed, and the forces exploiting the media for commercial ends are so powerful, that it is naive to suggest (as some cultural studies theorists have done) that the system can be effectively overturned by the individual agency of its consumers, deploying their power to concoct contrary meanings in their own minds. Nevertheless,

3 Bertolt Brecht, "Theory of Radio" (1932), *Gesammelte Werke*, quoted in Enzensberger's "Constituents of a Theory of the Media," *Critical Essays*, p. 49.

4 Enzensberger, "Constituents of a Theory of the Media," *Critical Essays*, pp. 48-49.

there is hope in new media, hope that they can be turned to genuinely multi-directional and interactive ends.

In using those new media and in promoting initiative, creativity, self-directed and cooperative expression through other cultural forms, community cultural development practitioners hope to shatter a media-induced trance, assisting community members in awakening to and pursuing their own legitimate aspirations for social autonomy and recognition. That requires active participation, getting up off the couch and interacting with fellow citizens. I'd like to think it was self-evident.

2) Diversity is a social asset, part of the cultural commonwealth, requiring protection and nourishment.

As movements for civil rights and equality in society have gained momentum, on a parallel track, diversity has been problematized, with one widespread line of opinion suggesting that if people just downplayed their differences, we would all get along much better.

Even some thinkers who recognize and value cultural diversity have come to advocate a laissez-faire model of cultural interaction, one that counsels us to relax and enjoy consumer culture. Consider this passage from "The Case for Cultural Contamination," an essay by Kwame Anthony Appiah appearing in the *New York Times Magazine* on New Year's Day 2006:

> When people talk of the homogeneity produced by globalization, what they are talking about is this: Even here, the villagers will have radios (though the language will be local); you will be able to get a discussion going about Ronaldo, Mike Tyson or Tupac; and you will probably be able to find a bottle of Guinness or Coca-Cola (as well as of Star or Club, Ghana's own fine lagers). But has access to these things made the place more homogeneous or less? And what can you tell about people's souls from the fact that they drink Coca-Cola?

Despite such voices, in some important places, diversity has increasingly been valued, as has the need for protection against the onslaught of mass commercial cultural products. This is effectively illustrated by UNESCO's 2005 cultural diversity convention. It elaborates on principles put forward in the "Universal Declaration on Cultural Diversity," adopted in November 2001. Article 1 asserts that cultural diversity is the common heritage of humanity, explaining

Culture takes diverse forms across time and space. This diversity is embodied in the uniqueness and plurality of the identities of the groups and societies making up humankind. As a source of exchange, innovation and creativity, cultural diversity is as necessary for humankind as biodiversity is for nature. In this sense, it is the common heritage of humanity and should be recognized and affirmed for the benefit of present and future generations.

This is an exciting and new point: that humanity's heritage and glory is the diversity of cultures itself, that the point is not the particular achievements of any individual or society, however beautiful or remarkable, but the whole colorful, generative, constantly-renewing complex of cultures. This awareness is the big news of our era, still sinking in. This understanding in no way diminishes any artist or creative work; to the contrary, it is a majestic truth that enhances the meaning of all creative expressions.

Community cultural development practice is predicated on this very different paradigm—that what is needed is not a masking of real differences, but understanding, appreciation and respect for them, as this community artist suggested:

An issue that remains completely unresolved is race relations—interracial and intercultural issues. So many schisms in this country have to be addressed and art is a useful platform to address and find solutions to these dilemmas. Cultural programs are great mechanisms to articulate problems and to seek alternative solutions. The mainstream art world is in denial about these national crises; and many alternative organizations need ... help ... so they can develop networks, exchange information, find new ways to create work.

Community artists' investigations of cultural difference often reveal deep commonalities within diversity: every culture has ways, however distinct, of encountering the universal in human experience from birth to death, and many of these resonate across cultural barriers. But grasping such commonality always begins by encountering difference—whether based in place, ethnicity, age, orientation or other life condition—and framing it as something to treasure.

We [who live in the United States] have a unique opportunity as a country to show how diverse people can live in a global culture. We have more cultural diversity than any other country. To be civilized in the next century, we need to learn to deal with other cultures.

3) All cultures are essentially equal and society should not promote any one as superior to the others.

The "right to culture" is an artifact of the 20th century, established through the United Nation's Universal Declaration of Human Rights of 1948, the foundational text for all subsequent articulations of cultural rights: "Everyone has the right freely to participate in the cultural life of the community."

While this statement may seem unobjectionable at first glance, it has had far-reaching and controversial implications, as was pointed out in 1970 by René Maheu, then Director-General of UNESCO:

> It is not certain that the full significance of this text, proclaiming a new human right, the right to culture, was entirely appreciated at the time. If everyone, as an essential part of his dignity as a man, has the right to share in the cultural heritage and cultural activities of the community—or rather of the different communities to which men belong (and that of course includes the ultimate community—mankind)—it follows that the authorities responsible for these communities have a duty, so far as their resources permit, to provide him with the means for such participation. ... Everyone, accordingly, has the right to culture, as he has the right to education and the right to work. ... This is the basis and first purpose of cultural policy.[5]

Two objections to the essential equality of cultures seem to be evergreen. Elitists protest that the achievements of cultures they see as preeminent should not be on the same plane with those they dismiss. In what sense can there be equality, they ask, between the culture that produced Shakespeare and the crude artifacts of some least-developed country? At the same time, progressives ask whether apartheid or other racist ideologies ought to be respected and granted the same scope and autonomy as cultures asserting universal human rights. Aren't there good and bad cultures?

From what perspective are such questions asked? There is nothing in the overarching principle of equality to deprive any individual of the right to make value judgments, to render aesthetic judgments, to prefer the expressions of one culture over another. But should the right to judge be granted to states? Which of us would wish it to be in someone else's power to rank the cultures of the world, assigning each its proper measure of respect and support? From that perspective, such questions are red herrings.

5 Augustin Girard, *Cultural Development: Experience and Policies*, UNESCO, 1972, pp. 139–140.

How is Shakespeare diminished by the ghazals of Hafiz or folktales from Mindinao? It is hard to see what injury inheres in treating cultures evenhandedly, for instance by extending the same copyright protections to all publications or by making a municipal theater space equally available and accessible to symphony orchestras and jazz ensembles. But it is easy to see the inherent slight in allocating the lion's share of grant funds for music to symphony orchestras while expecting a community chorus to get by on bake sales; or in awarding medals and prizes to master sculptors while master basket-weavers collect food stamps.

Neither does prizing diversity cancel human rights. The nations of the world have the means and ability to assert the basic commitments of human dignity and challenge each other to live up to them. In Article 4, "Human rights as guarantees of cultural diversity," the Universal Declaration on Cultural Diversity states:

> The defence of cultural diversity is an ethical imperative, inseparable from respect for human dignity. It implies a commitment to human rights and fundamental freedoms, in particular the rights of persons belonging to minorities and those of indigenous peoples. No one may invoke cultural diversity to infringe upon human rights guaranteed by international law, nor to limit their scope.

The limits of cultural diversity are set in place by international law's guarantees of human rights; no one—not apartheid, nor National Socialism nor any of their contemporary counterparts—has the right to transgress these in the name of free expression.

A tenet of community cultural development practice has been to demand public space, support and recognition for the right of excluded communities to assert their place in cultural life, to give expression to their own cultural values and histories. In the decades since the onset of the mid–20th century domestic civil rights movements in the United States, much of this activity has centered on the struggle for recognition of minority cultures and for evenhanded treatment of those cultures' expressions in art and community life. Above all, it asserts René Maheu's point that the right to participate in the cultural life of the community carries the "duty, so far as their resources permit, to provide…the means for such participation."

4) Culture is an effective crucible for social transformation, one that can be less polarizing and create deeper connections than other social-change arenas.

Marxists used to speak in terms of "base" and "superstructure"; community organizers often distinguish between "hard" and "soft" issues; and in the electoral arena, it has often been a commonplace that voters will be moved more by money than by meaning (which was why "It's the economy, stupid!" was the watchword of Bill Clinton's first campaign for U.S. president). But things are changing. Even in mainstream politics, we see signs that culture is beginning to be recognized as a significant factor. In the American elections of 2004, for example, pundits discovered "values voters," seeming to take in for the first time that many citizens vote for the candidates most nearly reflecting the bedrock values they cherish.

Whether the topic is money or values, though, the dominant model of discourse is almost always a contest between fixed positions, the kind of irreconcilable point-counterpoint that television loves: a tennis match with words instead of racquets. In meetings and debates, on op-ed pages and in blogs, people rehearse intractable differences, rarely discovering a mutual meeting-place.

Many community artists see another way. In practice, people speaking a cultural vocabulary—describing the social values that animate their communities, explaining how they mark and honor milestones in the lives of individuals and in their joint histories, telling true stories of lived realities—can sometimes reach a point of mutual comprehension seldom achieved through conventional debates over "hard" issues.

Here's how Michael Rohd, artistic director of Portland Oregon–based Sojourn Theatre, put it in a June 2005 panel discussion on his company's "Witness Our Schools" project, a two-and-one-half-year-long project designed to stimulate face-to-face dialogues on public schools. The performance incorporated the words of teachers, parents, students, politicians from every location and every perspective, taken from more than 500 interviews:

> If you're going to make a show that opens a space for dialogue, you don't want homogeneous audiences at all those dialogues. Which means you want people from all over the political and ideological spectrum involved from the beginning, so this type of diversity knows it's not only wanted, not only welcome, but respected. Which is tricky. You have to find groups, and individuals, who are coming from a strong, sometimes extreme point of view maybe different from your own....

We believe that polarization and ideological stalemate, nurtured for political gain, are central to our nation's inability to move forward on important social justice and economic justice and human rights issues.

Creating a cultural container for dialogue can give people the chance to encounter each other as human beings, to consider before they speak the effect their words may have on the listener, to speak from the heart. Not all differences can be resolved this way, of course. But this path almost always leads to the possibility of a world that can contain real differences without bursting apart at the seams.

Think about it in family terms. Friends of mine told me about a recent visit with strongly conservative relatives who absolutely oppose abortion. After listening to a great deal of anti-reproductive choice rhetoric, my friends pointed out that cousin Mary, laboring to support a too-large family on a too-small budget, had chosen to have an abortion. Would the family shun her? "Of course not!" came the reply. "She felt backed into a corner, she didn't see any choice—it was *Mary*, for goodness sake!" Not every family would have responded the same way, of course, but many have found ways to accommodate even profound differences between individuals with known faces, known hearts. This is the condition to which community cultural development-based dialogue aspires.

Among allies, cultural action frequently serves as a form of rehearsal for social change. Perhaps the clearest examples derive from the Forum Theatre practice invented by Augusto Boal (described more fully in Chapter Five: Historical and Theoretical Underpinnings), whereby community members use theatrical techniques to plan, rehearse and refine strategies for action taking place beyond the theater's doors. The theatrical form invites the whole person into the encounter. Workers contemplating a strike can rehearse what it might be like to confront the boss or to attempt persuading others to join the cause. If anger rises, if tears flow, that foreshadows the anticipated experience much more deeply and fully than a dozen carefully agendized planning meetings. The process reframes possibility, as this forum theater practitioner explains:

> I don't think of politics as being different from theater. We are masks in the world. It's all about enriching the theatricality of daily life. It's a huge improv. This understanding really helps people decide how to act in the world. I used to think about politicizing theater and now it's the theatricalizing of politics. ... We can quickly get to community urges and needs and get to problem-solving. ... This kind of theater is so accessible, so public and it engages everybody, whatever way they want: just to watch, to get involved. It's real pedagogy, real community learning.

5) Cultural expression is a means of emancipation, not the primary end in itself; the process is as important as the product.

Some community cultural development projects are entirely oriented to process, focusing on transforming participants' consciousness as they discover and express their own cultural values. Others give equal emphasis to outcomes such as the creation of a CD or video. But whereas outcome is everything in many conventional arts approaches—all that ultimately matters is what winds up onstage at curtain time—here, product is not permitted to overdetermine the nature of the project.

In part, this conviction is grounded in the understanding that direct, hands-on participation moves people more than anything else, enlarging their vision of possibility much more immediately than might be achieved through mere observation. Most people have seen this in action, but may not have transposed the learning to the larger social arena. For instance, when a child learns to play an instrument and performs a first, halting solo at a class recital, few of the listeners (other than the parents, perhaps) are likely to be moved by the power of music to alter their own lives. But the life story of almost every professional musician incorporates a moment like this in which the experience of making music, however imperfectly, set the course of a life.

In community cultural development practice, participants' experience of their own creative imaginations and expressions is understood to be intrinsically empowering. What gives the experience the most meaning is ensuring that the project's approach and aims are entirely consonant with the wishes of the participants, as this practitioner describes:

> Everybody brings something to the table and we need to help people figure out what that is, so they can have ownership. … [T]he arts allow us to imagine how the world could be different. … Quality involves the project leader's willingness to take risks and create partnerships that don't result in easy dialogues—real border-crossing. And they give a lot of credibility to the ideas participants are bringing into the project and provide a lot of tools to participants, so at the end they can make a space for themselves.

The product/process question is not entirely settled, however. Occasionally, one hears it framed as "community versus quality."

On the grounds that beauty knows no class boundaries—that everyone deserves to experience work created with skill, ambition and intention—some community artists strive for the highest available production values, creating

end products that compare favorably with the work of artists more conventional in approach. From this perspective, to demonstrate that the lives and stories of ordinary people can be the basis for skillfully executed and powerful art works makes a strongly positive social statement. It also recognizes that in the industrialized world, most people are accustomed to dealing with high production values, having so often seen them wrapped around schlocky commercial cultural content. (Alas, the even more challenging skill inherent in this approach—protecting and promoting community participants' equal authorship of a highly skillful artistic result—is often invisible to viewers of the end-product, who may simply assume the work was made by a professional artist.)

In contrast, on grounds rooted in a different sort of class analysis, other community artists reject end products they consider too slickly produced, too aesthetically similar to their art world or commercial counterparts. From this perspective, a homemade or "folk" aesthetic seems most in keeping with community-based work, because it presents no barriers to comprehension, carries no off-putting social codes: community productions should look funky and approachable or else they risk looking intimidating. When the folk or homemade aesthetic is organic to the work—for example, when participants are using vernacular forms to convey new content, as in some of the challenging, issue-oriented altars created in recent decades to make use of and refresh the Mexican celebration of *Días de los Muertos*/Days of the Dead—it often adds to the power of the resulting work. When it is imposed, it sometimes seems silly or condescending.

The community/quality dichotomy invites posturing and polarization, supported by a thin reed of substance that almost topples under the weight of rhetoric it is made to carry. I see it as a false choice. No one sets out to make bad art. Using whatever means are accessible, most community artists aim to make the products of their process-oriented work as good as they can be, judged by the criteria appropriate to the intention. To consciously execute something with less skill than one actually commands on the grounds that this is good enough for community work—surely the insult inherent in such a decision cancels any democratic intention that might motivate it.

What's more, the dichotomy itself implies a fixed idea of what is good or beautiful, some readymade standard that community cultural development work can either pursue or reject. But many community artists have learned that the quality of engagement alters the quality of result: more striking, effective or beautiful works of art can arise from the process of deep engagement with other community members. What is learned in process deepens our collective understanding of quality as well as community. Choreographer

Liz Lerman Dance Exchange artists lead a workshop at Jacob's Pillow.
Photo © Michael Van Sleen 2000.

Liz Lerman summarizes this in her essay "Art and Community: Feeding The Artist, Feeding the Art" in *Community, Culture and Globalization*:

> What happens to the performance ability of a dancer asked to research stories about a time and place, live with these stories over the course of a year, work with people in many settings to aid them in discovering their own stories, perform these stories in a house and on a stage and in a place where the actual events happened? I believe that the accumulation of physical, emotional and historical meaning leads the dancer to a new level of investment and a different understanding of what the movement itself might mean and convey to another person. In a world as abstract as the world of movement, such experiences carry enormous weight.
>
> For me, an excellent dance performance includes the following: the dancers are 100 percent committed to the movement they are doing; they understand why they are doing what they are doing. And something is being revealed in that moment: something about the dancer or about the subject, about the relationship of the dancers or about the world in which we live. Something is revealed. Too many dance concerts lack these elements. When I think about our dance training, I realize how little time and encouragement we receive to develop our skills in finding such meaning in dance.[6]

6 Liz Lerman, "Art and Community: Feeding the Artist, Feeding the Art," in Don Adams and Arlene Goldbard, *Community, Culture and Globalization*, The Rockefeller Foundation, 2002, p. 62.

6) Culture is a dynamic, protean whole and there is no value in creating artificial boundaries within it.

The red-carpet arts' status derives in part from epic efforts at purification and classification, segregating those enterprises deemed to be "high art" from the vulgarity of popular entertainments. Not much more than a century ago, a typical concert in a major American city might feature an operatic aria alongside a comic poetry recital and an instrumental rendition of a piece of Romantic music; most museums exhibited a hodgepodge of painting and sculpture alongside curios and oddities—a piece of petrified wood or a fossil, a two-headed calf. Boundaries were put in place near the turn of the century by tastemakers anxious to shore up elite culture against an onslaught of immigrants. For instance, this argument was asserted by Henry Lee Higginson, 19th century founder of the Boston Symphony Orchestra and a driving force behind purification from the orchestral repertoire of popular entertainments, who exhorted fellow plutocrats to "Educate, and save ourselves and our families and our money from the mobs!"

Such distinctions persist today even as postmodern esthetics have clouded them in the arena of advanced art: Damien Hirst's dead cow preserved behind plexiglass was placed in the category of art because the arrangement and staging of the carcass expressed an artist's intention, whereas a taxidermist's staging of a two-headed calf was deemed to express only unfathomable Nature. Among installation artists, it is common to borrow from consumer culture to make statements about high art. For example, Isaac Julien's 2003 project "Baltimore" unites music and imagery from "blaxploitation" films of the 1970s with depictions of art museums, using visual perspectives "quoting" Italian renaissance painter Piero della Francesca.

Community cultural development practice is marked by an even more expansive willingness to draw on the entire cultural vocabulary of a community, from esoteric crafts to comic books—whatever resonates with community members' desire to achieve full expression. For example, here's how former Philippines Educational Theater Association <www.petatheater.com> artistic director Maribel Legarda described a project based on the form of a radio talk show:

> In 1998, PETA launched a project entitled *"Tumawag Kay Libby Manaoag"* ("Call Libby Manaoag"). This production was part of a larger campaign, the National Family Violence Prevention Program (NFVPP). "Libby Manaoag" is the story of a radio-show host: many women call her program to talk about their issues. Three women who are experiencing different forms of domes-

tic violence—physical, emotional and sexual—become the main voices that shape the stories. We hear advice from experts such as lawyers, psychiatrists and social workers. The scenes are woven together with songs and dances, and the characters are all performed in a broad acting style with much humor.[7]

Distinctions between high and low art, commercial and nonprofit, vernacular and elite forms—although their meanings are intensely contested in mainstream art and funding arenas—are essentially irrelevant to community cultural development practice.

7) Artists have roles as agents of transformation that are more socially valuable than mainstream art world roles—and certainly equal in legitimacy.

The proper role of the artist is much debated, almost always focusing on whether the artist should remain an outsider and observer or engage actively in the issues of the day. The mainstream version of this debate is the ongoing controversy over Hollywood activists, whose qualifications to speak out are often questioned, especially by those who disagree with what they say. For community artists, there is no controversy. Without exception, they recognize an obligation to deploy their gifts in service of larger social aims as well as individual awareness and transformation. In fact, from a community cultural development perspective, this is the natural choice. Adopting a more restrictive notion of one's artistic identity and aims indicates a deficiency in understanding, as this commentator explained:

> It is unfortunate, but probably true, that the best reaction many North American mainstream artists may hope for is that a painting will sell or a performance piece will be reviewed. This is a less satisfactory response than the attainment of the more ambitious goal of the activist: a profound cultural impact outside of the art world. The question of why many artists settle for less than being understood, and for merely a career, may have something to do with their inability to conceive of themselves in historical terms and therefore to understand the world as a political structure.[8]

7 Maribel Legarda, "Imagined Communities: PETA's Community, Culture and Development Experience," in *Community, Culture and Globalization*, p. 345.

8 Emily Hicks, "The Artist as Citizen: Guillermo Gómez-Peña, Felipe Ehrenberg, David Avalos and Judy Baca," in *The Citizen Artist: 20 Years of Art in the Public Arena*, Critical Press, 1998.

In the more narrowly focused continuing debate between community artists and the arts establishment, the theme has been whether community cultural development practice deserves the label "art" and therefore whether practitioners are worthy of being called artists. The sense is that by choosing to partner with non-artists and by focusing more on institutions of the larger society than on acceptance by or participation in arts institutions, they have wandered too far beyond the conventional boundaries. It's not clear how much force this argument would have if money weren't attached; but if one must compete for scarce arts funding in the United States, it is necessary to assert one's standing as an artist, something community artists have been attempting to do since the 1960s. The trouble is, they don't want to do it by giving up their larger commitments and settling for the much more narrowly constrained roles conventionally reserved for artists.

One reason longtime community artists have seemed to be winning the argument lately is that other artists working from within the "mainstream" arts world—whose credentials, presuming they have acquired the proper signifiers such as degrees, a gallery or a good theatrical venue, are seldom subject to the same sort of scrutiny—have been adopting elements of community artists' approaches. For instance, increasing numbers of prestigious gallery artists and well-known performing artists are incorporating the work of non-artists into their productions. One veteran community artist, frustrated by this development, voiced concerns shared by many about the impact of inexperienced, personally ambitious people entering the field:

> Funders are not going toward uniquely creative work and now we're seeing bullshit work by people migrating into the field … without the same heart for the work: they'll paint at any cost. … You find municipal arts administrators and funders doing their own [public art] processes. They look at successful projects like ours and try to replicate them, but they almost never allow for the flexibility the artist needs: they misunderstand us and leave us out … commissioning more decorative work, with no contact with community people. … What made it really work is the artists and the organizations [like ours] that came from the grassroots.

For community artists, there has been some serendipitous benefit—an ironic sort of coattails effect, considering that it results from art world denizens borrowing community artists' own methods —in the art world's recent interest in participatory approaches to art making. But market-driven art thrives on novelty. It is likely that the art world will take another turn and non-collaborative modes of painting, sculpture and playwriting will once

again occupy the anointed cutting edge. When it does, community artists will continue to assert that their work constitutes a valid, meaningful alternative life for the artist. The effort of going against the grain may take a toll, but for most, it is more than balanced by the work's rewards: delight in discovery, connection and co-creation.

CHAPTER 3
A Matrix of Practice

It would be easy to create a typology of prestige arts projects, because they can be described in terms of end product: plays, ballets, symphony concerts, solo exhibits and so on. But no really accurate and useful typology of community cultural development work can be created. Its crossing of arts discipline boundaries, improvisatory nature, emphasis on process and impact in wider social arenas create too many variables.

Where would you situate the George Moses Horton Project of Chatham County, North Carolina? In 2000 a middle school, a local historical society and many community members joined to honor a 19th century poet who was born into slavery, yet managed to publish extensively and give many readings even while enslaved. Project elements included a play, a poetry competition, a quilting project, a work for chorale and piano, a song cycle and a public art project. Conventional arts categories don't fit a practice that encompasses such diversity of form and expression. Instead, community cultural development work can best be understood as existing within a matrix of options such as the program models, themes and methods listed below.

PROGRAM MODELS

Potentially, all of the elements described below are compatible. Any of these program models might employ any of the themes and methods outlined. Each

project incorporates a different constellation of such options, shaped by the participants' desires, their skills and aims and the context—the circumstances and issues—in which they operate.

Structured Learning

Many community cultural development projects are built around learning experiences. Overall, the aim is to transmit arts-related skills while helping to develop critical thinking and establish a clear link between both capabilities—thought leading to action.

For example, Fringe Benefits Theatre <www.cootieshots.org>, based in Los Angeles, conducts "Theatre for Social Justice Residencies" at schools around the U.S. In the 2004-05 school year, they worked with ninth grade students at Animo Venice High School. The year-long program of weekly workshops focused on students connecting past civil rights history to their own present-day realities. Participants were introduced to civil rights issues and movements, highlighting the role of the arts; they read and wrote about their own experiences and took part in theater exercises, particularly Augusto Boal's

Scene from New WORLD Theater's "Project 2050 On the Frontlines: Sex, War & Lies."
Photo: Edward Cohen 2005

techniques (discussed in Chapter Five: Historical and Theoretical Underpinnings); and they interacted with guests from civil rights and arts groups. In the course of the year, participants wrote and presented four interactive plays addressing discrimination as it affects their own school community.

Using a different model, since 2000 the New WORLD Theater <www. umass.edu/fac/nwt/> at the University of Massachusetts has sponsored "Project 2050," described as:

> [A] multiyear exploration of the year when it is projected that people of color will become the majority in the United States. Addressing the issues driven by response to these changing demographics, the project engages professional artists, youth communities, scholars, and community activists in civic dialogue and artistic creation. These creative processes and performances actively create forums for intergenerational, interracial, and cross-cultural dialogues in community and university settings. The project promotes the creative imagining of a near-future when it will become imperative to address issues of race construction, ethnic balkanization, social equity, and power.

Each iteration of Project 2050 results in performances created by the young participants, incorporating elements of contemporary youth culture such as hip-hop dance, music and visual art.

Community-based cultural projects commonly begin with research, most often with participants learning more about their communities. Sometimes participants start with their own direct experience, bringing to awareness and articulating internalized knowledge of their surroundings and neighbors, thereby coming to recognize the wealth of information already in their possession.

But research via introspection eventually reaches its limits. No individual's experience can stand in for collective reality. Community artists have devised research approaches that are dynamic, interactive and open to wider community involvement. For instance, project participants are often armed with media equipment—cameras, audio and video recording gear, sometimes with colorful props and costumes or portable displays to attract attention—in order to gather observations and stories from family members, neighbors and passers-by. One aim is to acquire information; a second equal and integral aim is to offer members of the community the opportunity to speak their own truths, to play important roles in articulating the collective realities of their community. By pursuing deep learning at every turn, participatory action research of this type ensures that community cultural development projects are grounded in real, local concerns.

Dialogues

When communities are split over contentious issues, community cultural development projects can sometimes create opportunities for dialogue rather than the type of debate that leads to greater polarization. Many different arts media can be used to articulate opposing views in ways that feel fair to the contending parties. Not every conflict has a win-win solution; interests are sometimes genuinely irreconcilable and in the fullness of time, someone must prevail. But if compromise solutions can be found, dialogue that avoids objectification and posturing is essential as a means to that end. Often, the experience of genuine, inclusive dialogue refreshes a sense of possibility, leading to more openings for real exchange.

For example, consider the "Witness Our Schools" project by Sojourn Theatre <www.sojourntheatre.org>, mentioned in the previous chapter. Beginning in March 2004, this multiethnic, multilingual ensemble theater company conducted interviews with students, teachers, administrators, activists and citizens involved in Oregon's beleaguered public schools. Their aim was to include all voices and all sides of the contemporary education debate in a theater piece to be performed for—and discussed with—community audiences throughout the region. The dialogues were popular and enthusiastic, impressing educators by opening up the possibility of true exchange on issues previously thought intractable. A new round was planned for the following year. Sojourn was asked to take part in a new advisory committee to define a policy for arts in education and in a new visioning process for Portland's five-year plan, because the company has demonstrated the ability to listen deeply and to reflect what is heard back to the community in a way that advances real dialogue.

Documentation and Distribution

A great deal of community cultural development work is grounded in the desire to unearth realities that have been obscured by suppression, denial or shame. Frequently, projects aim to create some sort of permanent record that can challenge the official story, whether in print, moving-image media or visual arts installation.

Seattle's Wing Luke Asian Museum <www.wingluke.org> has consistently grounded its exhibits and other programs with stories and artifacts contributed by members of the Asian-American communities of the Pacific Northwest. In 2002, Wing Luke mounted "If Tired Hands Could Talk." Asian-American garment workers—Japanese, Chinese, Filipino and Vietnamese women

who sustained garment manufacturing in the Northwest—shared their personal stories through oral history interviews, video, archival photographs and artifacts such as workplace equipment and clothing. In 2005, as part of its New Dialogues Initiative series, an exhibit entitled "30 Years After the Fall of Sàigòn" created space for Vietnamese Americans of all ages to cross class and ideological lines in sharing their experiences and opinions of the historic event that precipitated mass migration to America. In contrast to an official view of history that asserts the primacy of a single preferred meaning, the project makes the point that the same events can have very different meanings, even within a cultural community. As Wing Luke's materials explain:

> For many older Vietnamese who experienced firsthand the trauma of war or as political prisoners, April 30th is considered a 'holocaust day,' and an occasion to mourn the loss of their country and denounce communism. For many younger Vietnamese Americans, April 30 is also an occasion to reflect on their new homeland and a celebration of their survival and success in America. These differing viewpoints manifest to this day, as two separate events were held on April 30, 2005 in Seattle to observe the anniversary.

Community artists work with other community members to enliven and present such materials in every medium that can be imagined: in publications and exhibitions; in murals; in plays produced for theatrical and nontraditional settings; in documentary or narrative film and video programs; and in computer multimedia.

Claiming Public Space

Members of marginalized communities lack public space for their cultural expressions. Speaking concretely, they seldom have institutions, facilities or amenities equal to those available to more prosperous neighborhoods or communities. In terms of virtual space, they are likely to lack equal access to mass communications media and therefore to any meaningful opportunity to balance the sensationally negative pictures of themselves pervading commercial media. Many community cultural development projects take this as their starting point, aiming to improve the quality of local life by adding self-created amenities to their communities or by building visibility for their concerns.

In the late 1980s, Lily Yeh worked with residents of an inner-city neighborhood to create the Philadelphia-based Village of Arts and Humanities, through which local residents converted empty North Philadelphia lots into

Philadelphia's Village of Arts and Humanities founder Lily Yeh and friends at the October 2000 Kujenga Pamoja annual harvest festival. Photo © Matthew Hollerbush 2000

parks and gardens, celebrating their achievements with multi-arts festivals. The Village's immediate neighborhood includes nine parks and gardens and two alleyways featuring murals. Angel Alley includes nine powerful Ethiopian angel icons; Meditation Park was inspired by Chinese gardens, Islamic courtyards and West African architecture; the Vegetable Farm was the first step toward a community sustainable-agriculture project; and the Youth Construction Park, created with a group of young people, features a pair of cement and mosaic lions guarding its front entrance.

In 2005, Yeh's new project, Barefoot Artists <www.barefootartists.org> inaugurated its two-year Rwanda Healing Project, one element of which is the Survivors Village Project, which works with local children to paint murals on housing constructed for survivors of the genocide whose own homes had been destroyed, thereby making this new place their own.

Appalshop <www.appalshop.org> in Whitesburg, Kentucky, is a multimedia arts and education center begun in 1969 with funds from the War on Poverty to finance job creation schemes for young people. The intention was to train Appalachian youth in media skills they would then use to find work in the film and television industries, escaping the poverty of their home region. Instead, the young filmmakers chose to stay home and make their own films, telling true Appalachian stories to counter media stereotyping. Appalshop today has a theater company, a cultural center, a filmmaking and

distribution program, its own TV series and a radio station, among other initiatives. Through its Appalachian Media Institute, succeeding generations of young people from the region have learned to use video cameras and audio equipment to document their communities' traditions and the complex issues they face. The following is an excerpt from AMI participant Natasha Watts' commentary on an early 2006 mine disaster in West Virginia in which a dozen miners, trapped underground, lost their lives:

> In West Virginia, the media will leave in a matter of days. Yet the people there will forever feel the effects of this disaster and the ones to come. Some of the losses don't get much attention but they continue to occur. We can hear it in the raspy voices of retired miners with black and rock lung. It's easy to forget how dangerous mining is. To me mining is just something that takes place everyday in the place where I grew up.

Residencies

Long-term community residency models such as the "town artist" approach (discussed in Chapter Five: Historical and Theoretical Underpinnings) have evolved abroad, where public agencies have seen community cultural development work as a legitimate, effective way of advancing their educational and organizing aims. The town artist concept came into being to assist residents of purpose-built new towns in post–World War II Europe to put their own stamp on otherwise anonymous structures and public spaces. In this model, an artist would be employed by public authorities to live and work in a community at the service of the community. David Harding, generally recognized as the first town artist for his work from 1968 on in Glenrothes, Scotland, describes how the role was understood as integral and ongoing:

> When I came to Glenrothes, I was employed, as it were, as a civil servant in the town under a contract with retirement at 65. There were doubts about where to place me, and I suggested I should be part of the Planning Department. This was a sensible idea because it meant that I could attend planning meetings and be involved in early discussions with planners about the shape of the town. After a couple of years, I feel an historic decision was made in the town. It was part of the planning briefs which came out of the planning department to the architects and engineers. It contained a clause which said that "the artist should be consulted at every stage of the development." That was an ideal, of course, but it was something that one could fall back on if wanting to make a fuss. I decided to live in a housing project in the town because it was important to experience the kind of environment one was contributing to. I

set up my workshop in the city's Direct Labour yards. Also, after a couple of years I joined the Builder's Union because I realized that most of the work was taking place on the building site, and that identifying myself with the men who were working on the building site was politically very important. I tried to create opportunities for the building workers to display their often latent skills by using only the materials of the building site, so much so that many of the works were executed or completed by them.[1]

Because the United States has seen no equivalent of a local development authority willing to subsidize long-term, open-ended, artist-community relationships, U.S.–based residencies tend to be briefer, more narrowly focused and more outcome-oriented. A typical residency project in the United States would link an artist with a school for a single term or less or subsidize an artist or company to work for a few days, weeks or sometimes months with the clientele of a particular institution (e.g., a senior center) to create a specified product (e.g., a mural), rather than provide for development of ongoing, open-ended, collaborative relationships between artists and other community members.

Glass panel mural at Kawabe Memorial House in Seattle, a collaboration between artist Rene Yung and elder residents. Photo © Rene Yung 2005

Nevertheless, some artists and sponsoring groups have been able to find the resources to sustain longer collaborations. "Postcards in Time" was a community-building art project commissioned by the Seattle Office of Arts & Culture Affairs ARTS UP (Artist Residencies Transforming Seattle's Urban

1 Roth, Moira, "Town Artist: An Interview with David Harding" in Linda Frye Burnham and Steve Durland, editors, *The Citizen Artist: 20 Years of Art in the Public Arena*, Critical Press, 1998.

Places) program, a collaboration between sound, media and visual community artists and the residents of Kawabe Memorial House, publicly funded elder housing in Seattle's International District. Using images and text culled from extensive interviews with residents, artist Rene Yung created a set of 16 multilingual postcards. For example, one card shows two images of a man's hand gesturing toward his body, one upturned and the other turned toward the ground. The text by Taek Sang Jung, who was born in Kangwon, Korea, reads, "Everything is different (in America), even gesturing to come." The postcards were widely distributed; recipients were encouraged to inscribe them with their own experiences, then send them back to the project. Images from the postcards were rendered in architectural glass panels situated in the Kawabe entryway, where visitors could also interact with a listening station offering the elders' oral histories and their chosen music. At this writing, additional components of the project are in process.

Unfortunately, the resources to sustain ongoing collaborations are scarce. One artist involved in such open-ended community work explained how funders' lack of commitment to long-term work has put a brake on possibility:

> We know we have a long-term commitment to a community, but we have to say to local people just how far we're able to commit. … If we made a longer-term commitment and the funds broke down, it would be counterproductive.

THEMES AND METHODS

Using many different art forms, community cultural development projects often focus on key themes relevant to community identity and mobilization.

History

Official histories reliably leave out many of the most resonant truths of marginalized communities—the reminders that sustain pride and hope. When such things pass from living memory, they deplete the stock of images and ideas from which an imagination of the future is constructed. As John Berger has put it,

> The past is never there waiting to be discovered, to be recognized for exactly what it is. History always constitutes the relation between a present and its past. Consequently fear of the present leads to a mystification of the past. The past is not for

living in; it is a well of conclusions from which we draw in order to act.[2]

Often, mainstream histories privilege the actions of great heroes and villains along with monumental public events—battles, treaties. A strong through-line in community cultural development practice has been to add human-scale information and meaning to the official record by sharing first-person testimonies and the artifacts of ordinary lives.

Oral histories have formed the basis for countless plays, publications, murals and media productions. The impact of such projects is described by this director of an organization that works with teenagers:

> Oral history: now that's really relationship building. It brings the generations together. [An oral history project] was the most amazing project I've worked with. A young person, in their 20s, fresh out of college, interested in the kind of work we're doing, had a group of kids [to train and supervise for project work]: some who'd been hanging out here, flipping rubber bands and not doing much. I saw these kids really change. We gave them pads, tape recorders, cameras and sent them out to gather stories from people in [the neighborhood]. Turned out most of them were from there, though we didn't realize it before. In a very short period, we saw them changed, transformed—from hangers-out to producers of a book, an exhibit, performances. … Now I'll be talking with them about their goals and ambitions and they'll say, "Maybe I should get into theater" or museum work, or "Could I write a book?" And you must understand these are kids who are struggling with their adjustment to this country, as well as young people trying to figure out what they can do.

In another example, community artist Ellen Frankenstein <www.efclicks. net>, based in Sitka, Alaska, has worked with local young people to create video and still photography projects depicting their experiences for members of the larger community who may otherwise dismiss them as "just kids." *No Loitering* is a collaboratively created film that intercuts video shot both by teens and the filmmaker, working together to address the dearth of expressive outlets for youth in a community marked by ubiquitous "No Loitering" signs. "Eyes on the Wall" is an ongoing project with local high school students to create archival black-and-white portraits of Alaska Native artists and elders. Students interview as well as photograph their subjects and write their own reflections on the process. In 2005, a selection of the portraits and other project materials traveled to cultural centers throughout Alaska. Project participants describe their goal this way: "to change the 'eyes on the wall,' those looking

2　　John Berger, *Ways of Seeing*, Penguin, 1972, p. 11.

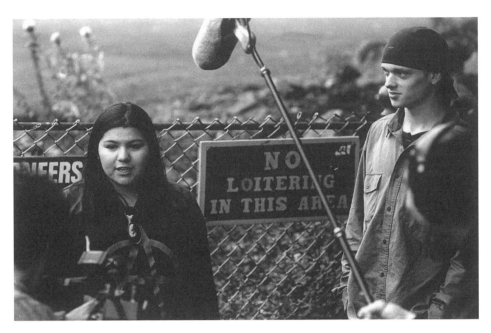

"No Loitering" is the title of this production about young people's lives in Sitka, Alaska.
Photo: © James Poulson 2000

out at us, to reflect who lives in and leads the community."

Similarly, rescuing folktales and other storytelling traditions from obscurity has been a way to assert cultural continuity and use the wisdom of heritage to inform choices about how to move forward. Describing her own inspiration to enter the cultural development field, one community artist credited

> My *abuelitas*—grandmothers, great grandmothers—my father. ... They've shared their singing and dancing and stories. ... Our sharing of our stories, telling about our joys and fears, telling of how we survive, who we love, how we hate, how we deal with attacks towards our lives, how we celebrate—*todos estos cuentos* are the secret of our survival as *gente*. ... We need to tell the real story of our people and rid ourselves of the negative stereotypes. All our lives, through television, newspapers, radio, movies, songs and stories, we've been told that ... our community is lazy, dumb and smelly. ... What we don't hear is the truth and the only way to hear the truth is for each of us to be able to tell our stories. By telling our stories, we challenge stereotypes.

Identity

As wielded by mass media in the United States, cultural identity has long functioned as a blunt instrument, with two main categories—"white middle-

class" and "other." With growing diversity, there has been greater differentia-
tion, but the categories are still broad: Asian, Latino and so on, each subsum-
ing a multitude of specificities. No one's heritage can be adequately expressed
by categories as wide as continents such as Asia or Europe. In actuality, we are
Sicilians or Latvians, Punjabis or Tamils, and even within those categories,
we have our distinct stories of family heritage and intermarriage, our con-
nection to a particular place on the land or to a particular system of belief or
practice, our condition of life informed by class or gender or level of physical
ability. You could say I was white, or Euro-American, but what would that
reveal about my lived experience? Saying I am first-generation American, the
descendent of Russian and Polish Jews fleeing unbearable conditions in the
places of their birth—that will get you a few degrees closer, but still very far
from particularity that is mine.

Very often, community cultural development projects are predicated on a
kind of reclamation work, with participants discovering and claiming their
own ethnic, gender and class identities as a way to recast themselves as mak-
ers of history rather than its passive objects. Grounded in the specifics of
identity, individuals and communities can meet as equals—different and yet
the same.

For example, the Shigang Mama Theatre Troupe was an outgrowth of the
work of Taiwan's Assignment Theatre, founded by Chung Chiao, with wom-
en in a traditional Hakka village devastated by an earthquake. Using tech-
niques devised by Augusto Boal (see Chapter Five: Historical and Theoretical
Underpinnings), the women of Shigang and Chung Chiao created their 2003
production, *River in the Heart*, based on discussions and experiences in a pro-
tected workshop setting, enabling them to transcend Hakka taboos about
women speaking out. This project surfaced unspoken realities about women's
roles in that tightly bounded culture as Ronald E. Smith wrote in his paper
on the project:

> In the Shigang workshops, Chung Chiao merged together exercises and dia-
> logues that were intended to awaken the Mamas' critical social consciousness
> and lead them away from their traditional roles as passive, voiceless observers
> towards becoming active participants for change within the Shigang com-
> munity.

Here are the play's opening lines, depicting grim reality in poetic, evocative
language:

There is a river that flows through my heart
I remember, I shall never forget
In those days, youth accompanied me
My eyes are like the first glimmering of light
I am awake in a meadow
My dreams are waiting for the serene cool nights
Leaves shine like the stars in the sky
Time and youth pass by,
Same for all the women of this world,
They light a candle by exhausting their bodies.[3]

Cultural Infrastructure

Marginalized communities lack cultural infrastructure as surely as they lack economic infrastructure. Just as economic development aims to stimulate the flow of capital and goods within a community and between it and other sources of prosperity, community cultural development aims to stimulate the flow of cultural information and resources. One way this aim can be advanced is by training people to deploy cultural tools for social change, asserting themselves as artists within their own communities and winning recognition for their contributions to cultural capital.

For example, in 2005, the Ukiah Players Theatre <www.ukiahplayerstheatre.org>, a community arts-oriented group in rural northern California, inaugurated The PlaceMeant Project, focusing on the meanings particular places within the community hold for people who make it their home. UPT offered writing and digital storytelling workshops, guiding participants through a series of discussions and exercises to write vivid and compelling stories about a local place of their choosing that has meaning for them. Participants of all ages included Pomo Indians whose ancestors have lived on that land for thousands of years; newly arrived members of the local Latino community, still learning English; several residents who arrived during the "back-to-the-land" era of the 1970s, as well their children, second-generation back-to-the-landers; and members of old farming and timber families. Their writings became the narration for brief sound-and-image digital stories created by participants. The finished digital stories could be experienced as computer multimedia or projected as short films.

3 From Ronald E. Smith's paper, "Magical Realism and Theatre of the Oppressed in Taiwan: Rectifying Unbalanced Realities with Chung Chiao's Assignment Theatre," presented for the Association for Asian Performance at the 2004 Association for Theatre in Higher Education conference.

Acknowledging the Ukiah Valley's trees in the final scene of "The PlaceMeant Project: Stories of Why Where Matters" by the Ukiah Players Theatre in Northern California.
Photo © Ukiah Players Theatre 2005

Subsequent workshops further developed the material into a live dramatic presentation for the community: digital stories were projected on two screens juxtaposed with live performance combining spoken word and movement, presented by a diverse cast of 25 community members. The production coincided with an important event in the life of the community: an unprecedented proposal for development was being debated in city and county boardrooms, calling for a 700-unit housing development and a super-size "big box" retail park, a potentially huge impact on a rural community. The production was cited repeatedly in community meetings, according to its organizers, helping to "focus public conversations on our collective responsibility to not only protest unwise development, but, more importantly, to work together as a community to imagine and manifest the kind of growth that allows for the development of housing, industry and jobs, while preserving the agricultural nature and beauty of the region."

Another way to build cultural infrastructure is to link cultural development and economic development directly, creating outlets for cultural products created by community members. For instance, YA/YA (Young Aspirations/Young Artists) <www.yayainc.com> is a New Orleans-based group with this mission: "to provide educational experiences and opportunities that em-

power artistically talented inner-city youth to be professionally self-sufficient through creative self-expression." YA/YA is best-known for the hand-painted chairs young people produced in its workshops beginning in the late 1980s. Other projects have focused on clothing, murals and environments designed and executed by young people. For instance, in 2004, using skills they learned through YA/YA's Inner-City Threads fabric training program, participants worked with local artists to create the Tremé Storytelling Quilt, comprising four panels, each telling a different story of the New Orleans neighborhood Tremé, the oldest urban African American community in the United States. YA/YA's work has been successfully promoted and distributed, generating significant income for the organization and participants. At this writing in 2006, YA/YA has largely regrouped from the devastation of 2005's Hurricane Katrina, which damaged its headquarters and dispersed its members. Among its spring 2006 projects was "Katrina Storytelling Quilts," in which elementary school students in the earliest grades created one-foot–square self-portraits depicting their experiences and homes during or after the hurricane. Sewn together, the portraits became quilts which were installed at one of New Orleans' new post-Katrina charter schools.

Space One Eleven <www.spaceoneeleven.org> in Birmingham, Alabama, has established the City Center Art Program, bringing children aged 6 to 18, most from local public housing, to after-school and summer art programs. Selected graduates of the program serve as apprentices, receive stipends and work towards paid internships as artists' assistants. The largest impact on cultural infrastructure has been the Birmingham Urban Mural, completed in the spring of 2000, spanning the side of Boutwell Auditorium, easily seen from the main interstate highway crossing Birmingham. All of the 28,000 clay tiles used in the mural were handmade by City Center Art Program participants.

Organizing

In contrast to elite arts activity, which asserts the primacy of "art for art's sake," community cultural development is undertaken in aid of the larger goals of social transformation and personal liberation. In some cases, arts activity provides a sort of lab or rehearsal for social action. Of such approaches, the best-known are the liberatory education practices of Paulo Freire and the related work of Augusto Boal in "theater of the oppressed" (often abbreviated TO), discussed further in the next chapter.

El Teatro Lucha por la Salud del Barrio is part of Project COAL (Communities Organized against Asthma & Lead/Comunidades Organizadas contra la Asma y el Plomo), a coalition of South Texas community groups funded in

2003 by the National Institute of Environmental Health Sciences (NIEHS) to use Boal's methods to create interactive theater experiences bringing residents of neighborhoods affected by environmental poisons together with scientists and activists to explore and address the problem. The primary community partner is de Madres a Madres, a movement of mothers and their children in Houston's near north side that offers prenatal education and mentoring, job assistance, a food bank and social-services assistance based on years of on-the-ground experience. John Sullivan, the theater facilitator working with de Madres a Madres, describes the group as "the most caring and competent community-based organization I've ever worked with; they are really a vital part of that community, almost like its heart."

To form the troupe, ten community members were trained in the philosophy and techniques of TO and briefed on the impact of lead and asthma on local communities. The project includes three phases over four years, 2003-07. First, Forum Theatre methods were used to assess community knowledge of threats such as lead poisoning and asthma and their prevention, taking cultural factors into consideration. In the second phase, the troupe created dramatic scenes accurately representing ground-level environmental facts and

El Teatro Lucha de Salud del Barrio sets up changes in the opening fluid image in Forum Theatre. Photo by Karla Held 2005

modeling successful grassroots responses. In the third phase, the same techniques would be used to assess Project COAL's partnerships and methods, feeding into a new show, "Our Neighborhood of the Future," which will tour the community, inviting further involvement. El Teatro Lucha and its collaborators are already planning a further project focused on obesity and diabetes prevention.

In a very different model, the Documentary Project for Refugee Youth was designed as a collaboration among young refugees, the Global Action Project, the International Rescue Committee and other community organizations and artists in New York City. The 12 young refugees comprising the project's core group live in New York; most are West African or Balkan, from Sierra Leone, Bosnia, Burundi and Serbia. In September 2001, the group began working together to share and understand their own experiences, collect testimonies from others, learn photography, write and create powerful short films that can be accessed at its website, <www.global-action.org/refugee>. As one young woman said of her experience:

> I felt like there is no person who suffered more than me. But then, talking to other people and finding out that it's not just me, that it's half the world. Before I didn't know there were so many conflicts and wars, and now that I know, and have the opportunity to do something about it, I want to let other people know.

In further iterations, the project is distributing its films and publications to wider audiences and inviting testimony from other refugee youth.

BOUNDARIES AND INTERSECTIONS

How do we judge the success of an innovative, transformative practice? Is the result greater if a heterodox idea permeates and influences hegemonic tendencies, creating widespread, incremental change? Or if the insurgent idea gains sufficient force to take shape as a distinct, bounded feature of the cultural landscape? From what I have observed, the most influential (perhaps it would be more accurate to say the best-timed, the ripest) ideas do both.

Consider complementary medicine—herbs, touch therapies, acupuncture and other non-Western health treatments. In a few decades, these have grown from marginal, fringe practices to billion-dollar industries with their own clinics, professional associations and journals, indeed, all the trappings of a distinct field. At the same time, chain drugstores stock homeopathic remedies

and herbal formulations while major university-based medical schools include complementary practices in their curricula, gradually integrating what was once an insurgency into the mainstream.

So it has been, albeit on a much smaller scale, with community cultural development.

For example, artists like Suzanne Lacy <www.suzannelacy.com> straddle the advanced art world of conceptual, installation and performance art and the community cultural development field. Her project "No Blood/No Foul" from the mid-1990s was a collaboration among Lacy, public officials working toward a communitywide youth policy, police and young people in the stressed urban community of Oakland, California. (Collaborators were collectively named TEAM, an acronym for "Teens + Educators + Artists + Media Makers.") No Blood/No Foul was part of a multiyear series of projects each consisting, in the artist's words, of "a performance, policy interventions, a thoughtful media strategy, and direct services to participating youth."

As Lacy describes it, "No Blood/No Foul was an event that pitted youth against police officers in a tough, competitive, and fast-paced 'basketball as performance' artwork. The performance, with its live action video interrupts, pre-recorded interviews of players, half-time dance presentation, original sound track, and sports commentators, mixed up the rules of the game. Adult referees were replaced by youth referees, then no referees (street ball, where the rule is, 'If there is no blood then there is no foul') and for the last quarter, the audience as referee. The performance received extensive local and national television coverage, an example of the Oakland Youth Policy Initiative in action, and was attended by the mayor and several council members." The project advanced its collaborators' social as well as artistic goals: "Oakland City Council passed the Oakland Youth Policy Initiative and funded US$180,000 for a youth-to-youth granting program and a Mayor's Youth Commission."

Like core community cultural development work, Lacy's approach is collaborative and oriented toward social change. It departs from community cultural development values in one main particular: as with conventional conceptual art, its products exist apart from the process, with ultimate validation deriving from the art world. In this case, for example, graffiti murals, a basketball court and video interviews for the project were featured in a Tokyo-based international exhibition of conceptual and installation artists. The artistic products traveled to an exhibition venue as another artist's paintings might do, having another life of their own as part of an artist's catalog.

Activism has also been affected by community cultural development values and approaches, although by and large community cultural development methods have been seen as ways to create practical tools for activists, rather

than as a type of activism in and of themselves. For instance, the February 2006 National Conference on Organized Resistance in Washington, DC, featured half a dozen sessions on visual art, poetry, theater and other ways to deploy collaborative artistic creativity for social change. The description of a workshop on "Inter-Activism Through Music" begins this way:

> Ideas and thoughts presented musically may stimulate parts of the brain and psyche even the most heartfelt words cannot. The most successful inclusive movements reach both the right and left brains. This "whole-brain" interactive workshop is designed to involve participants in the immediate and serendipitous co-creation of conscious music. We will look to current events and issues of interest to participants as a way of exploring expression through ballads, chants, call-and-response and other musical forms.

Creative expression drawn from community members' own stories has been recognized as an important contribution to health and healing, as for example in the work of Richmond, California–based ArtsChange <www.artschange.org>, which has taken this as its mission:

> [T]o present innovative and artistically significant exhibitions that support cultural interchange and expression among the diverse communities of Richmond; forge a new artistic tradition between professional artists, healthcare workers and patients; and demonstrate that the arts can educate, transform medical institutions and enliven the work of healing.

The chief venues for ArtsChange's exhibitions are local health centers. Its winter 2006 exhibit was entitled, "In Celebration of Pumpkin, Greens and Catfish Stew, Oh My!/*En Celebracion de Calabaza, Espinaca y Pozole, Que Sabrosa!*" It opened with a film on local youth and food in Richmond made by a neighborhood theater group; an interactive healthy kitchen installation; an exhibit of works of art on food created by ArtsChange artists; a musical performance; discussion; and celebratory meal. Community cultural development influences are evident in the project's drawing on local culture and engaging community members in exploring themes important to their own well-being; it departs from core community cultural development values in that it focuses on work that is not the product of a hands-on collaboration with non-artists.

When the present community cultural development field began to take shape in the 1960s, public funding was primary. But after decades of cuts and privatization, artists and activists are just as likely—perhaps more likely—to

work the margins of commercial culture than to look to the public sector for support and opportunity. In some cases, commercial cultural producers adopt a social agenda that motivates them to reach out for direct involvement with communities others in their industry might see merely as units in a market segment. For instance, London-based community artist Gary Stewart describes music workshops for teenagers at ADFED, the educational wing of the popular and commercial music group Asian Dub Foundation <www. asiandubfoundation.com>:

> Some of these young people are under cultural attack, and they're not actually allowed to go and do extra activities. Their parents or guardians have to be convinced that a safe place for them can be provided so that they can interact with other people without being at risk.
>
> It's worked out as a 10-week block, and so there are specific technical headings that enable them to learn the specifics of music making. But in addition to that, other issues around racism and antideportation campaigns are discussed—they also bring up issues themselves, obviously. There are opportunities for them to talk about issues that affect them personally such as immigration legislation and more global issues, the links between racism and corporate power and Third World countries.
>
> Basically, the music is used as a kind of metaphor. The workshops themselves are about exploring the rhythms of different sounds and exposing participants to connections. It's a bit like an extended metaphor for the connections between people, economics and history.[4]

In 2006, ADFED was one of several partner organizations (including local government and major London-based cultural institutions) to open Rich Mix, described as "a new creative space for London," a public-private cultural center in East London offering screenings, exhibits, classes and performances as well as projects such as the Rich Mix Asian Women's Creative Collective (RAW) <www.richmix.org.uk/raw.html>, aiming to

- create an open and nurturing environment for Asian women to show cultural work with feedback from contemporaries
- open up mentoring relationship opportunities with established artists providing relevant support to newer Asian women artists
- build up a network for the sharing of ideas and creative collaborations
- open up Rich Mix's programming team to themes and talent they feel is relevant

4 Adams and Goldbard, *Community, Culture and Globalization*, p. 162.

To some extent, community cultural development values have permeated every sector. The gargantuan public-private enterprise called the Internet has opened space for countless collaborative cultural interactions, from sites where game-players collectively create interactive fantasy scenarios to sites for collaboration at a distance on visual artworks, musical compositions and literary works. This vast virtual venue provides outlets (and very often, comradeship, attention and assistance) to amateur and professional artists from every cultural background, working in every possible form and medium. At this writing, Myspace.com, a popular social networking site, hosts nearly 1,300 online discussion groups devoted to some aspect of the arts: book clubs, photography groups, places to share poetry or visual art, theater and dance discussions, regional groups for arts participants from Detroit, Charlotte, Los Angeles and many other places.

In 2004, when George W. Bush was re-elected President of the United States, a group of activists set up a website inviting members of the nearly half of the electorate who voted against Bush to post visual apologies to the rest of the world. What must that election "have looked like to the world outside our borders? America proudly re-appointed its reckless, incompetent and corrupt government. How much of America? Fifty-two percent. The rest of us are aghast and dismayed." Since then, drawing on submissions to the website, <www.sorryeverybody.com>, *Sorry Everybody*, a full-color, large-format 256-page book of photos was published. Each page carries several images drawn from 26,000 submitted to the site, almost all featuring one or more Americans holding text and/or graphic images conveying their apologies to the world.

When they get up from their computers, many go to coffeehouses' open-mike nights to read their work or compete in poetry slams; they take craft classes at stores selling arts-and-crafts supplies; they play in garage bands or maintain plots at community gardens; they paint and fire pottery, purchase yarn and learn how to knit at chain shops created to cater for the expanding social purpose of individual creative expression. I don't mean to suggest that these huge publics are consciously linked to the community cultural development field, but it is in part due to the field's democratizing influence that so many people now feel authorized and encouraged to explore and share their own creativity in the interstices of the public square and market economy. That they do so generates an implicit critique of the elite orientation of so much of the mainstream nonprofit arts sector, as Maribel Alvarez has written:

> Nonprofit arts organizations are for the most part, not perceived as interested in upsetting the definition of who's an artist and who's not. Therefore, as one amateur actor opined, formal arts organizations are relatively "irrelevant" to

the social transactions and conversations that connect people with participatory art-making. They are just not the kinds of places to which people who want to act, sing, play an instrument, dance or paint gravitate when they are seeking avocational arts experiences.[5]

But is all this community cultural development? Does it advance the movement's aims of pluralism, participation and equity? With a fluid, evolving practice like community cultural development, two opposite and equal definitional difficulties arise.

On one side is the temptation to see the practice too broadly, without standards and qualifiers. Given so many approaches, models and media, isn't it legitimate to say that any community-oriented arts activity is a form of community cultural development? On the other side is the danger of being too strict or purist, imposing an orthodoxy on an insurgent practice that always mutates beyond such boundaries.

My choice is to walk the tightrope between them. Flexibility is good, but too much leads to flaccidity. Community cultural development practice has had growing impact on other practices, from advanced art to social science; yet there are core values that cannot be ignored or transgressed without diminishing a project's force for cultural transformation. Chief among these is the commitment to genuine collaboration, to participants' joint authorship of the experience and equality in choosing its direction, in controlling the uses to which it will be put, in articulating its meaning.

In the mainstream art world, we mostly see non-artists' creativity deployed in the service of a lead artist's aims. Playwrights may base their characters on information derived from oral histories. In constructing their environments, installation artists may use narratives, photographs or artifacts provided by non-artists. Other artists may feature community members in their public performances or make use of individuals' technical skills (such as needlework or woodwork) in constructing large-scale visual art pieces. However wonderful the work may be, if the participatory elements are tightly bounded (so that a seamstress participates in an installation in the same way a plumber "participates" in laying pipe to an architect's specifications), the work is not community cultural development. The key distinction turns on the artist's role: when the individual artist's vision, that person's aesthetics, choices and vocabulary, control the work in which community members take part, the work—however strong, striking, or moving, however valid as art per se—is not essentially about community cultural development, because it violates the

5 Maribel Alvarez, *There's Nothing Informal About It: Participatory Arts Within the Cultural Ecology of Silicon Valley*, Cultural Initiatives Silicon Valley, 2005, p. 75.

underlying principle of equality of participation and the underlying aim of collective expression.

This is not merely a distinction of technique, style, or skill, but of core purpose. Techniques and skills cannot be separated from their critical emancipatory aims without reducing what purports to be community cultural development to a practice that might be applied toward any goal, even coercive ones.

Consider the example of international development agencies. As such agencies have learned, it may be effective in terms of health promotion to package essential information on HIV prevention or other health risks in skits, radio broadcasts or television programs that use vernacular styles, stories and tunes to humanize the information, easing its delivery to local receptors. Such an approach will employ some community arts methods: the writers and producers of these works must interact with local people to learn enough about their cultural values, vocabularies and taboos to ensure that their messages can be received as intended by the local population. But the aim is to better communicate a message from the center to the margins. As targeted commercial advertising proves, such techniques might just as well carry a message that is not so worthy, whether to drink sugary carbonated beverages instead of juice or water, to promote expensive patented hybrid seed rather than continued use of self-generated seed stocks or to introduce chemical-intensive forms of pest management.

What makes community cultural development different from clever advertising, do-it-yourself crafts kits, advanced art or inspiriting protest songs is that its means and ends are one. I see them as simultaneously spiritual and political: to use the expressive gifts that are uniquely human to convey each cultural community's special contributions to our common task, understanding and repairing the world we share. So I welcome the influence of community cultural development on every sector of society, applauding its integration, and at the same time I must insist that is insufficient. To achieve its full social impact, community cultural development must also be recognized and strengthened as a distinct, value-driven practice, which sometimes requires drawing the line, saying that a project departs too much from those core values to be called community cultural development.

Las Chismosas: From an improvisation to develop a play addressing homophobia during a Fringe Benefits Theatre for Social Justice Residency at Wilson High School, fall 2005. Photo © Fringe Benefits

CHAPTER 4
An Exemplary Tale

Having stipulated that there is no paradigmatic community cultural development project, I now need to invent something very like one to offer the reader a concrete, start-to-finish example of the unadulterated practice. As long as I'm inventing, I want my creation to be deep and spacious, hinting at the rather remarkable range possible with such practices. To do this, I have to engage in several forms of fantasy and appropriation.

First, I imagine a team of artist-organizers with ample time and resources for an open-ended, multiyear project. This project subsumes several smaller project elements, each of which might stand alone. (As I am writing in times of real scarcity for U.S. community cultural development support, this takes a large leap of imagination.)

Second, I borrow and adapt techniques and approaches from many community artists, without attribution. No one has a patent on community cultural development methods (although quite a few groups have devised formal methods, sometimes known by distinct acronyms), and there are countless variations on every theme. Nevertheless, I ask forgiveness for borrowing so freely without giving particular credit to those who have become best-known for developing or adapting certain practices. Of course, there are many other practices I haven't mentioned; this chapter features only a sampling of the possible.

Third, because every project is so strongly shaped by the individuals involved, the character of the community, the spirit of the times and numberless

other factors, only an exact moment-by-moment account could successfully depict any project in its entirety. My dilemma is something like the one Jorge Luis Borges laid out in his one-paragraph story, "On Exactitude in Science," in which the cartographers' quest for absolute accuracy produces a map that is exactly the same size as the territory it covers. Unless I devote my entire book to a minutely inclusive account of process, my map will necessarily be marred by many omissions, as it is.

THE BASICS

Where: I'm borrowing some of the characteristics of my San Francisco Bay Area community to portray the fictional "Bayside." We live in single-family houses and small apartment buildings. Relative to nearby communities, Bayside isn't an expensive place to live, but even rents that are low by Northern California standards would seem sky-high in other parts of the country. You have to work hard to stay even.

When: Bayside's centennial will be celebrated in two years, so people have an interest in looking both backward and forward in time. Happily, there are also resources to support community cultural development projects: the state arts and state humanities agencies and historical society all offer grants for centennial projects, and there are regional foundations and local businesses willing to help.

Who: This is a diverse community. Early in the 20th century, it was a predominantly Anglo agricultural area with a small port. During World War II, shipping boomed, bringing large numbers of African Americans here from the South to work in war industries. Now the industrial base is mostly gone and the economy is deeply depressed. People work service jobs or commute to jobs in the city. Immigrants from Asia and Central America have joined the older populations. In the neighborhood where I live, over 40 percent of the residents speak English as a second language. My neighbors hail from every part of the world. We live side-by-side in harmony, but we aren't really part of each other's lives. After several years, we don't all know each other's names, nor have we all been inside each other's homes.

The Team: Our five-person team includes a photographer-filmmaker, a visual artist, a theater worker, a writer and a musician. (For ease of comprehension, I will use their primary specialties as their surnames: Rosa Filmmaker, Joe

Painter, Chan Actor, Nayo Writer and Eli Musician.) We're all experienced community artists who've had the good fortune to be working out of a neighborhood center for the last few years. Cobbling together funds from economic development programs, educational enrichment programs through the local school system, foundation grants and contracts with social service agencies, we've been able to pay salaries and support several ongoing projects. Now the Bayside Neighborhood Association has obtained a grant from the Town Centennial Committee to support two years of work leading up to the big event, so we enter into partnership.

ACTION RESEARCH

Getting Acquainted: Our team already has quite a few contacts and partners in Bayside, but there are still many people we don't know (and vice versa). We need to renew old relationships and get acquainted with new folks in a way that actively involves people, advancing the work. Our mode is "action research": learning by doing. We definitely want to avoid the distanced, often alienating position of outside researchers, putting local culture under a microscope.

We start by making a list of everyone we already know who is connected to a community group or just happens to be a good networker, then splitting up so that one of us visits every person on the list. To each person we explain that over the next two years we are eager to work with Bayside residents to learn about and engage in their own community as part of the approaching centennial. We will make our skills available to collaborate with people however they choose.

We share some information on our past projects. Most people have experienced at least one of them—"Oh, you worked with the kids on that mural at the Y! My son painted part of the garden. He's so proud every time we go by there!"—and that starts to build a bridge. But the main connection happens when the other person does the talking. We ask each one a few general questions:

- How long have you lived here? How did you come to be here?
- What do you really like about Bayside? What's the best thing about living here?
- If you could change one thing about Bayside, what would it be?
- If you were starting a project here, who would you be sure to talk with and why?
- Who should be involved but might not be?

When our team comes together after these interviews, we share notes on all the responses we gathered, building a master-list of individuals and organizations whose names were mentioned. We also compile the things people said about Bayside. When we review and discuss them as a team, certain themes emerge:

There's a steady stream of newcomers here, but also a sizeable group of people who've lived in Bayside for generations and are deeply attached to the place. Many feelings are mixed up together: nostalgia, loss, attachment, hope, excitement, uneasiness.

The things people like best are the diversity (even though it's not without conflict), the natural beauty and the community events that bring everyone together: fireworks at the port, the farmers' market every week, the Juneteenth picnic, the Cinco de Mayo parade.

What people would most like to change are the tensions between different ethnic groups, the turf feelings that make certain people feel unwelcome, and the negative rap the community gets from the outside world, which only hears about Bayside when something bad happens here.

Three Action Research Projects

Based on our team's learning so far, we brainstorm possible next steps that cover as many of the bases as possible: what will produce the most knowledge and the most participation? We decide to try out three action research projects to learn more and get more people involved:

Self-portraits: The weekly farmers' market is a great place to meet people. Most of the stands sell produce that's hard to find at the supermarket: shell beans in season, all kinds of Asian greens, fresh chiles and much more. So with permission from the folks who run the market, we create a place right in the middle of everything to do self-portraits. We set up a backdrop and a digital camera on a tripod with a cable release. Curiosity attracts a crowd. Whenever it dwindles, we go through the market asking vendors and shoppers if they'd like a free photo portrait.

Self-portraits are a terrific icebreaker, because the threshold to participate is very low—just agreeing to take your own picture, which gets you a free copy—and the payoff is big. As the project unfolds, people will get to see their portraits become part of something larger and wonderful, such as a community exhibit, a project website or eventually a publication.

We explain the self-portrait process to each person. Then people fill out a form with their names, phone numbers and mailing addresses, so we can send them their portraits. As they wait, they answer a couple of questions: Why do you come to this market? Is there anything about Bayside that makes it special? We jot their answers on their forms. Then they pose themselves in front of the backdrop, and when they're ready, press the button on the cable release to take their own photos. When we print the photos and send them to people, we'll also send them information on how to take part in other project activities. We store the photos and captions digitally, to be used in future project elements.

By the end of the day, we've hit it off with several of the vendors and gotten them involved in the next action research project.

Story circle potluck: We plan a story circle, inviting the folks we've already worked with and the active community members and organization reps whose names we gathered through the first round of interviews. Our friends from the farmers' market contribute produce in season, hooking us up with some of their most devoted customers who love to cook. To sustain everyone's energy, we have three big pots of beans—Salvadoran style, Louisiana style and Udipi style from southern India—and ask people to bring breads and desserts to share.

After some ice-breaker exercises, the food comes out. While people are eating, our team members introduce the Bayside project and the upcoming centennial. Then we explain the story circle's ground rules: everyone focuses on the teller, everyone gets a turn, everyone's story is part of the mosaic. One of our team—Nayo Writer—comes from a family that's lived here for generations, so she starts with a story her grandmother used to tell about how exciting it was to work in the shipyards alongside the men, handling the big tools and knowing the work she did would help to defeat the Nazis.

It turns out Nayo isn't the only person present with a Rosie the Riveter in the family: a few variations on her story follow in rapid succession. When there's a pause between stories, a much older woman begins to talk in a voice full of emotion, mingled anger and sadness: "All that was true," she says, "what your grandma told you: it was fun. But don't tell me we all got along like one big family, because I was called some names that still bring tears to my eyes. And when the war ended, they had no more use for us." She looks around the circle, head swiveling slowly. "And some in this town still don't."

Eli Musician picks up on this theme, asking some of the newcomers if they have stories about how it's been for them coming to Bayside: "How were you welcomed?" he asks. "And how weren't you?"

As the evening draws to a close, a young African American man who's been pretty quiet starts to speak up. He catches the eye of an Indian man near his own age. "I see you around," he says to the other, "we nod sometimes, right?" The young Indian man smiles cautiously in acknowledgement. "But we don't know each other's names, and this is the first time we broke bread together. Have you ever had those red beans before?" The Indian man replies, "No, but they were very tasty. And I'm Ravi Vidur." The first young man nods, "Eugene, Eugene Simmons. And that pot of beans you all cooked, those were good. So many flavors at once." He looks around the circle, holding people's eyes. "That's what I'd like to change with this centennial. Make Bayside a place where people share things, know each other's names and sit down to eat side by side. I don't know about anybody else, but that's what I'd like to see."

Community altars: The local Latino community grows steadily, but there were few Latinos at the market or story circle. It's October, so we plan a different type of gathering the weekend before the Mexican holiday *Días de los Muertos* (Days of the Dead). Traditionally, Mexican families bring decorations and gifts to the cemetery or create altars for the dear departed, decorating them with memorabilia and offerings of food and flowers. This practice has been widely adopted by artists here in California, even those without roots in Mexico. So we plan an event that will bring together Latino families and artists who live around here, as well as anyone else who's interested.

The Concilio Latino, a pan-Latino community group, agrees to cosponsor a day-long altar-building workshop. Over coffee, we spend some time brainstorming themes that will pull people in, speaking to their interests. The best choice seems obvious: using the event to remember the young people who've been killed in drive-by shootings and other gang violence.

Joe Painter organizes a carload of art supplies while the rest of us round up fruit crates and scraps of wood and fabric. On the day of the event, we set out tables and folding chairs in the courtyard. Around three sides of the courtyard, people are invited to erect and decorate small individual altars to their own loved ones or heroes. On the fourth side, we've built the armature for a collaborative community altar to all the people from Bayside who've lost their lives through violence. Throughout the day, we repeat short how-to workshops on stenciling, lantern-making, paper-cutting, flower-making and altar-building.

People create many touching individual altars. Some are elaborate creations filled with elements they made at home and brought here to assemble: framed portraits and clippings, arrangements of paper flowers, small figures of saints, objects representing favorite pastimes. Other altars are created on the spot

with the paints and paper and orange crates we provide. Some are so sad: the beloved son who lost his life in Iraq, the young mother who succumbed to cancer, leaving a houseful of children. The community altar is amazing, tragic and frightening: hopeful grade school photos of the now-departed sit side-by-side with stark headlines in newspaper clippings: "Bayside Death Toll Reaches 39 with Shooting of Teen."

When the sun begins to set, Eli Musician and friends from the neighborhood play lovely processional melodies as we light the lanterns and circle the courtyard. People speak their hearts. Our team of community artists goes last, thanking everyone and inviting all to stay connected through the centennial project. Rosa Filmmaker shoots images of the altars, collecting addresses and comments as we did at the farmers' market, promising to send people prints of their own creations. Everyone is invited to eat some of the treats that have been brought. People from the Concilio promise to guard the courtyard for the next few days, so the altars can stay up for others to visit through the end of the holiday.

KICK-OFF AND PROJECT DESIGN

Our team spends serious time looking at the action research documentation and going over the many conversations we've had with community members. The next step will be a report-back to the community, inviting everyone who took part in any of these events to come out and talk about what's next. We need to get a grip on the information ourselves so we can avoid overwhelming people with miscellaneous facts. Our aim is to offer an interesting, organized presentation that gives people many ways to enter in. Based on past experience, there are a few things we know are essential for the report-back:

> It needs to be fun and interesting, not just a meeting. Food helps. So do music, images and activities.

> We need to suggest a real range of possibilities, engaging people in figuring out what works best for them. We can't impose, nor will it work if we disappear into the background. This is a partnership.

> We need to have structures in place to pick up on what people want. We need to be able to jump-start work right away, or the momentum will dwindle.

Our program for the late afternoon-early evening event shapes up this way:

• Welcomes from our team and introductions for all

• Rosa Filmmaker takes everyone through a quick Powerpoint slide show of self-portraits from the farmers' market and altars from the Concilio courtyard; the soundtrack includes snippets from interviews and bits of music that interviewees mentioned. Some of the people involved are present, so Rosa calls on several to say a few words about the experience.

• Eugene Simmons and Ravi Vidur from the story circle potluck tell people about the story circle, reprising Eugene's comment about breaking bread together and knowing each other's names.

• Team members report on what we took away after reviewing all this information: we were blown away by Bayside's remarkable diversity; we heard some strong messages about what brings us together and what divides us. The action research tells us that leading up to the centennial, whatever project we do together needs to have room for different ages, backgrounds and types of people to take part, and it needs to look both at what unites us and what divides us. (Lots of smiles and "Yeahs!" and nods at that, which feels good. The atmosphere of the room is warm and excited.)

• Our team members lay out two different proposed project models we've devised:

Community self-portrait: Joe Painter explains that the first model is a community self-portrait focusing on the diversity of personal milestones, holidays and community events that take place in Bayside each year. We have a small fleet of digital cameras. We'd lend them for a week apiece to people of all ages who want to document some event in their own family or in the life of the Bayside community. Using a participatory process, the images would be curated into an exhibition to tour local community centers. Other media could be used too: Rosa Filmmaker could organize kids who want to learn to video interviews, and they could gather first-person stories from as much of Bayside's last hundred years as remains in living memory. If there were a good space and enough people who wanted to work on it, Joe Painter could coordinate a mural project. Chan Actor speaks up to say that transcripts from interviews could be edited into a theatrical presentation too, with projected images from the photo project. There could even be a product to sell at the centennial celebration, for instance, a Bayside holidays calendar.

Food project: Nayo Writer then explains the second project model, which harks back to what Eugene said about breaking bread together. Everybody loves to eat, yet some of our foods seem pretty strange to others. What about

a project focused on food? It could use many of the same approaches Joe just described: teenagers could be trained to interview seniors about the foods they ate as children; interviews could focus on memories of home and food, with each interviewee making a dish of his or her choosing and providing the recipe so others could make it too. The stories could be the basis for a theater piece, or the images could be blown up and exhibited. If people wanted to work toward a product, it could be a cookbook with stories. We could even sell it to benefit the food bank or school lunch programs.

We ask people if there's anything in either of those project ideas they can relate to, or if something else would be better. The general feeling is that there is plenty to sink our teeth into (no pun intended) with these two ideas, so the next segment happens over dinner.

• While people eat, we ask them to think about two things. First, we've given everyone a large green gummed dot. We ask people to spend some time over their meal thinking and talking about the options, and before we come back together, to place their green dots on one of the two sheets we've posted, either "Community Self-Portrait" or "Breaking Bread." If one project is the clear favorite, we're on our way. If both have about the same number of green dots, we'll talk further about how to combine them.

We also give people three small Post-its apiece, asking them to write their names and phone numbers on each, then number them one to three. Across the room, we've posted several large sheets of paper, each headed with a project type: theater, video, mural, publication, music. We ask people to put their Post-its on as many of these as interest them personally. What would you personally like to learn or work on, whichever project ideas are chosen? If you're interested in more than one thing, we say, put the Post-it labeled "one" on your favorite, "two" on your second favorite and so on. If you want to be more specific, write more, like, "I'd like to do video interviews with elders" or "I'd like to help put together a photo exhibit."

• After dinner, everyone looks at the dots and Post-its together. "Breaking Bread" is the clear favorite, and people have indicated interest in many different ways to take part. The community artists' team divides up, pulling chairs into different parts of the room. People go to caucus with the team member who corresponds with their first choice: Nayo Writer for publication, Eli Musician for music, and so on. In each small group, people take turns going around the circle, sharing initial responses—both excitement and reservations. Before we come back together to say goodnight, each group makes a plan to meet again.

THE MAP UNFOLDS

Here's where my map necessarily lacks detail. Over the course of two years, several elements of the Breaking Bread Project develop concurrently, two processes unfolding in parallel: the personal development of project participants and the larger project in which they are involved; learning to work together and engaging the larger community.

Learning from Each Other

Once our recruitment efforts have helped build good-sized teams for each project element, those involved must come to know and trust each other and improve their own skills. The people who work most directly on each project are deepening their community knowledge while they build working relationships, navigating sometimes treacherous interpersonal and inter-community terrain.

For instance, one team member works for a local social service agency. She's alarmed at the growing urgency of youth violence problems in Bayside. "How are you going to get these at-risk kids to be part of this?" she asks Nayo Writer, her voice skeptical, as if daring Nayo to even try for a worthy answer. "How are you going to get these gang kids involved?"

Nayo turns the question back on the group: "Are we going to get them involved?" she asks. "What do you think? And if we are, how? Is there anything in the way you got involved yourself that might work with them?"

People chime in with ideas: find the "bridge" kids who have a foot in both worlds; find the best youth organizers and get them on board; make teens feel like their ideas really matter; give them things to do that are easy and fun, to get them through the door; and so on. That leads to a discussion about focusing on who's not here instead of who is. Is the work useless if it doesn't reach all of the kids who tend not to participate in community things? Would it be good enough even if everyone isn't involved? What if some people say the project is bogus because it doesn't reach all the kids they call "at-risk"? Should we pack it in now, knowing we can't be perfect? Or should we see it as part of a process that continues through the centennial and far beyond?

People opt for the long view and work goes on: dividing up the task of contacting youth organizers and "bridge" kids, planning short workshops that can give young people a taste of the fun and freedom of participating, planning for teens to reach out to other teens.

Each team spends time in learning situations: the people who will video-tape interviews and stories familiarize themselves with the equipment and

techniques, practicing on each other; the people who'll work on the cookbook learn desktop-publishing skills, and so on. This also yields considerable learning about group processes. Team leaders must be skilled to maintain awareness of all levels of interaction as group members get to know each other: how are people doing on the practical, technical level? Is the pace of learning appropriate and stimulating? Are there emotional issues beneath the surface that need attention, or even problems that that have already erupted and need healing? Do people have a grasp of important information about the community and the project? Have they taken part in the conversations necessary to explore its larger meaning, its political and spiritual significance? Community cultural development projects engage the whole person in all dimensions; none of them can be ignored.

For example, a project that centers on food may at first seem innocuous. But here are some of the themes that surface:

Scarcity and abundance: Some participants feel alienated from a celebration of rich heritage honoring ancestors. A few sessions into the project, one girl, choking back tears, shyly admits she didn't know her grandparents—or her parents—let alone what they ate. Chin held high, an older man says that most of the time, his family didn't have enough to eat. This moves a girl on his right to say, "Where I stayed when I was real little, nobody really cared what I ate. I never sat at the table and ate a whole meal off a plate till we went to live with my *Abuela*." The subsequent discussion leads people to agree that the project needs to focus on all kinds of hunger as well as everything that satisfies it. A lot of people who now live in Bayside grew up without being able to walk into the supermarket and buy enough to fill a refrigerator. Where they came from, nobody even had a refrigerator and by the end of the week after payday, people were eating biscuits and gravy for dinner. "Or nothing but rice," says a boy whose family came from Laos.

Otherness and acceptance: When they get to know each other, some participants admit feeling repulsed by things others love to eat. Sometimes foods transgress dietary prohibitions: Ravi says he's a vegetarian and his friend's a Muslim; they were almost sick when the neighborhood barbeque turned out to include a very aromatic pig roast. Sometimes foods' strangeness triggers a reflexive avoidance: Rosa tells how embarrassed she was when her sister poked her in the ribs at an Asian Spring Festival gathering and loudly asked, "Did you see what those people *eat*?!?" Everyone talks about how tastes are so personal, yet they can give offense to others. How do we handle that? Everyone agrees to maintain a pleasant expression if they possibly can, even when confronted by things that trigger weird reactions, and to keep potentially in-

sulting remarks to themselves. We'll also make every effort to accommodate different dietary restrictions in communitywide events.

Newcomers and old-timers: A project like this can bring up deep pain of loss for immigrants who were forced to leave a rich heritage culture behind, or it can expose hurt feelings at being disrespected by their new neighbors when they arrived. When Trinh's family left Vietnam in 1975, he was 11. As he recalls buying shrimp paste grilled on sugar cane at the street market in Saigon, he surprises himself by breaking down. He can almost feel the steamy heat rising, smell the flowers and smoke. Betty, sitting on his right, pats him quietly on the back, giving his feelings space. Later, some of the younger people crowd around, begging him to tell the story of the airlift—a story their own parents haven't wanted to repeat, instead changing the subject, admonishing them to look to the future, not the past.

Long-time residents can also feel threatened by newcomers they fear will displace them in jobs or housing, or whose influence seems to be turning familiar streets into strange territory. At the end of one evening work session, two women start a quiet conversation that turns into a painful group discussion. She went to the market, Gloria West says, but couldn't find what she was looking for on the shelf. She asked three clerks, but none of them spoke English well enough to get the question; they just pointed her to the wrong place, the place she'd already looked. "What is happening to Bayside? Why don't people learn the language when they come here?" "This land was ours first," replies Maria Ortiz. "Did the newcomers learn our language?" Everyone pauses for breath.

Neither experience invalidates the other; both contain deep truths and deep resentments. How do you promote a mutuality of respect and understanding? That is an ongoing challenge for everyone involved.

Engaging the Community

While participants solidify their skills and teamwork, project work reaches into the larger community. Some team members visit senior centers, arranging to come back later and conduct interviews. Others make contact with ethnic community organizations, sororities and sisterhoods. Team members line up locations to serve as our "test kitchens" to tape the preparation of recipes and the reminiscences they bring up. The people who run a couple of after-school programs with computer labs have agreed to let participants use their equipment at designated times.

Team leaders—Rosa Filmmaker, Joe Painter, Chan Actor, Nayo Writer and Eli Musician—have already invested a great deal of time and effort organizing the project's superstructure:

- a database for keeping track of contacts and storing images and stories;
- a master calendar and timeline to ensure that all the project elements unfold without major conflicts and to keep people aware of decision-points (e.g., if we do a cookbook, when does it have to go to the printer to be ready in plenty of time for the centennial week?);
- project-wide gatherings scheduled at strategic intervals to keep every-one connected, share information on progress and discuss issues as they arise;
- regular reports to keep the funders apprised; and
- a monthly project newsletter with opportunities, information and in-vitations to take part, to keep the project's door open to newcomers from beginning to end.

As things evolve, the Breaking Bread Project focuses on three elements:

Image and text project: Rosa Filmmaker and Nayo Writer work with a group of people reaching throughout the community to document many people's stories of a favorite heritage dish, to be with them as they prepare their dishes and to witness and record the memories and feelings that come up. Some participants take still photos too. Rosa and Nayo work with a team to create digital stories: each participant crafts a short online film incorporating words and images about an experience with one interviewee, making use of what that person offered as well as the response it evoked in the interviewer. These will be available in an online archive, and participants can also copy them onto CDs or email them to their friends and families.

Performance project: Chan Actor, Eli Musician and their team screen the interviews, selecting those to be transcribed. They also share their own stories about Bayside. While they were discussing which interviews and stories to use, team members got into some fairly heated conflict. Choosing one person's experiences seemed to members from other neighborhoods or ethnic groups to reduce their own involvement in the drama; and vice versa. Quietly, Chan tapes some of the hottest arguments and transcribes key sections. At the next session, he gives people the pages for a read-through, saying only, "I thought this stuff might work. What do you think?" Tragedy turns to comedy as ev-eryone realizes they have their hook. From this material they craft a theater piece to be performed at the centennial: "Breaking Bread: What Unites and Divides Bayside?" Eli works with some local musical groups who'll perform before and during the show. If people want to take it further, they can tour the show to other venues, but right now, it's planned as a one-time thing.

Cookbook project: Joe Painter and Nayo Writer spearhead the cookbook project. They've done a lot of research, figuring out how it can be done affordably. Participants who want to work on their writing skills, create illustrations or learn desktop publishing meet weekly to work on the cover, the text and the images. It's all coming together. A great many local shops have agreed to carry the cookbook, and many of the community groups involved in the project will promote it in their newsletters. If all goes as planned, the food bank and school lunch program stand to gain some real resources from book sales.

While progress is being made on so many outward manifestations of the work, what is happening for the participants? Here are just a few significant milestones on the project map:

Interviews at the senior center have been really satisfying for everyone. Some of the teenagers have adopted "grandparents," visiting them regularly. In fact, two of the girls—Shakila and Ahn—have accepted an after-school job at one center, leading story circles two days a week. They've learned a lot of interesting things about what it was like to be young in Bayside in the middle decades of the 20th century. They've asked Rosa Filmmaker and Nayo Writer for some help getting support for a project of their own, one that looks at the challenges and delights of being a teenager, now and then.

Nitin, a first generation immigrant Ravi brought into the project, has discovered theater and it's as if he'd been born onstage. His delight almost scuttled the project, though: when he told his parents he wanted to work in theater, they nearly exploded. Chan Actor went through the same thing twenty years earlier, so he knew what to do: he arranged a meeting including the parents, a teacher Nitin really likes, Nitin and Ravi. It was tough—angry words and tears—but in the end, Nitin's parents were impressed with Chan's assessment of their son's talents and prospects; they agreed to respect their son's interest in art if he maintained his grades, keeping his other options open.

James and Ricardo are both hugely into computers. That was probably the start of their rivalry, a kid saying to James that he should ask Ricardo how to do some complicated maneuver, or vice versa. Before long it escalated into a personal race war: each one called the other one names everyone knew weren't allowed. Their friends tried to stop them at first, but then most people started choosing up sides. The Latinos hated what James was saying about them, but when they complained, the African Americans said somebody should teach Ricardo how to show respect—and the same thing happened in reverse. The whole community artists' team was called in to help deal with this one, holding a long story circle about racism and scapegoating, all the ways we've learned to hurt each other by the time we're half-grown. Everybody was cry-

ing by the end. James and Ricardo made peace. In fact, they teamed up to do a digital story about what they'd learned, and Rosa Filmmaker helped them send it to a student film competition, where they jointly won a prize! They started a group at the high school together—Colors/*Colores*—for kids to speak out against all forms of disrespect.

And in the larger community? Well, there have been some bumps and some smooth going. The biggest bump came from the Bayside Chamber of Commerce, one of the groups making grants for centennial projects. They received some complaints about the Breaking Bread Project: someone didn't like the idea of being quite so open about what divides us. Several important people in the Chamber's leadership would like Bayside to project an image of perfect racial harmony to attract new businesses. They said it would hurt the community to air Bayside's dirty linen. They threatened to withdraw their grant if it didn't get cleaned up. The issue was laid out at a project-wide meeting. Team leaders asked people what they wanted to do, explaining that withdrawing the money wouldn't doom the project, but things would be a little tighter for everyone. When a few people said it didn't do to upset the powers-that-be, energy in the room flattened out the way temperature drops when a window is left open on a cold night. By then, Eugene Simmons had become something like the project's voice of conscience. He stood up and put it this way: "Our responsibility is to the people who gave us their stories. If we say their stories don't fit, we're saying *they* don't fit. If we do that, what is this project about?" After Eugene spoke, not a single person disagreed.

Luckily, folks from the local NAACP and Concilio were at the meeting too. They offered to talk to the Chamber president, making it clear that Bayside's image would be harmed more by exposing this censorship attempt than by any of the true stories that were being shared through the project. Chamber leaders decided not to withdraw the grant, a happy outcome. But as it turned out, their threatening to withhold the money contributed as much to project solidarity as almost anything else that happened. People have discovered one more thing that brings us together: a common threat.

By the time project work begins to draw to a close, the big map of Bayside in our office is crowded with dots and arrows. In addition to the projects that were formal parts of Breaking Bread, people in the community have spun off almost as many satellites and tangents. The community garden groups promise flowers and salad stuff for our big celebration and we include a section on community gardening in the Breaking Bread book, right next to the section on the farmers' market. Just about every school in Bayside has a website, but most of them didn't have much content beyond calendars and announcements before the project started. We supply them with a steady stream of images and

excerpts from stories collected by local high school students. That's been such a hit that some schools are adding their own pictures and stories about food in Bayside, collected by their own students. The editors of local weeklies and shopping news tabloids agree to run Breaking Bread features in their food sections; they're happy to get the free material, and it's great publicity for the project. Potential connections are unlimited—or rather limited only by the hours in the day and our energy.

CELEBRATION TIME

Saturday and Sunday of centennial week are one long party. The Breaking Bread concert and show play the civic auditorium, bracketed by speeches from the mayor and other officials. The standing ovation lasts for five minutes. Afterwards, everyone pigs out on a giant community feed, only instead of choosing between hot dogs and hamburgers like previous communitywide events, this time we've got stands offering thirty different types of food: Louisiana gumbo, Vietnamese sandwiches, Salvadoran pupusas and Jewish knishes among them.

A computer kiosk is set up, running a continuous loop of digital stories. A few feet away, at a table staffed by food bank volunteers and piled high with Breaking Bread cookbooks, sits a phalanx of senior cooks, all busy autographing their personal recipe pages for book-buyers. In between autographs, they're asking people to contribute stories to a new project they want to do, an oral history of urban redevelopment, tentatively titled "Renewal or Removal?" Local housing activists are jazzed about it, hoping it will bring attention to their campaign for affordable housing.

After the performance, Ricardo makes his way to the fringes of the crowd, holding the hand of a girl who looks about thirteen, her shy eyes downcast. "This is my sister, Maria," he tells Joe Painter. "She can draw anything. Before I leave next month (he's off to the Art Institute on scholarship, majoring in multimedia), I told her I'm gonna introduce you. She has a really good idea for a mural." Ricardo waves to someone across the room and in a minute, James ambles over, coaxing a younger boy ahead of him. "Actually," says Ricardo, pointing to the boy, "Maria and Kareem had the idea together."

CHAPTER 5
Historical and Theoretical Underpinnings

Community cultural development is an art, not a science. The most skilled practitioners rely on qualities of sensitivity and intuition that cannot be quantified or standardized. Indeed, those who focus too closely on "models," "replicability" and "best practices" tend to produce dull work, lacking depth and heart. What Isaiah Berlin has written of political action also pertains here:

> [T]heories, in this sense, are not appropriate as such in these situations. ... The factors to be evaluated are in these cases too many and it is on skill in integrating them ... that everything depends, whatever may be our creed or our purpose ... [T]heories no doubt do sometimes help, but they cannot be even a partial substitute for a perceptual gift, for a capacity for taking in the total pattern of a human situation, of the way in which things hang together—a talent to which, the finer, the more uncannily acute it is, the power of abstraction and analysis seems alien, if not positively hostile.[1]

Many historical and theoretical ingredients form a mosaic of influences that interact with practice, helping to shape community artists' work and their thinking about it. It is true that the field has lacked sufficient infrastructure to sustain the development of theory; there have been relatively few

1 Isaiah Berlin, "Political Judgment," *The Sense of Reality*, Farrar, Straus and Giroux, 1996, p. 50.

journals, training programs and forums for dialogue on practical, aesthetic and ethical issues. But I don't think that all the resources in the world would have produced a grand unified theory of community cultural development, which would have to be as complex and encompassing as a unified theory of what it is to be human, and therefore equally useless. Given the nature of the work, its address to the whole person and whole community, this is as it must be and should be, as active practitioners know:

> We should be looking at models with a small "m," so people can pick and choose and be aware of the values underpinning each one. There are constitutive elements people can extract from models. Large foundations often look for models with a capital "M"—things to replicate. I'm concerned that [they] not try to replicate models in this way.

Culture can be seen as a tapestry; pull on any thread and eventually one is connected to every other. Because my own experience is grounded most firmly in the United States, the influences discussed below include some that are specific to this country and undoubtedly omit some that are equally significant (and specific to) the shaping of community cultural development practice in other parts of the world. Without claiming to weave the whole tapestry, then, this chapter offers a number of significant threads.

AN ACTIVISM OF IDEAS

Looking back over the history of community cultural development, it is evident that community artists' vigor and influence gain strength in periods when social activism and social conscience awaken. We are accustomed to the notion that ideas have provenance. But it is also true, as a very depressed king named Ecclesiastes wrote a couple of thousand years ago, that there is nothing new under the sun. This history could arguably begin with the cave painters of Lascaux who responded to the community's need for a record of significant events by tracing the shapes of animals on rock walls. But it seems most apt to take as a starting place the height of the Industrial Revolution, when industrialization, having given birth to urban anomie, also created its own opposition, expressed in nostalgia for a human-scale past.

The Social Integration of the Artist

William Morris, associated with the British Arts and Crafts Movement, was

the most famous 19th century exponent of a countervailing idea of the artist. According to the Romantic tradition that preceded Morris, artists are tortured geniuses who stand apart from social convention and ordinary concerns; they may suffer materially as a result of their indifference to such things, but even their suffering is exalted—Lord Byron's "spirit burning but unbent." The work of such artists must serve no practical function; it is pure embellishment, created for those with the exquisite sensibility (and generally the purse) to apprehend it.

In contrast, Morris called for the social reintegration of the artist in a revival of artisanship, creating employment for skilled craftspeople capable of producing objects both useful and beautiful, filling lives with material harmony in defiance of the exploitative disharmonies of industrialism. In the April 1885 edition of *Commonweal*, Morris wrote:

> [T]he chief source of art is man's pleasure in his daily necessary work, which expresses itself and is embodied in that work itself; nothing else can make the common surroundings of life beautiful and whenever they are beautiful it is a sign that men's work has pleasure in it, however they may suffer otherwise. It is the lack of this pleasure in daily work which has made our towns and habitations sordid and hideous, insults to the beauty of the earth which they disfigure.

To fuel his visions, Morris dreamed of tempering the best of England's past with a democratic spirit. He predicted a revival of art with the advent of socialism, which he saw as the only remedy for "The advance of the industrial army under its 'captains of industry' ... [which] is traced, like the advance of other armies, in the ruin of the peace and loveliness of earth's surface."

As bourgeois society's complacency thickened and spread, it grew confining to those who longed more for passion and deep meaning than for mere comfort. One ironic consequence was a powerful attraction to the art of cultures aggressively submerged by colonialism—the craze for "orientalism," the dream of total integration of art and life in romanticized imaginations of "primitive" societies. This enchantment persists: who has not heard the frequently repeated assertion, "In Bali, there is no word for art; everything they do is art"? The Romantic idea of the artist also persists in our own time—the inflated visual art markets of the late 20th century would have been impossible without it. But so does the conviction that there is a higher and more socially useful role for the artist than to decorate the surroundings of wealth.

This is one of the foundation stones of the community cultural development field and has been a constant theme within the field. In 1982, as co-

directors of the Neighborhood Arts Programs National Organizing Committee (NAPNOC), Don Adams and I convened a national conference of community artists in Omaha. Among the participants were now-recognized leaders in the community cultural development field Liz Lerman and John O'Neal. We recorded their observations on this topic in *Cultural Democracy*, the newsletter we edited for NAPNOC. Here's how dancer/choreographer Liz Lerman described her own path out of conventional art dance into community cultural development:

> I believe dance historically was an incredibly major part of the people's lives. You danced and it would rain, you danced and your kids got better. ... Take a look at what's happened to dance in most Western countries: what you find is a mirror of fragmentation. ... You've robbed dance of its therapeutic qualities, its community, social qualities, all the things that dance is supposed to be doing for people. ... I think my own need to experiment came ... because this was a dead end. ... My solution was to start working with people who are not trained dancers. That unleashing of their own creativity—it was so powerful and so beautiful that it would infuse any stage. And my job was to help them find and learn how to keep that moment. ...

John O'Neal, who was then planning the "funeral" of the Student Nonviolent Coordinating Committee–affiliated Free Southern Theatre, spoke of the connection between cultural action and other forms of social action, recognizing

> ...a relationship of dependency of the artist on a vital social movement, because we don't exist in a void. The link, it seems to me, has to be some kind of organized political link between self-conscious, conscious artists working in some community and the structures that exist in that community for it to make decisions about what it's going to do.

Around the world, community artists and their allies have attempted to bridge the gap between artist and community by connecting their work to social activism, as several subsequent sections of this chapter describe. But another path to social integration has also been followed: drawing on vernacular forms, rooting one's work in modes of cultural expression already deeply engrained in their communities. For example, the British director John McGrath, in a groundbreaking series of Cambridge lectures on popular theater, invoked the English tradition of the Christmas pantomime ("panto"), a madcap, profoundly discontinuous variety show form which has been deeply influential for community artists from that region of the world:

Somehow, through all the comedians doing their spots, the ultra-violet underwater fish-ballet, the lady with the white doves, the pop singer who can't speak, the principal girl who can't sing, the numb-faced little girls from the local dancing classes, and the merry crash of over-ambitious scenery, somehow there's a story, no matter how secondary its role, usually a narrative from the folk tradition. …

The performer, if any good at all, can establish a personal relationship with the audience which will allow him or her to signal very clearly to them when it is time for a song or a gag that have got nothing to do with the plot, and they will deploy their imaginations accordingly. Now this whole process is much too difficult for a Royal Court audience—they would demand some consistent relationship with the fictional character, and in the absence of that find themselves very confused, and go off to complain about it. The *safety* of observing a distanced slice of life, or a poeticized piece of fantasy, is not necessary for a working-class audience on its home ground.[2]

In the 1960s through the mid-1980s, community cultural development work in Britain was particularly innovative and influential in adapting such vernacular cultural forms to the purposes of democratic cultural development. Another such practice is the "fire show," a pyrotechnic spectacle inspired by Guy Fawkes' Day bonfires commemorating the attempted burning of the Houses of Parliament by Catholic radicals in the Gunpowder Plot of 1605. In 1980s demonstrations against Britain's Conservative government policies, for instance, English community artists worked with activists to stage projects through which large-scale paper figures representing oppressive policies were constructed by community members, then paraded to a bonfire site and torched in a symbolic catharsis. *Engineers of the Imagination*, the handbook published by Welfare State International, a group widely known for its multimedia participatory spectacles, is particularly useful in providing how-to information on adapting such practices for community cultural development.[3]

From the state of Morelos, Mexico, Martha Ramirez Oropeza of the theater company Mascarones describes how her group has attempted to revitalize and reclaim the ancient ritual called *Mikiztli* in Nahuatl, and in Spanish *Días de los Muertos* (Days of the Dead):

For the past 35 years, our theater group has performed *"Las Calaveras de Posada"* ("The Skeletons of Posada"), a play we adapted based on the characters created by the great engraver Jose Guadalupe Posada. Using skeletons

2 John McGrath, *A Good Night Out*, Methuen, 1981, pp. 28–29.

3 Tony Coult and Baz Kershaw, *Engineers of the Imagination*, Methuen, 1983.

to comment on contemporary social and political conditions at the time of the Mexican Revolution of 1910, Posada combined art and satire to criticize the powerful—a combination that inspired the Mexican muralist tradition a generation later. Mascarones' production of this play has proven to be our most popular and enduring—a fact we attribute to its reflection of a purer time in which the Day of the Dead celebration had not been trivialized by the culture of globalization.

The scope of the play carries the audience from pre-Hispanic times, in which the skeletons quote the great Nahuatl poet-philosopher Netzahualcoyotl; through the European invasion, in which the skeletons relive the attempt to exterminate their civilization; through the colonial period, in which the skeletons recount three centuries of oppression at the hands of foreign kings; through the War of Independence from Spain, the French Intervention, the U.S.-Mexican War and the Agrarian Revolution of 1910, in which the skeletons pay homage to Posada and describe the social conditions that brought about the revolution; into modern times in the form of a debate between two popular characters, the Pulquera, a witty, truth-telling drunkard, and the Catrina, a snobbish, prissy member of the nouveau riche; and finally the play ends with all the skeletons throwing a big party and inviting the audience onto the stage to dance.[4]

Kwesi Owusu, a Ghanaian-British writer and filmmaker, has similarly summoned the tradition of "orature." Although this word is sometimes used to denote oral literature in general, Owusu used it to describe a fusion of multiple art forms and ritual based in traditional oral cultures and enacted by groups, often for the community good:

In orature, the most important "actors," "poets," "directors" and "painters" are the people, the masses living out their life dramas and expressing them through cultural media and institutions. Many traditions of orature recreate the principles of social production through human symbolisms, as in crop dances and festivals of the agricultural cycle. A participant in a maize dance does not merely mimic the plant and its phases of growth. He or she creates social meaning, re-enacting social relations with other dancers in the process of articulating determinant social experience.

Orature still informs the culture of popular majorities in Africa and Asia, very much alive outside the urban enclaves of Western culture. Thousands of people still congregate in villages and towns to celebrate festivals which harness the best of individual talent and initiative through communal

4 Martha Ramirez Oropeza, "Huehuepohualli: Counting The Ancestors' Heartbeat," in *Community, Culture and Globalization*, pp. 41–42.

creative processes. In the exciting kaleidoscope of a Dagomba yam festival in northern Ghana, hundreds of feet pound the dusty earth to brekete drums, affirming contact with the natural source of life as well as acknowledging the human bonds that make utilization of this resource possible. Across the Atlantic, in the Caribbean, the streets may be full of carnival Mas and revelers celebrating the joys of post-slavery society in costumes of dazzling beauty and skilled construction.[5]

Owusu went on to connect traditional forms to popular resistance movements in the developing world. Discussing the 1929 "Women's War" protest against British taxation in colonial Nigeria, he described the *Nkwa*:

Sometimes called "Sitting on a man," this dance-drama brought women together as a collective force against male domination. During an *Nkwa* the aggrieved women gather, usually in their hundreds or thousands, at the compound of the offender. They sing and dance and dramatise the problem. Movements convey dynamic images which emphasise the argument. Accompanying songs, with their potent ridicule and satire, serve as effective media of social criticism.[6]

Owusu's book on the Notting Hill Carnival, site of many clashes between community members and police in the 1970s and 1980s, described that contemporary expression of orature as "the most expressive and culturally volatile territory on which the battle of positions between the Black Community and the State are ritualized."[7]

Mining our collective past, the search for a valued and integral social role for the artist continues, though still as a counter-proposition to the persistent dominant image of artist-as-entertainer. There are numberless examples of success, where working together, artists and other community members have drawn on reservoirs of cultural memory, reinventing the past in order to understand and change the present. But when it comes to support, unfortunately, community artists propose and resource providers mostly dispose, leaving practitioners with the challenge of supporting pro bono work in a market-driven world.

5 Kwesi Owusu, *The Struggle for Black Arts in Britain*, Comedia Publishing Group, 1986, p. 130.

6 Owusu, *The Struggle for Black Arts in Britain*, p. 142.

7 Kwesi Owusu and Jacob Ross, *Behind the Masquerade: The Story of the Notting Hill Carnival*, Arts Media Group, 1988, p. 5.

The Settlement House Movement

The contemporary concept of culture and its centrality began to cohere in American history in the late 19th century, when earlier generations of relatively prosperous immigrants from Western Europe and their descendants faced unprecedented waves of impoverished migrants from Ireland, Russia and Italy. Would the newcomers be successfully inducted into American culture or, as growing numbers of "America Firsters" warned, would they overwhelm and degrade that culture with unwashed foreign ideas and customs?

One coping mechanism was the establishment of settlement houses—community service, education and recreation centers in poor neighborhoods—of which the most famous was Jane Addams' Hull House in Chicago, begun in 1889. The underlying impulse was to integrate immigrants into what was put forward as the common culture, sometimes by providing health care and nutrition advice or wholesome recreations, sometimes by offering training that parents were unable to provide for their own children. (Kindergarten, an invention of the settlement houses, later became integral to public schooling.)

For their inventors, the settlement houses' function of pulling immigrants into a dominant culture was a wholly good thing, a simple matter of equity, as Jane Addams stated it:

> The common stock of intellectual enjoyment should not be difficult of access because of the economic position of him who would approach it.[8]

The subsequent critique of this impulse goes to foundational concepts of community cultural development: that real development consists in involving and drawing upon people's own cultures, not imposing a standardized middle-class culture. Today, individuals are inevitably multicultured; social mobility derives in part from mastery of multiple cultural vocabularies, not the abandonment of one's heritage. Still, in most social realms, mobility is limited if mastery does not encompass the signifiers of establishment culture.

In this respect, the settlement houses were a more complex phenomenon than they might at first appear. It was very often necessary that they adopt elements of language and culture characteristic of those they wished to instruct—Yiddish on the Lower East Side, Spanish in San Antonio—thus validating, even inadvertently, the concept of multiple belonging. Still, the primary aim was to inculcate middle-class values, rather than to aid communities in self-directed development.

8 Jane Addams, *Twenty Years at Hull House*, Macmillan, 1910.

Expressions of both impulses continue to coexist. Establishment arts institutions focus primarily on bringing new populations into contact with received culture, busing school groups to museums and offering lecture-performances on Western classical dance or music at schools and community organizations. Operationally, these activities are seen as "audience development," a long-term promotional strategy to cultivate the particular tastes and habits that will bring more paying customers to the prestige arts institutions. In contrast, community cultural development devotees focus much more on multidirectional cultural dialogue, working with immigrants to devise drama or photography projects depicting their own struggles with assimilation and difference in relation to mainstream culture—projects that may in turn be seen by audiences of non-immigrants, furthering cross-cultural understanding. The long-term aim is cultivating a mutuality of knowledge and respect, rather than marketing.

Popular Front and Class Consciousness

In the mid-1930s, much of the American left adopted a strategy known as the "Popular Front," calling on activists to abandon their critical disdain for the values of mainstream culture, to cease standing apart from it, instead involving themselves in every aspect of the larger society. With fascism on the rise in Europe, there was widespread feeling that artists must be part of this movement—that art should have social value, that it should in some way contribute to the struggle against totalitarianism and for democratic societies. To many artists, the Romantic idea of the artist as an emblem of alienation seemed tired and irrelevant. The painter Stuart Davis, opening the first American Artists' Congress in 1936 (as its secretary), expressed it this way:

> In order to withstand the severe shock of the crisis, artists have had to seek a new grip on reality. Around the pros and cons of "social content," a dominant issue in discussions of present day American art, we are witnessing determined efforts by artists to find a meaningful direction. Increasing expression of social problems of the day in the new American art makes it clear that in times such as we are living in, few artists can honestly remain aloof, wrapped up in studio problems.[9]

9　From Davis's address "Why an American Artists' Congress?" delivered in New York in February 1936, as recorded in *Artists Against War and Fascism: Papers of the First American Artists' Congress*, edited by Matthew Baigell and Julia Williams, Rutgers University Press, 1986.

Later, the Red Scare of the 1950s stigmatized activist artists, triggering a rapid retrenchment from this stance. One hypothesis is that abstract painting and its equivalents in other art forms were oblique expressions of dissent from Cold War America—that through abstraction, dissent went underground. Maybe so, but for all practical purposes, there was a radical discontinuity between the activist artists of the 1930s and the generation of artist-organizers emerging in the 1960s.

So it would be difficult to demonstrate a direct line of inheritance from the Artists' Congress to the resurgence of activism 30 years later. But the general parallel in circumstances was certainly evident to young activists: consider the popularity during the 1960s of the political art of Ben Shahn, an emblematic socially engaged artist and one of the signers of the "Call for the American Artists' Congress."

Elsewhere, however, the discontinuity was not so great. In Britain, trade unions continue to be a much greater factor in working-class life than in the United States, with 29 percent of wage and salary workers unionized in 2004 compared to 12.5 percent in the U.S. They have established a strong tradition of banners—large, elaborate paintings on fabric stretched between poles—to be carried in marches and displayed at rallies and other events. During the protracted, violently resisted coal miners' strike of 1984-85 (a chief site of struggle in Britain's transformation toward greater economic privatization under Margaret Thatcher's Conservative government), community artists worked extensively with striking miners and their supporters to renew the banner tradition and mount other projects that could bring attention and support to the strikers.

Indeed, in every country with a strong trade union sector, some form of organized workers' cultural provision emerged in the 1930s, as did some role for art in organizing. For example, "Workers' Art Clubs" were established in Australia. This quotation is from the catalog for "Working Art: A Survey of Art in the Australian Labour Movement of the 1980s," an exhibition mounted at the Art Gallery of New South Wales in 1985:

> The Workers' Art Clubs, established in Melbourne, Sydney and elsewhere in the early 1930s, and later the Workers' Art Guild in Perth, were the first indication in Australia of radical artists and writers modeling their activities on international socialist cultural practices. ... The slogan 'Art is a Weapon' was adopted and popularized, though the basis of populism was vastly changed from that of the late nineteenth century. Increasingly comprehended in ideological terms, art was to be placed at the service of the people.

In part, the clubs' work was instrumental: they offered classes on how to make banners and posters, as well as in theater, literature and public speaking. There were parties, film screenings and performances, both premieres of original plays and agit-prop performances as part of demonstrations. Building on the longstanding trade union tradition of carrying elaborate banners in marches and parades, club members contributed art work, such as large-scale portable posters of labor heroes. The clubs themselves were a fairly short-lived phenomenon, in part because they did more to provide outlets for progressive artists than to attract the rank-and-file members they were devised to serve. But successor groups mounted countless lunchtime concerts and exhibits of workers' art at factories and other work sites.

Like the continuing search for a social integration of the artist, the pursuit of solidarity with other workers persists among socially conscious community artists. In the United States, though, this impulse is a little frayed around the edges, tending toward the sort of nostalgic romanticization of the worker that produced the kitsch of social realism. Its pitfall is to impose an ungrounded optimism on a complicated reality, as with art works that celebrate trade unions' strength and power in the U.S., where membership has declined steadily from the 24 percent attained in 1973 to half that. When this impulse succeeds, it encompasses complexity, as with New York-based artist Marty Pottenger's *City Water Tunnel #3*, a theater piece, video and exhibit grounded in oral histories produced during a multiyear collaboration with Local 147 of the Tunnelworkers Union and the city's Department of Environmental Protection, focusing on the largest public works project in the Western Hemisphere, a tunnel begun in 1970 and scheduled for completion in 2025.

The New Deal

U.S. President Franklin Delano Roosevelt's New Deal engendered employment and subsidy programs designed to put people back to work during the Great Depression of the 1930s. From very early on, New Deal programs included arts initiatives. It is said that George Biddle, a signer of the American Artist's Congress call who had studied in Mexico with the painter Diego Rivera, put the idea of a publicly supported mural program into FDR's head. The first New Deal art initiative was the Public Works of Art Project, a section of the Civil Works Administration created to help ameliorate unemployment during the bitter winter of 1933-34 by commissioning murals for schools, orphanages, libraries, museums and other public buildings. By 1935, "Federal One" of the Works Progress Administration (WPA) was in full swing, with major divisions covering visual art, music, theater, writing and history.

New Deal cultural programs began in response to massive unemployment—with the arts treated as a sector of the work force, like farm or factory labor—the primary aim being to give jobs to artists who could not hope to make a living in the private economy under prevailing conditions. That included writers such as Ralph Ellison and Richard Wright, painters such as Jackson Pollack and theater artists such as Burt Lancaster (who was then a circus performer).

But once so much talent had been harnessed to public purposes, visionary leaders such as Hallie Flanagan, head of the Federal Theatre Project (FTP), comprehended the potential for social change inherent in these programs. "In an age of terrific implications as to wealth and poverty," Flanagan wrote, "as to the function of government, as to peace and war, as to the relation of the artist to all these forces, the theatre must grow up. The theatre must become conscious of the implications of the changing social order or the changing social order will ignore and rightly, the implications of the theatre."[10] To consider a single example of Flanagan's response to that changing social order, the FTP's "Living Newspaper" productions treated such controversial and urgent topics as poverty and exploitation (*One-Third of A Nation*) and the spread of syphilis (*Spirochete*) before they were closed down in 1939 by the House Committee to Investigate Un-American Activities, a harbinger of the anti-communist witch hunts to come.

Beginning in the 1970s, young community artists in the United States manifested keen interest in the WPA. To cite examples from my own experience, the *Bicentennial Arts Biweekly* (I served for a time on the editorial group of this newsletter published as part of the countercultural "People's Bicentennial" in San Francisco, formed to counter the triumphalism of the official U.S. government celebration planned for 1976) began with its second issue in November 1974 to feature stories on the New Deal for artists. The third issue included a memoir of WPA mural painter Robert McChesney, "to see what relevance those years might have for artists today." A later issue featured WPA muralist Bernard Zakheim, a signatory of the American Artist's Congress call. A centerpiece of the People's Theater Festival in September 1981 was a panel of veterans of the Federal Theatre Project. The January 1982 issue of *Cultural Democracy* was devoted to a survey of New Deal cultural programs on the 50th anniversary of FDR's election.

In the United States today, community artists continue to be inspired by the New Deal. It established the importance of oral history as a basis for cultural preservation; for instance, most surviving slave narratives were collected

10 Hallie Flanagan, *Arena*, Duell, Sloan and Pearce, 1940, pp. 45–46.

through the WPA. It suggested the possibility of a permanent role for artists in community service. As Stuart Davis said at the time, "The artists of America do not look upon the art projects as a temporary stopgap measure, but see in them the beginning of a new and better day for art in this country."[11] This possibility was revived in the 1970s with the advent of CETA (the Comprehensive Employment and Training Act, discussed later), the first public service employment program since the 1930s to make extensive use of artists.

Arts Extension

Parallel to the development of the settlement house movement, American universities set up extension services, so called because they were intended to extend the educational and cultural resources of the university to the larger community. This was not uniquely American, of course: the settlement house movement had itself been inspired by an academic initiative in Britain, begun as a campaign to encourage university students to settle in depressed communities and work there to improve living conditions. But in the U.S., several university extensions pioneered the concept of arts extension.

The Arts Workshop of Rural America[12] by Marjorie Patten profiles the national Rural Arts Program of the Agricultural Extension Service, with chapters devoted to projects stretching from North Dakota to West Virginia. Perhaps the most notable was directed by Frederick Koch (who also served as a regional FTP director) in North Carolina. His North Carolina Playmakers, with its commitment to folk drama, has continued to inspire community artists in the South to pursue Koch's dream of a truly local and inspiriting drama. In rapid succession, Patten quotes Koch twice in a way that highlights the contradictions of the extension concept. As with the settlement houses, the core dialectic of extension—the contradiction that must be traversed—is between the notion of extending cultural bounty from the center to the margins (from cultural wealth to impoverishment) and the competing idea of exchange, collaboration and support between equals (nurturing cultural resources everywhere). On the one hand, then, Patten offers Koch's definition of folk drama, replete with unintentional condescension:

[T]he work of a single artist dealing consciously with the folk-ways of our less

11 Quoted in Richard D. McKinzie, *The New Deal for Artists*, Princeton University Press, 1973, p. 250.

12 Marjorie Patten, *The Arts Workshop of Rural America*, AMS Press, 1967.

sophisticated and more elemental people who live simple lives apart from the responsibilities of a highly organized social order. The term applies to that form of drama which is earth-rooted in the lives of struggling humanity.

A sentence later, Patten quotes from Koch's deeply insightful understanding of art's intrinsically local nature:

In order to be considered as art, play-writing must be intensely local. The only art that has become universal has been intensely local. Everybody is potentially an artist and everybody should be an artist in his own tongue. In the making of an American drama we need to cherish the locality; if it be faithfully interpreted, it will show us the way to the universal. If we can see the lives of those about us with understanding imagination, why may we not interpret them in significant images for all?

The longest-lived arts extension program was established in Wisconsin in 1907. Its most dynamic period began in 1945, when Robert Gard arrived to head up its theater program, which developed and produced plays about rural life in Wisconsin, held playwriting classes and contests, produced radio plays, sponsored a playwright-in-residence program, carried out research and offered correspondence courses—among other initiatives aimed at developing a grassroots theater in the state. It eventually branched out to involve writers, music and art programs.

The animating idea behind his involvement in arts extension was contained in a letter graduate student Gard wrote to the Rockefeller Foundation in 1939, describing his aspirations:

I ponder more and more the question: in this great American growth of a non-commercial theatre ... a theatre of the people ... what will be the outcome, the goal? And increasingly it seems to me that the answer may be in the development of a ... drama in which the ... life of a community might be crystallized into dramatic form by those best able to do it: those who lived and [had] been a part of that legend and life. ... The true "people's theatre," as I see it, will be the creation for the community of a drama in which the whole community may participate. ...[13]

One insistent theme of community cultural development has been a critique of the urban domination of art-making and a parallel assertion of the validity

13 Quoted in Maryo Gard Ewell's introduction to Robert Gard's *Grassroots Theater: A Search for Regional Arts in America*, University of Wisconsin Press, 1999, p. xviii.

of rural forms, themes and styles. The ground for this conviction was laid in part by arts extension efforts from early to mid-20th century.

Civil Rights and Identity Politics

"The Sixties" is a commodious rubric, scooping a multitude of related phenomena into a single handy category. It conjures a period of cultural awakening during which marginalized groups embraced divergent identities, asserting their rights to recognition, liberty and a fair share of social goods.

During this period, cultural signifiers became a battleground. "Black is beautiful" is arguably the clearest possible use of aesthetic standards to symbolize both a universe of oppressions and the struggle to overturn them. Underpinning civil rights slogans was a sophisticated discourse about cultural transmission of self-hating self-images.

A key contributor to this analysis—and an acknowledged influence on activist-writers such as Malcolm X and Amiri Baraka—was Frantz Fanon, a psychiatrist born in Martinique. Fanon came to consciousness of his revolutionary ideas while practicing in Algeria during its struggle for independence from France. Focusing on the psychology of the colonized and colonizer, he explored in depth the false consciousness created by colonizers, asserting the curative value of cleansing revolutionary violence against dominating powers. Fanon's discussion of the relationship of artists and intellectuals to popular liberation movements was deeply influential, especially to militant black activists, who easily extrapolated his colonial analysis to the experience of the descendants of slaves in the United States:

> In the first phase, the native intellectual gives proof that he has assimilated the culture of the occupying power. His writings correspond point by point with those of his opposite numbers in the mother country. ... This is the period of unqualified assimilation. ...
>
> In the second phase we find the native is disturbed; he decides to remember what he is. ... But since the native is not a part of his people, since he only has exterior relations with his people, he is content to recall their life only. Past happenings of the bygone days of his childhood will be brought up out of the depths of his memory. ...
>
> Finally in the third phase, which is called the fighting phase, the native, after having tried to lose himself in the people and with the people, will on the contrary shake the people. ... [H]e turns himself into an awakener of the people. ... During this phase, a great many men and women who up till then would never have thought of producing a literary work ... feel the need

to speak to their nation, to compose the sentence which expresses the heart of the people and to become the mouthpiece of a new reality in action.[14]

Fanon points to issues that are a central focus for a great deal of community cultural development work: interrogating the social formation of identity, liberating participants' self-identity from imposed notions. People of color, women, gays and lesbians, rural people and other marginalized groups are primary participants in this work. Fanon's revolutionary formulations continue to resonate, even as his romanticization of revolutionary violence has become increasingly stained with wasted blood. Along with several extensive quotations from Fanon, this excerpt from the writings of Kenyan exile Ngugi Wa Thiong'o was quoted by Thabo Mbeki, President of the Republic of South Africa, in an August 2000 Oliver Tambo Lecture that attracted a great deal of inflammatory press attention:

> The effect of [the] cultural bomb [dropped by imperialism] is to annihilate a people's belief in their names, their languages, their environment, in their heritage of struggle, in their unity, in their capacities and ultimately in themselves. It makes them see their past as one wasteland of nonachievement and it makes them want to distance themselves from that wasteland. It makes them want to identify with that which is furthest removed from themselves; for instance, with other people's languages rather than their own.[15]

In American society, the politics of race are as complicated in the community cultural development field as anywhere else. Much of the 1980s and 1990s were marked by a passion for cultural specificity, complicating relationships between differing individuals and groups. Over the last three decades, many of my consulting clients have been groups based in communities of color. In the late 1980s, I began to get calls from clients who said they valued my approach but couldn't be seen working with a white consultant; could I recommend someone whose work was just like mine, but who happened to be a person of color? I also had experiences like this: being asked by a member of a group I had been engaged to facilitate to resign that role because it was offensive to her as a person of color to raise her hand and be recognized by a white person. Such interactions are at once entirely impersonal (i.e., everyone is perceived and treated as an exemplar of a category, rather than an individual) and highly personal (the individuals involved experience an intensity of feeling unique to themselves, their own particular righteous anger, hurt or offense).

14 Frantz Fanon, *The Wretched of the Earth*, Grove Press, 1963, pp. 222–223.

15 Ngugi Wa Thiong'o, *Decolonising the Mind*, London: James Currey, 1986, p. 3.

More than a century ago, W.E.B. DuBois famously said, "The problem of the 20th century is the problem of the color-line." It is a great shame and scandal that this epigram can be transposed to our own new century with ease. Everyone who encounters racial and cultural difference is obliged to relate in some way to the dual truth of cultural identity, that each of us is part of one or more groups with shared history and shared social position, both of which influence our interactions; and at the same time, each of us has unique individual character and identity which cannot be adequately described by listing labels and categories.

However slowly, things change. As I write, the spirit of the times seems more sympathetic to inclusion and collaboration than at the height of separatist identity politics. Fanon's focus on rage is tempered by an inclination to celebrate—to revel in—differences, harking back to the concept of "negritude," conceived in the 1930s by Martinican poet and statesman Aimé Césaire and popularized by Senegalese writer and president Leopold Senghor. Negritude, which had in turn been influenced by the Harlem Renaissance, valorized indigenous African cultures, arguing against assimilation of imposed colonial cultures, asserting the deep value of traditional knowledge and cultural forms that had been suppressed by colonial powers attempting to impose European ideas and forms. Whether in the community cultural development field or other art worlds, the tremendous outpouring of creativity by artists with roots in colonized cultures speaks every day for the relevance of this philosophy.

Liberating Education and Theater

Like Fanon, Brazilian educator Paulo Freire derived his theories from experience in the developing world—in Freire's case, through literacy campaigns with landless peasants in Brazil in the years preceding his expulsion following the military coup of 1964. The theories and methods of Augusto Boal, a Brazilian theater director (who from 1992-96 served in Rio de Janeiro's municipal legislature), were developed during the same period and have much in common with Freire's thought. Freire's first book to be released in the United States was entitled *Pedagogy of the Oppressed*; Boal's was *Theatre of the Oppressed.*

The spine of Freire's work is that without the ability to read and write—to comprehend and interpret the modern world—individuals become objects of others' will, rather than subjects of their own history. Internalizing their oppressors' views of their own identity and capabilities—taking as their own these extremely reductive and disabling notions of their value as human beings—they become passive objects of a world the workings of which seem mysterious and incomprehensible. Indeed, they may experience a disabling

"fear of freedom" that prevents even trying to reach beyond such imposed self-definitions.

By engaging in dialogue stimulated by "generative themes" (pregnant images or concepts of great moment to those discussing them), participants comprehend their real relationships to these themes, experiencing the power of language and their own power to shape culture through its use. Instead of seeing literacy training as a scheme foisted upon them by authorities for reasons having nothing to do with their lives, they come to understand that learning to read empowers one to decode the world and to act within it.

This "transformation of consciousness" from "magic thinking" (seeing reality as the product of baffling and hidden processes beyond one's control) to "critical consciousness" (being able to comprehend and enter into the process of shaping reality) is the primary goal of Freire's approach to education, usually referred to as "liberating education" or "critical pedagogy."

While much of Freire's attention focused on the transformation of individual consciousness and small-scale group work, his ideas also have larger relevance. As discussed in my first chapter, he wrote in *Pedagogy of the Oppressed* that every epoch is characterized by "a complex of ideas, concepts, hopes, doubts, values and challenges in dialectical interaction with their opposites." That each epoch generates such a "thematic universe" is an extremely useful insight for those who wish to understand why our own era is pulled in so many directions by force of faith or reason, of imposed versus self-led development, of cultural diversity and cultural privilege. None of us can confidently say that any particular element of our thematic universe should be regarded as the foreground, relegating the rest to background noise. Freire's work suggests that it is the interaction of themes in and of itself that ought to command our attention.

International associations, conferences, academic specializations and scores of interpretive books and courses have sprung up around Freire's ideas, as well as nonacademic networks for people who work with farmworkers, for instance, or immigrant communities. They have also spread far beyond the field of literacy education, greatly influencing adult and popular education programs and cultural organizing in the United States and abroad.

In community organizing contexts, one of Freire's most powerful concepts is "internalization of the oppressor," the process whereby individuals and communities are subliminally persuaded to worldviews and self-images that serve interests counter to their own. Social movements of the 1960s, for example, focused on recognizing and rooting out invidious self-concepts such as the idea that women are less capable than men or that European ideas of

beauty are superior to all others. Similarly, a common element of community cultural development projects is to focus on the gulf between the way one's community is regarded and portrayed in mainstream culture and the way it comes across in uncoerced self-portraiture.

Boal's work also turns on dialogue—a free exchange between equals—which he considers the ideal human experience. Using the language of theater to comment both on dramatic work and on the larger world, he asserts that oppression occurs when dialogue becomes monologue:

> [T]he ruling classes took possession of the theater and built their dividing walls. First, they divided the people, separating actors from spectators: people who act and people who watch—the party is over! Secondly, among the actors, they separated the protagonists from the mass. The coercive indoctrination began!
>
> Now the oppressed people are liberated themselves and, once more, are making the theater their own. The walls must be torn down. First, the spectator starts acting again: invisible theater, forum theater, image theater, etc. Secondly, it is necessary to eliminate the private property of the characters by the individual actors: the "Joker" System.[16]

Of all Boal's approaches, Forum Theatre has had the widest influence on community cultural development work. This method involves setting up situations in which actors are not divided from spectators; rather, all are "spectactors," able to cross the invisible "fourth wall" of the theater and enter the action. Together they share stories of unresolved political or social problems. Then a smaller group of spectactors devises a skit or scene (perhaps ten minutes in length) encapsulating the salient elements of one or more stories, including a possible (but ultimately unsatisfactory) resolution. This is performed for the group. (For instance, a group of workers might enact the process of registering a grievance with management and when satisfaction is not forthcoming, staging a wildcat strike.)

Then the "Joker," a kind of facilitator, asks members of the larger group to consider whether they are satisfied with the proposed resolution and if not, to imagine other points of intervention, other ways to proceed. The skit is then performed again, exactly as it was the first time; only now, any spectactor may call a halt to the action and come onstage to replace the protagonist(s), taking the scene in a new direction (always remaining in character, taking part fully in the dramatic action). A group may choose to replay the scene from the beginning more than once, to allow a greater range of scenarios to be at-

16 Augusto Boal, *Theater of the Oppressed*, Urizen Books, 1979, p. 119.

tempted. At the end, the process may be discussed by all; or it may be that the enactment itself suffices.

This approach has been used to great effect in the developing world, for example, with *Dalit* communities in India, as a way to plan social action with groups of people who are not in the habit of attending meetings. It has also become much more visible in the United States since the 1980s, as Boal has worked with several groups in the States to start branches of the Center for the Theatre of the Oppressed.

If asked to name the most powerful international influence on community cultural development practice, I would choose the interrelated work of Freire and Boal. Freire's name was mentioned most often when in the course of my research, diverse groups of community artists have been asked to enumerate their own influences. Boal's name came up with the majority of theater people and was mentioned by others involved in community organizing.

My own sense is that these ideas have such influence because they make powerful links between individual and social transformation. Most of us know what it feels like to internalize a too-small identity, disempowering ourselves in some way. It's not a huge leap to connect processes like Freire's and Boal's, which have helped us understand and root out internalized obstacles to our own sense of possibility, with the sense of powerlessness that pervades contemporary societies. In Boal's book about the way his theatrical principles and experience shaped his own approach as a legislator, he does this explicitly:

> We do not accept that the elector should be a mere spectator to the actions of the parliamentarian, even when these actions are right: we want the electors to give their opinion, to discuss the issues, to put counter-arguments, we want them to share the responsibility for what their parliamentarian does.[17]

Culture *and* Development

A fairly pervasive confusion about terminology has been exacerbated by parallel discourses that use many of the same words to mean different things, for example, "culture" in its narrowest sense signifying the arts and related codes of beauty, value and meaning versus "culture" broadly, as it was defined at UNESCO's 1982 World Conference on Cultural Policies:

> [T]he whole complex of distinctive spiritual, material, intellectual and emotional features that characterize a society or social group. It includes not only

17 Augusto Boal, *Legislative Theatre: Using performance to make politics*, Routledge, 1998, p. 20.

arts and letters, but also codes of life, the fundamental rights of human beings, value systems, traditions, and beliefs.

In international aid circles, when people speak of "Culture and Development" they typically refer to the use of cultural forms as instruments for economic or community development. Here's how it was defined in a 2000 special issue of *Culturelink* devoted to the subject:

> In general terms, Culture and Development is about the role of culture and cultural processes in achieving development, as in issues of poverty, human rights, gender equality, health, environmental concerns, and associated fields. The objective of Culture and Development is development: it is about the relationship between culture and very pragmatic and practical issues of survival and the improvement of the human condition, and ways in which culture can contribute to, or influence, the success of interventions in these areas.[18]

A few paragraphs later, the authors provide a contrasting definition of "cultural development" I find tendentious, in that it seems to wedge a very hard dividing line between two closely-linked ideas. But that is their point, to assert that the first phenomenon has a greater urgency and importance than the second:

> Cultural Development focuses on the development of cultures and cultural capacities. This terminology encompasses a vast range of issues appertaining to cultural policy, cultural industry and sociocultural development. The objective of Cultural Development is culture—as a sociological dynamic in which society grows and changes; as a powerful sector of the economy; as a professional environment inhabited by skilled creators, artists and craftspeople; as a transmitter of aesthetic expression, ideas and values.[19]

The most widely known expression of Culture and Development has been Theater for Development, typically referring to the work of troupes touring indigenous communities and using enactments, stories and music in local languages to convey development-related knowledge, such as how to ensure a clean water supply, increase crop yields or prevent the spread of HIV. Very often, the underlying aim is to make use of those understandings deeply embedded in local culture that can help promote development, while encourag-

18 Kees Eskamp and Helen Gould, "Outlining the debate," *Culturelink* Special Issue 2000, Institute for International Relations, p. 4.

19 Eskamp and Gould, "Outlining the debate," p. 6.

ing a critical relationship to those cultural understandings that deter it. As Ugandan social scientist James Sengendo wrote, "[I]n every society, there exist social values, traditions and behaviours which are vital for the quality of life, while at the same time there exist also the phenomena that are rather detrimental to human improvement and development."[20]

Many community artists in the developing world have taken part in Theater for Development projects (that's often where the funding is). It is the main subject of two chapters in the *Community, Culture and Globalization* anthology. Based on such experience, their views tend to be critical, warning of the dangers of using local cultural forms to impose the agendas of international development agencies, that instead of inviting people into deep exploration of the underlying causes of social problems and possible self-directed responses, Theatre for Development projects can fall into prescribing what the development agencies funding them think best. This is from Masitha Hoeane's interview, based on experience in Lesotho and South Africa:

> As a practitioner of Theater for Development, you have to provide what you might call a courier service for the ideas, to have some way for them to reach rural areas. And in the process of doing that, you find yourself compromised, because you are like somebody who is employed to do something that sometimes is not what you believe in yourself. When you go out to the village, if you're a genuine community worker, you begin to commune with people. You might find that the conclusions you reach might be different from the ones you've been given the brief to do. But if you are working to a brief, if these are your sponsors, then you must see the message through, because that's what they paid you for. The practitioners of the theater—when they are not themselves the generators of the message, when it is generated elsewhere—I think it is not appropriate for the theater and for the village as well.
>
> In other words, for it to develop properly and genuinely, for it to remain relevant and authentic, it needs to break that link with the current sponsor, or to get a sponsor in a different mode, who thinks differently, who can say, "Go to your community. I want to help that community." Then I didn't come with an agenda: there's no self-interest in any way, and I respect the integrity of that community to be able to identify what is desired and help it along.[21]

20 James Sengendo, "Culture and Development in Africa," *Culturelink* Special Issue 2000, p. 118.

21 Masitha Hoeane, "Culture as the Basis for Development," *Community, Culture and Globalization*, p. 269.

This is from David Kerr's analysis, based on experience in Malawi and Botswana:

> The main sponsors for Theater for Development projects are NGOs with specific missions of their own. They are part of a global aid industry, which is subject to some of the same disciplines of accountability as global corporations. The project directors can only guarantee continued budgets from their donors if they provide fairly concrete indicators of success, normally within a system of annual audits. In such a system, success can only be easily audited through concrete achievements—wells surrounded by cement protective guards, or condoms distributed, and so on. Attitudes are notoriously difficult to measure, and there is no managerial incentive to engage with complex, global relationships underlying the development problems of different sectors. Nor is there any incentive to analyze historical causes of problems; the "developmentalist present" proves just as restrictive as the rightly maligned "ethnographic present."[22]

There is a growing body of writing about Culture and Development, much of it underwritten by the World Bank. While it seems positive that a cultural understanding of development is permeating international aid circles, it is not clear that the distinctions being made have much real-world relevance. To me, they seem more animated by bureaucrats' and policymakers' passion for distinctions and categories than by practitioners' needs. From what I have seen, the impact of this discourse on practitioners themselves has been minimal. But Theatre for Development experience has itself been an influence, ironically helping to reinforce community artists' commitment to self-directed community cultural development practice. Building on David Kerr's and Masitha Hoeane's points, if Theatre for Development work were to be underwritten by sponsors who don't wish to control its potential for local self-determination, the distinction could become moot.

CETA and Public Service Employment

In the U.S., the Comprehensive Employment and Training Act (CETA) has come to be used as shorthand for a whole constellation of public service employment programs created by the Nixon and Ford administrations during times of high unemployment in the mid-1970s. CETA was ended almost overnight when Ronald Reagan took office; but at its height in Fiscal Year

22 David Kerr, "The Challenge of Global Perspectives on Community Theater in Malawi and Botswana," *Community, Culture and Globalization*, p. 254.

1979, the Department of Labor estimated that US$200 million had been invested in CETA arts jobs in that year alone. CETA was demonized by Reagan-era politicians as a pork-barrel program; the same rhetoric that would later be deployed to condemn putative "welfare queens" was used to evoke the specter of taxpayer-subsidized employees goofing off in painting and theater workshops while having the temerity to call it work. But to community artists, it was indeed work and it was a tremendous boon.

Thanks to a fortuitous combination of personalities and circumstances, San Francisco was one of the first places CETA arts jobs took off. John Kreidler, at this writing, director of Cultural Initiatives Silicon Valley, worked during the Nixon administration for the U.S. Office of Management and Budget (OMB) where he was responsible for a portfolio of Federal programs involving youth employment and occupational health. He took his OMB-derived knowledge to the San Francisco Neighborhood Arts Program, turning it into jobs for community artists.

For instance, the *Bicentennial Arts Biweekly* of December 18, 1974, featured an article describing "a queue of 300 unemployed artists—each hoping to get one of 24 new art positions recently made available by the Emergency Employment Act" (a CETA forerunner). An article in the January 9, 1975, edition began, "Unemployed artists are being hired with federal funds in San Francisco in a program reminiscent of the WPA during the '30s Depression." At that time, 23 artists had just begun work at the San Francisco Art Commission's Neighborhood Arts Program and the de Young Museum Art School at the subsistence salary of US$600 a month. Due to open any day were applications for 90 additional jobs for muralists to work in schools and housing projects, performing artists to fill residencies with community organizations and writers to work on oral histories of San Francisco's neighborhoods. By June of 1977, many CETA-funded artists were employed not just by city agencies and institutions, but through private nonprofit organizations. The June 1, 1977, issue of the *Bicentennial Arts Biweekly* noted that 899 proposals had been made by nonprofits to use the 1,500 CETA jobs then available to nongovernmental organizations, many from arts and community organizations.

Similarly, Britain's Manpower Services Commission devised job creation programs in the 1970s that supported many community arts jobs with pioneering groups such as Free Form Arts Trust and Cultural Partnerships, Ltd. (which have since morphed into other types of arts and media groups); and other nations had their counterparts.

There is scarcely a U.S. community artist who was around in the mid-1970s who did not either hold a CETA job or work directly with someone

who did. Most community-based groups in the United States dating from that time were launched on their labor-intensive path with CETA support. The way many community artists speak about the experience evokes Stuart Davis's comments on the WPA: that the public employment of artists was a foretaste of a "new and better day for art in this country." But in this era of privatization, in the U.S. as in most industrialized nations, it's off the menu now.

People's History and Anthropology

Certain techniques popular within the community cultural development field, such as oral history, are used in multiple realms. A huge body of oral history material has been created and put to diverse uses by historians, anthropologists and community artists. They have included WPA workers collecting slave narratives or tramping through cotton fields to record traditional blues with commentary in the singers' own words; "radical history" projects of the 1960s and 1970s, preserving the life stories of activists from a previous generation; and pioneering anthropologists like Barbara Myerhoff, whose work with elders demonstrated the power of telling one's own story.[23]

Community artists have been resourceful in mining other fields for useful material without necessarily adopting the particular standards, styles and approaches of those specializations. As artists, for example, they generally feel free to rummage through oral-history collections, selecting and juxtaposing snippets of text. Such a patchwork approach to composition often yields powerful composite portraits (while sometimes setting orthodox academic historians' teeth on edge).

For three decades, Roadside Theater <www.roadside.org>, based at Appalshop in Whitesburg, Kentucky, has been collaborating with communities to collect stories and other signifiers of cultural memory as a basis for performances that mirror back to a community its own sense of meaning and identity. Here's how Roadside Director Dudley Cocke describes part of that process:

> [W]e prompt community music and story circles so the participants can begin to hear and appreciate their own voices. We pick a theme for the circles, maybe some compelling incident in their local history or current event, and community members start telling and listening to each others' stories and songs. This becomes compelling, like fresh news, because partici-

23 See Barbara Myerhoff, *Number Our Days: Culture and Community Among Elderly Jews in an American Ghetto*, Meridian, 1994 (originally published in 1979).

pants often hear new information about a common experience. From the circles, a complex sense of a particular place begins to emerge.

The songs and stories, which are often recorded, become the basic ingredients of community celebrations that end the second phase [of a Roadside residency]. We often have these celebrations around potluck suppers. People get up and play music, sing, and tell the stories that they've by now somewhat crafted. Through big, structured celebrations, the community voice proclaims itself in public. All such celebrations are composed of many voices, because we insist on always keeping the door open for new people to participate.[24]

An equivalent use of visual imagery can be seen in "The Great Wall of Los Angeles," a mural more than a half-mile in length created on the walls of the Tujunga Flood Control Channel in the San Fernando Valley near Los Angeles. Begun in 1974 by Judith F. Baca, founder of the Social and Public Art Resource Center, existing sections portray an ethnic peoples' history of California from prehistoric times to the 1950s. At this writing, while funds are being raised to support restoration of earlier decades' installments, public dialogues have been held toward designing subsequent panels. Proposed images through the 1990s can be viewed at SPARC's website <www.sparcmurals.org>.

No single scholar or academic specialty has been put forward as a key influence on the community cultural development field, but many community artists have drawn inspiration from particular historians or anthropologists. This niche of the field is better networked than most, thanks in part to its closer affinity to academic structures, museums and other cultural institutions that have provided modest underwriting. There are local, regional, national and international oral-history associations as well as many specialized archives and collections. Community artists may draw on all of this material, but there are no programs specifically intended to support their use of oral histories. This lack of financial and technical support limits the amount of community-based work going on today; but there is a positive sense of forward momentum among leading practitioners, not only in the United States but internationally. As noted by Mary Marshall Clark, Director of the Columbia University Oral History Research Office, community cultural development practice offers a great deal to oral historians and their partners:

The expansion of the interview into a performance, whether of a single narrator or a group of witnesses, provides the opportunity to challenge the existing

24 Dudley Cocke, "Art in a Democracy," *The Drama Review*, Fall 2004.

Artworkers assemble at Tujunga Flood Control channel in Van Nuys, California, to help create the Social & Public Art Resource Center's Great Wall mural. Photo: © SPARC 1983

order of things and propose a new order. Because the interview is an expression of identity on multiple levels, and the intersection of interviews in a performance reveals the interconnections between personal and cultural forms of expression, the performance can reshape our collective self-understanding in ways that a single performer or one director might not imagine. ...

The art of oral history is to inspire those who have been silenced to speak out and to hear their own stories. The praxis of oral history is building the community from which those stories, told and retold, will transform history.[25]

Cultural Democracy and Cultural Exchange

International cultural policy discourse has had an indirect influence on community artists in the United States, through visiting artists and scholars as well as publications and organizing initiatives. The most influential idea has been "cultural democracy"—the major postwar innovation in international cultural-policy thinking.

In the period following World War II, European cultural authorities,

25 Mary Marshall Clark, "Oral History: Art and Praxis," *Community, Culture and Globalization*, pp. 104–105.

aware that the public interest in cultural development expanded as their nations rebuilt and continued to industrialize and urbanize, experimented with methods of "democratizing" elite culture. These were primarily center-to-the-margin distribution schemes for approved cultural products, such as busing schoolchildren to symphony concerts, subsidizing nonprofit theater tickets, staging art exhibits in local community centers and mounting huge "block-buster" museum exhibits with massive promotional campaigns intended to draw new audiences. After sustained investment in this approach, it was found to be largely a failure:

> In theatre, for example, thanks to price reductions resulting from subsidies running as high as three quarters of real cost, access has become possible for those whose cultural background already gave them the desire and the need to come. But the general public still stays away.[26]

In response to this failed strategy of "democratizing high culture," cultural ministers refocused their attention on "cultural democracy" in the early 1970s. It became the main watchword in international discourse until the mid-1980s.

Where is the concept rooted? In an essay first published in 1981, Don Adams and I cited the first English use of the term in J. Drachsler's 1920 book, *Democracy and Assimilation: The Blending of Immigrant Heritages in America*, but attributed the idea's early influence to Horace Kallen, who devised the term "cultural pluralism" as an antidote to the rise of the Ku Klux Klan and America-Firsters in the early 20th century. In his 2005 book, James Bau Graves cites Rachel Davis Dubois, an American educator who in 1941 founded the Intercultural Education Workshop, later called the Workshop for Cultural Democracy. This is from a book published by Dubois in 1943:

> The melting pot idea or "come-let-us-do-something-for-you" attitude on the part of the old-stock American was wrong. For half the melting pot to rejoice in being made better while the other half rejoiced in being better allowed for neither element to be its true self … The welfare of the group … means [articulating] a creative use of differences. Democracy is the only atmosphere in which this can happen, whether between individuals, within families, among groups in a country, or among countries. This kind of sharing we have called cultural democracy. Political democracy—the right of all to vote—we have inherited. Economic democracy—the right of all to be free from want—we are beginning to envisage … But cultural democracy—a sharing of values

26 Girard, *Cultural Development: Experiences and Policies*, p. 66.

among our cultural groups—we have scarcely dreamed of. Much less have we devised social techniques for creating it.[27]

While each of these commentators uses the term in a slightly different way (and all are slightly different from its use in contemporary cultural policy discourse), the core of meaning holds. Cultural democracy is predicated on the idea that diverse cultures should be treated as essentially equal in our multicultural societies. Within this framework, cultural development becomes a process of assisting communities and individuals to learn, express and communicate in multiple directions, not merely from the top—the elite institutions of the dominant culture—down.

The theory is promising, but for fairly obvious political reasons, most practical applications have been halfhearted. Although Europe's greatest need for cultural development in the post-World War II period existed in previously marginalized communities, most cultural ministries' practice fell far short of fulfilling this need. Their budgets instead reflected a continuing perception of prestige institutions as their primary clientele. Nevertheless, most European cultural authorities also undertook to support community cultural development efforts in some fashion, experimenting with various approaches to *animation socio-culturelle*.

At the same time, decolonization in the developing world was presenting cultural authorities there with a related dilemma: how to de-emphasize culture deriving from colonizing powers in favor of indigenous development. Experimental efforts here also focused on new roles for *animateurs* and other cultural development workers, as well as on development of basic cultural infrastructure and on creative uses of culture to support community development. Third World practitioners led the way in adapting cultural forms to the tasks of exploring issues, identifying options and mobilizing action around such basic problems as water, women's rights, unemployment and agricultural development.

American community artists came into contact with this work mainly through individual exchanges. From Don Adams' and my earliest days at the Neighborhood Arts Programs National Organizing Committee, we provided information on international resources for community artists (e.g., the second issue of the newsletter carried a review of UNESCO publications). We also served as a contact point for international visitors whose inquiries about cultural policy drew only uncomprehending stares at the National Endowment

27 Rachel Davis-Dubois, *Get Together Americans: Friendly approaches to racial and cultural conflicts through the neighborhood-home festival*, Harper & Brothers, 1943.

for the Arts, and as an outlet for information from abroad. For instance, in the October 1980 NAPNOC newsletter, John Pitman Weber, director of the Chicago Mural Group, described a visit to Europe in which he encountered a range of community cultural development initiatives not widely known in the United States, including the "town artist":

> More than a long-term residency, the town artist is an integral part of a new town's planning/building team. The town artist is most often a trained sculptor. He has his own workshop and team, including apprentices (a postgraduate position). The town-artist team provides permanent media artwork including landmark sculptures for housing and shopping areas, social seating sculptures and play sculptures and cast architectural ornament for housing, underpasses, painted murals and special paving designs. The town artist often facilitates participatory projects by residents, e.g., a recent mosaic underpass in Glenrothes, Fife [Scotland], by children, led by a member of the arts team.

In December 1980, the newsletter featured an article based on an interview with Jacob Sou, director of the Regional Cultural Action Center (RCAC) in Lomé, Togo, then visiting the United States to explore an African-American theater exchange at the request of members of Alternate ROOTS (<www.alternateroots.org> the Regional Organization of Theaters South, a still-active association of community-based theater companies and performing artists). In the following passage, his description of the ways that RCAC's program had been affected by the legacy of colonization is followed by our summary of the approach:

> "I didn't study African history in school. I studied French history and because it wasn't my country, I couldn't keep it. ... I don't know that much about African history—I have [had] to learn it, after school. So we try to teach people 'What is Africa?' 'What are African customs?' and generally, they are just learning it for the first time." Since each animateur's work will center on reawakening active interest in African cultural forms, this attention to African traditions, economics, social life and politics continues throughout the training period and serves not only to educate the students themselves, but to prepare them to involve other community members in the same process of recovering cultural traditions and creating new African cultural activities.

By the time of NAPNOC's annual conference in Omaha in 1982, it had become a priority to keep up an active international exchange. A centerpiece of the conference was a presentation by Andrew Duncan, a founding member of London's Free Form Arts Trust, itself an offshoot of Inter-action, one of the

first British community arts organizations. He described a range of project models that had considerable influence on his American listeners: planning projects using video and community gatherings to help residents of a housing estate organize themselves to press for community use of derelict facilities; making a slide/tape with developmentally disabled young people, based on Polaroid snapshots and snatches of ambient sound they'd "collected" walking through their own neighborhood with cassette recorders; and creating huge fire-shows comprising a community procession and a performance climaxing in a bonfire in which symbolic structures of oppression were constructed, then burned.

Political change has affected European groups doing this sort of communi-ty cultural development work. In the 1970s and 1980s, they received reliable general operating support from public arts agencies and local governments, leaving them free to pursue projects on the basis of community interest. But the recent trend toward privatization led to lower levels of general support and more earmarked, project-oriented funding from a variety of sources—for those groups that have been able to survive. Most of these funding sources are still public. A project that touches on HIV prevention, for instance, might receive a local health authority grant, a European Union grant and support from local educational authorities.

Since the late 1980s, as noted earlier, Australia established an international reputation as the national cultural policymaker most influenced by the values of cultural democracy, and most committed to ongoing support for commu-nity cultural development. More recently, with conservative politics shaping the government, Australia's policy too has been moving away from cultural democracy, although for the time being, community artists still have reliable sources of public support.

In contrast, public support for such work in the post-Reagan United States is minuscule and private funds for community arts don't approach the level of support still available in other countries. In fact, even as some of the rheto-ric and vocabulary of community arts has permeated mainstream discourse, U.S. cultural policy is racing away from cultural democracy, back to the old "democratizing high culture" model. The National Endowment for the Arts has invested heavily in old-style "culture to the masses" schemes. For instance, here's the NEA's description of its "Poetry Out Loud National Recitation Contest": "an exciting new national initiative to help high school students learn about great poetry through memorization, performance, and compe-tition," and there's also its "Shakespeare in American Communities"—"the largest tour of Shakespeare in American history."

So even with the reduced circumstances prevailing abroad, connecting with

foreign community artists has kept alive for their U.S. counterparts an enticing vision of what could be, if only resources permitted. Whenever possible, community cultural development practitioners around the world have eagerly engaged in exchanges and collaborations with their counterparts abroad. For example, *Community, Culture and Globalization*, the anthology from which I have drawn many quotations in this volume, was planned at an international meeting of community cultural development practitioners supported by the Creativity & Culture division of the Rockefeller Foundation. In her chapter, "Huehuepohualli: Counting The Ancestors' Heartbeat," Martha Ramirez Oropeza described one of the international exchanges central to the Chicano arts movement of the 1970s and beyond (similar exchanges also helped other dispersed linguistic and ethnic groups connect and explore questions of connection and identity):

In 1970, Teatro Campesino invited the Mascarones Theatre Group to participate in a cultural exchange with Chicano theater groups from California. One outgrowth of this festival was TENAZ (Teatro Nacional de Aztlan, or Aztlan National Theater), a transnational association co-founded by Mascarones that organized an annual festival and promoted the creation of new theater groups—more than 50 within the United States and Mexico within the 1970-74 period alone. That momentum culminated in the Fifth Annual TENAZ Festival hosted by Mascarones in Mexico City and attended by 700 people, representing 50 theater groups from North, Central and South America.

The opening ceremony of this festival took place in Teotihuacan, or Where the Creators Gather, the greatest ceremonial site of Central Mexico. Amid the great pyramids and temples of Teotihuacan, the hundreds of participants heard the unity speeches spoken in four different languages—English, Spanish, Nahuatl and Portuguese. The spirit of the opening ceremony pervaded the rest of the festival: because the shared origins of our identity were represented by the power and majesty of Teotihuacan, a profound sense of belonging began to emerge. The following days provided an exchange of experiences that helped bridge the gap between Chicanos and Mexicanos. By performing their plays before a Mexico City audience, Chicanos were able to feel themselves part of a family separated only by a political boundary, and their Mexican counterparts were able to hear in their stories of alienation the Chicanos' struggle to recover their history and culture.[28]

28 *Community, Culture and Globalization*, p. 47.

Spirituality

This is a time of high and growing religious participation in the United States, where most people—even if they are not religious themselves—have at least a passing knowledge of and tolerance for some of the many forms spiritual practice takes. Even many of those who feel no connection with religion describe themselves as "spiritual," indicating their interest in exploring non-material realities, or their dissatisfaction with a view of life that begins and ends with the physical world. Indeed, in discussing cultural democracy, James Bau Graves suggests that the values driving community cultural development are part a "great awakening" akin to a religious revival: "[T]he demands of the Fourth Awakening are for enriched access to genuine experience, as reflected in each individual's immersion in a community sharing common values."[29] The foregrounding of spiritual questions has had expanding influence on the U.S. community cultural development field.

In other countries with a high degree of religious participation, it is common for community artists to borrow from spiritual vocabulary or ritual to connect their work to deeply shared cultural meanings, as can be seen, for instance, in some of the work of the Philippine Educational Theater Association, or in the deep connection to spirituality that infuses the Nahuatl University in Morelos, Mexico, created by the Mascarones theater troupe using a sacred architecture of four pyramids, described as follows:

> The four main pyramid-like buildings, covered with murals depicting the creative forces within, are oriented towards the four cardinal points in the conventional ancient disposition.
>
> Ketzalkoatl is to the east, the dawn, the guide, wisdom—teachers' homes; Tezkatlipoka is to the west, the ancient memory—the library; Uitzilopochtli is to the south, the will power of fire and water of our inner war—open door theatre for ceremonies, theatre and dance; and the northern Ometeotl structure is a big complex with dorms, classrooms, healing *temazkal* bath, all-purpose workshop space and Tonalmachiotl science room. Also, as a part of this *kalmekak*—school of higher learning—is a kitchen-cafeteria and outside round warrior *temazkal*.[30]

Comfort with a spiritual vocabulary doesn't always cross national boundaries, however. In Europe, for instance, community cultural development

29 Graves, *Cultural Democracy: The Arts, Community & the Public Purpose*, p. 203.

30 The Nahuatl University website can be found at <www.kalpulli.org/unahuatl/>.

practitioners often adopt a progressive politics that regards religion as a form of false comfort or escape from reality. Others' critique of organized religion's abuses closes the subject for them; they feel they cannot condone or participate in anything they see as generating social structures of domination.

But here in the U.S., and in some other parts of the world, many community cultural development practitioners have found a link between their own work and spirituality, discovering that the search for meaning pervades both. While it is true that some people may feel their religion gives them unimpeachable answers to life's mysteries—and in many ways, all fundamentalisms are antithetical to the questioning, democratic, participatory values of community cultural development—all spirituality is rooted in the great questions that precede and may elude any answer, in what Rabbi Abraham Joshua Heschel dubbed "radical amazement":

> Wonder or radical amazement is the chief characteristic of the religious man's attitude toward history and nature. One attitude is alien to his spirit: taking things for granted, regarding events as a natural course of things. To find an approximate cause of a phenomenon is no answer to his ultimate wonder. He knows that there are laws that regulate the course of natural processes; he is aware of the regularity and pattern of things. However, such knowledge fails to mitigate his sense of perpetual surprise at the fact that there are facts at all.31
>
> As civilization advances, the sense of wonder declines. Such decline is an alarming symptom of our state of mind. Mankind will not perish for want of information; but only for want of appreciation. The beginning of our happiness lies in the understanding that life without wonder is not worth living. What we lack is not a will to believe but a will to wonder.[32]

Many community artists have seen questions of faith as fruitful ground for community cultural development. For example, from 2001 to 2005, Los Angeles' Cornerstone Theater <www.cornerstonetheater.org> sponsored a cycle of plays collaboratively created with many different faith-based communities. The project kicked off with a festival of 21 original plays at Hsi Lai Buddhist Temple; the Los Angeles Baha'i Center; the Faith United Methodist Church; Temple Emmanuel, a Jewish synagogue; and New Horizons School, a private Islamic school. Among the many plays developed and performed in the five-year cycle of story circles and collaborations were *Beyond the Jordan*, a collabo-

31 Rabbi Abraham Joshua Heschel, *God in Search of Man*, The Farrar, Strauss and Giroux, 1955, p. 45.

32 Rabbi Abraham Joshua Heschel, *Man is Not Alone*, The Noonday Press, 1951, p. 37.

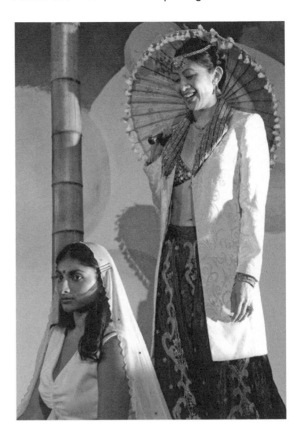

Page Leong (standing) and Meena Serendib in Cornerstone Theater Company's production of "As Vischnu Dreams," created in collaboration with the Los Angeles Hindu community. Photo by Michael Lamont 2004

ration with Arab Catholics; *As Vishnu Dreams*, a Hindu community collaboration; *Center of the Star*, a Jewish community collaboration; *Body of Faith*, involving the gay, lesbian, bisexual and transgender community members of many faiths; *Order My Steps*, a collaboration with African-American clergy and African-Americans affected by HIV and AIDS; and *You Can't Take It With You: An American Muslim Remix*, a Muslim community collaboration. The project surfaced many deeply controversial issues, such as acceptance of gay men and lesbians within conservative faith communities, fostering countless hours of community dialogue.

The culminating production was what Cornerstone calls a "bridge show," including the performers of all previous plays in a large-scale production that brings together many themes and elements. Cornerstone's materials describes *A Long Bridge Over Deep Waters* as

> a sprawling, panoramic epic that stages an interlocking chain of unexpected encounters between communities of faith in today's Los Angeles and features more than 50 professional and community artists. *A Long Bridge Over Deep*

Cast members in rehearsal for Cornerstone Theater Company's "A Long Bridge Over Deep Waters," created in collaboration with ten communities of faith in Los Angeles. Photo by John C. Luker 2005

Waters is inspired by the religious history of Los Angeles, hundreds of faith-cycle participants and Schnitzler's classic play *La Ronde*. It traces a joyous, painful, surprising and restless circle through our wide-open spiritual landscape in the City of Angels.

From 1998 to 2002, choreographer Liz Lerman and her Dance Exchange company mounted another interfaith community arts extravaganza, national rather than local. The Hallelujah Project ("Hallelujah" means "praise God" in Hebrew) was conceived to "celebrate edge-of-the-millennium America in all of its vividness, beauty, strength and quirkiness." In 15 different U.S. communities from Maine to Los Angeles, from Minneapolis to Greensboro, North Carolina, the Dance Exchange worked with community collaborators to create and perform dances in praise of their own communities. Like Cornerstone's, this project culminated in a huge final event, bringing 120 participants from many communities together to develop and perform programs incorporating excerpts from earlier venues, such as: "In Praise of Fertile Fields," developed at Jacob's Pillow in Becket, Massachusetts; "In Praise of Animals and Their People," from Washington, D.C.; "Anatomies and Epidemics," a new piece by the Dance Exchange company; "In Praise of Constancy in the Midst of Change" from the Vermont project; "In Praise of Paradise Lost and Found" from Michigan; and "In Praise of Borrowed Blessings," new material

interspersed with excerpts from the "Hallelujahs" in Tucson, Los Angeles, Minneapolis, North Carolina and Maine.

Questions of faith were strongly entwined with the project. As Dance Exchange Humanities Director John Borstel wrote in material given to participants and audience members at the project's finale:

One of the roots of "Hallelujah" is the question: "What are you in praise of?" What does it really mean to give praise? Is it a purely religious concept? Is it unique to particular religions and not to others? Is it an idea that people can relate to without reference to God or a deity?

Has "Hallelujah" been an experience of spirit, faith, religion, prayer or ritual for you? If so, how? Has it been different from or similar to other arts experiences for you?...

A liturgical dancer who participated in the Michigan "Hallelujah" said this: "I've never had the Holy Ghost experience by hearing a preacher speak the Word, but I have had it dancing." How does any form of artistic expression make a link to the divine? Is there a line between personal artistic expression and channeling the holy spirit? Where would you draw that line?

Our Los Angeles "Hallelujah" included reverends and rabbis representing Buddhist, Christian and Jewish denominations. One of the Buddhist Reverends said this: "I've participated in a lot of interfaith gatherings. This one is different because it's not just talking. We are doing something together. As a result it's been a deeper experience of the differences and commonalities in our practices."[33]

The project straddled the terrible events of September 11, 2001, putting the question of praise in a different light, as company member Michelle Pearson described in a post-project interview with writer Linda Burnham:

The pre-September 11 ones had more of a party kind of feel. And the post September 11s have a somber, what I call a deep happiness. Maybe happiness isn't the right word. Instead, I noticed this quiet kind of accepting peace that would radiate, as opposed to this fiery, explosive happiness, jubilation. The peace happiness kind of radiates out. I think the North Carolina "Hallelujahs" were more like that. When you think of the image of the woman turning at the end of "Lace" and being filled with the beauty of her own story. She had no idea it was so beautiful. She began to cry during the dress rehearsal …

33 All the quotations pertaining to this project are from Linda Burnham's excellent writings, interviews and compilation of Hallelujah Project materials, available at the CAN website at <www.communityarts.net/readingroom/hall/index.php>.

she said she just wasn't aware of the significance of her story ... And then the river of hair and Grandfather Mountain. I don't want to call them bittersweet, but they are. Thomas was separated from his granddaughters, yet they both have these same profiles. And he says look at me, "I used to be big, now I'm small. I'm an old man, I'm smaller," but he goes [puts on a deep voice] "That's not bad." They're beautiful ancient mountains there in Boone, but they are getting smaller.

There is interest in the community development world in what is called "asset-based community development," grounded in the idea that more can be accomplished by focusing on communities' tangible and intangible assets than on their deficits and problems. Efforts build on community members' skills, their voluntary associations, the resources already in the possession of local businesses, nonprofits and government agencies, and on the environmental and cultural resources present in a specific location. Positive approaches often generate energy by helping people to feel resourceful and see possibilities inherent in their communities. They avoid a common pitfall of problem-based organizing, which inadvertently discourages people with an overwhelming laundry list of intractable-seeming issues; but they sometimes fall into the opposite trap of minimizing obstacles, which can also lead to discouragement if these turn out to be truly formidable.

It seems to me that community cultural development work grounded in spirituality has just as much inspiriting potential and fewer discouraging pitfalls. Our inquiries into life's hidden meanings help us recast our own personal stories in a much larger context. Searching for meaning, we connect our individual struggles with those of our friends and family, community, society, species and indeed, of other life-forms sharing the planet. Our spiritual stories organize collective memory into a repository of useful lessons, stimulating our imagination of possibility. The great 18th century Hassidic teacher Rebbe Nachman of Bratslov said that, "The antidote to despair is to remember the world to come." This is a paradox. How can we remember what has not yet happened? The answer must lie in the little foretastes of a perfected world we glimpse in our connections with loved ones, in our experiences of the ineffable in the natural world, and in the alternate universe we are able to create in art.

It's not yet clear what to make of the convergence of spirituality and community cultural development practice: is it simply that community artists have been picking up on the spirit of the times? Or is it an emergent phenomenon, deepening community cultural development practice beyond its political roots by incorporating another aspect of culture? I feel it is the latter, but it is too soon to say.

CHAPTER 6
Theory from Practice: Elements of a Theory of Community Cultural Development

So far as I am aware, there has been no attempt by practitioners in the United States to formalize a theory of community cultural development. People rightly insist that their ideas about the work emerge from practical experience, which might be distorted by imposing an overarching theoretical framework. Some groups have developed formalized methodologies, but these focus on practical steps in approaching projects, rather than principles, values or informing ideas.

For example, in their *Beginner's Guide to Community-Based Arts*, Mat Schwarzman and Keith Knight put forward CRAFT: Contact, Research, Action, Feedback and Teaching, described as a "conceptual map" standing for "five territories of the community-based art process."[1] Michael Rohd of Portland, Oregon's Sojourn Theatre published a how-to manual based on his "Hope Is Vital" interactive theater techniques.[2] There is keen interest in sharing practical information and the ideas behind it. For instance, the Liz Lerman Dance Exchange offers an online "Toolbox" of "instructions for a variety

1 Mat Schwarzman and Keith Knight, *Beginner's Guide to Community-Based Arts*, New Village Press, 2005, p xxv.

2 Michael Rohd, *Theatre for Community Conflict and Dialogue: The Hope Is Vital Training Manual*, Heinemann Drama, 1998.

of art-making techniques, concise descriptions of principles and practices, and essays that explore the theory, background and applications of many of these ideas" at <www.danceexchange.org/toolbox/home.asp>. The Toolbox offers tools, defined as "concrete, take-action techniques for structuring art, generating artistic content, and engaging people in learning and collaboration"; foundations, defined as statements of principle elaborated by "brief descriptions of practices for effective teaching, leading, crafting and collaboration"; and essays written by individuals associated with the company.

A few groups, having become recognized leaders in certain specialties, have put forward theoretical frameworks as well as methodologies in their areas of specific focus, such as New York's Elders Share the Arts (ESTA), which in the mid-1990s published *Generating Community: Intergenerational Partnerships through the Expressive Arts*, a guide to its work.[3] Since then, there has been so much interest in arts and aging that in 2001, ESTA formed the National Center for Creative Aging; information on its many programs, publications and other resources are available at its website <www.creativeaging.org>.

All such resources have something valuable to teach, but they will never result in a definitive formula for success or a set of archetypal best practices. When practice becomes frozen into a model rather than remaining fluid, improvisatory and constantly evolving, it ceases to be authentic community cultural development. What is useful is not a theory but an armature: an array of basic concepts and principles sturdy enough to support many different approaches to practice. Based on a synthesis of community artists' own experience, I offer the following framework for further understanding of community cultural development practice.

DEFINITIONS

In community cultural development work, community artists, singly or in teams, place their artistic and organizing skills at the service of the emancipation and development of an identified community, be it one of proximity (e.g., a neighborhood or small town), interest (e.g., shipyard workers, victims of environmental racism) or any other affinity (e.g., Latino teenagers, the denizens of a senior center). While there is great potential for individual learning and development within the scope of this work, it is community-focused, aimed at groups rather than individuals, so that issues affecting individuals are always

3 Susan Perlstein and Jeff Bliss, *Generating Community: Intergenerational Partnerships through the Expressive Arts*, ESTA, 1994.

A veteran at St. Albans VA Hospital in New York displays a collage depicting stories from his life, created through Elders Share the Arts' "Legacy Artwork" project. Photo © C. Bangs 1996

considered in relation to group awareness and group interests.

In this context, "community" is understood as dynamic, always in the process of becoming, never static or complete. In a social climate of pervasive alienation, part of the community cultural development practitioner's task is to help bring a consciousness of community—often, of multiple belonging—into being.

One of the commonest ways community cultural development practice is diluted or undermined is by focusing entirely on individual development. For instance, some mainstream institutions have created after-school or summer classes for young people to learn how to make paintings or build sculptures. Despite the fact that discussion is limited to instructions and encouragement provided by teachers and the clarifying questions students pose in return, the classes are represented as community arts projects. Such activities may be wonderful learning experiences for individual students, but without the collective experience of self-discovery, without participatory learning about themselves as a group and about their community, without meaningful participation in shaping collaboratively created work, the project does not contribute directly to community cultural development.

CORE PURPOSES

Community cultural development work is predicated on the understanding that expression, mastery and communication through the arts powerfully encode cultural values, bringing deeper meanings of experience to the surface so they can be explored and acted upon. Community cultural development work embodies a critical relationship to culture, through which participants come to awareness of their own power as culture makers, employing that power to build collective capacity, addressing issues of deep concern to themselves and their communities.

Community cultural development makes use of artistic forms and practices (rather than other types of social action) because they are such potent carriers of meaning, as I wrote in 2002:

> Art is emblematic of culture, its purest expression. Where language carries its instrumental burden—"stop" and "go" can't accommodate much subjective meaning without triggering the mother of all traffic-jams—and furniture must bear our weight, where religion must contain our radical amazement and cooking stoke our energy throughout the day, art alone traffics in the uncut substance of culture. As a result, it can be adapted to serve many purposes, very often functioning as a flash-point for cultural conflict or a platform for cultural assertion. Art is the canary in culture's coalmine. In community art—rather than loitering hopefully, beaks in the air—the canaries get together and put on a show, telling the miners like it is.[4]

Community cultural development work incorporates certain core beliefs about the nature of the social transformation practitioners seek to advance:

• **Critical examination of cultural values can reveal ways in which oppressive messages have been internalized by members of marginalized communities.**

It can be surprising to learn that certainties, especially those ungrounded in provable realities, can limit our possibilities. At any moment, there are certain things that "everybody knows" which have no particular basis in reality. In my lifetime, I have heard countless things that "everybody knows," such as "there are no great women artists," or that "you can't fight City Hall," to

4 Arlene Goldbard, "Overlaps, Intersections and Conflicts: An Introduction to Arts and Culture," Community Arts Network Reading Room, go to <www.communityarts.net/readingroom> and search for the title.

mention just two of countless bits of common knowledge that serve only to reify the existing division of power. Comprehending such "internalization of the oppressor" leads to interrogating our own assumptions, often the first step toward learning to speak our own truth in our authentic voices.

- **Live, active social experience strengthens individuals' ability to participate in democratic discourse and community life, whereas an excess of passive, isolated experience disempowers.**

Like every challenging human task, connecting with others to examine and create culture is a learned activity, one that gets easier and makes more impact with practice. Community cultural development work gives individuals and communities the opportunity to practice active citizenship in settings that allow for great freedom and range, for learning by doing.

- **Society will always be improved by the expansion of dialogue and by the active participation of all communities and groups in exploring and resolving social issues.**

This principle might sound self-evident, but it is certainly preached more often than practiced. In these times, it stands in marked contrast to some groups' wish to limit civic participation to their own supporters. For instance, the last few national elections in the U.S. have been marred by campaign activists who spread disinformation about voting access to discourage those who might vote for their opponents, as by distributing flyers in certain neighborhoods with false information about polling places or hours, or spreading rumors that voters with outstanding traffic fines will be arrested when they show up at the polling place.

- **Self-determination is an essential requirement of the dignity and social participation of all communities.**

This is the spine of democracy, however intermittently honored: no narrow interest within society should have the power to shape social arrangements for all others.

- **A goal of community cultural development work is to expand liberty for all, so long as no community's definition of "liberty" impinges on the basic human rights of others.**

This is a challenging principle, because it sometimes comes into conflict with the desire to support traditional knowledge and traditional systems of authority. If I work with a community whose most conservative members believe women ought not to speak out in public, how do I work with a group of girls just beginning to sense their own agency? Am I aligned with tradition or choice? Negotiation is often involved: how much am I willing to compromise my own values to work smoothly with others? In the end, community cultural development is a freedom-loving practice; its adherents can't support cultural restrictions that deny anyone's human rights.

- **A goal of community cultural development work is to promote equality of opportunity among groups and communities, helping to redress inequalities wherever they appear.**

In game theory, there is a famous test for fairness: how to ensure that two parties are both satisfied with their respective slices of a single cake? The simple answer is that one cuts and the other chooses between the resulting segments. Community cultural development work aims to equalize both opportunity to participate in setting the terms of social power—cutting the cake—and in allocating the benefits—choosing one's slice.

Community cultural development work helps create conditions in which the greatest number are able to discover their potentials, and thus are moved to use their resources to advance these aims for everyone.

RESPONSE TO CONDITIONS

Whenever and wherever they are deployed, community cultural development initiatives are responsive to social and cultural conditions. In our era, many pressing social problems—racism, homophobia, conflicts over the nature of public education and conflicts over immigration, to pick just a few examples—are understood to be essentially cultural. To address them, cultural responses are required. Indeed, attempts to address them by means such as litigation and legislation have often fallen far short of the mark because they ignore the cultural dimension. Cultural values are transmitted and sustained by human beings in community, not by laws, edicts or court decisions, regardless of the power these may exert in other realms. As former French Cultural Minister Augustin Girard wrote more than 30 years ago in

his foundational book on cultural development, "Culture concerns everyone and it is the most essential thing of all, as it is culture that gives us reason for living, and sometimes for dying."[5]

While some social characteristics are overarching, affecting all members of a society, others are particular to a region or community: the former steelmaking region of Western Pennsylvania faces the particular challenges of communities abandoned by industries that once sustained them, while a couple of hours away, the challenges are quite different.

Social conditions cannot be generalized: even a single county's overall demographic makeup may obscure marked differences in the complexion of individual towns; and knowing a town's overall economic profile may not provide much useful information about conditions in a particular neighborhood.

For these reasons, an essential feature of community cultural development practice is participatory research into the life of the community, engaging participants in building a "thick description"[6] of their own cultural conditions and challenges, which then serves as a basis for any future work. In the context of community cultural development, the aim is to use many sources and types of testimony and evidence to construct a multilayered, nuanced account of cultural life and conditions.

There are many ways to approach this (a few are mentioned in Chapter Four: An Exemplary Tale). My partner's and my personal practice has been to start with formal information sources such as census data, historical accounts, maps and the kind of public information typically made available by local authorities or regional associations. The next step is to pursue direct information by interviewing key people, in each case asking interviewees for the names of other knowledgeable individuals, good networkers, representatives of important (especially countervailing) viewpoints and key organizations. Through these "snowballing referrals," one becomes acquainted with the community while building a pool of contacts and potential participants. Amassing dozens of accounts of the same community provides a thick description, solid grounding for the work that comes next.

5 Girard, *Cultural Development: Experiences and Policies*, p. 22.

6 This phrase, now in wide usage, derives from anthropologist Clifford Geertz's essay "Thick Description: Toward an Interpretative Theory of Culture," in *Interpretation of Cultures*, Basic Books, 1973. In brief, Geertz calls for interpretation of signs that incorporates the full range of potential meanings, rather than applying to one culture the bias toward a particular meaning favored in another. He uses the example of the "wink of any eye," which may be a physical reflex, a secret code, a parody or joke and so on.

CONFLICT

Conflict lies at the heart of community cultural development work, though its ability to resolve conflicts is limited, as with all practices. It may be true that if all one has is a hammer, every problem looks like a nail, but that doesn't mean that every problem obligingly buries itself when you pound on it.

Community cultural development is grounded in reciprocity and authentic sharing. When parties in conflict are more or less equal in social power, community cultural development methods can evoke and illuminate multiple coexisting realities, overcoming stereotyping, objectification and other polarizing habits of mind. Appreciation for valuable distinctions and deep commonalities can emerge from reciprocal communication through arts media, as participants begin to perceive common interests and possible compromises where they previously saw only intractable differences.

A classic situation of this kind would occur between members of an age cohort who find themselves in conflict over differences, such Asian and Latino teenagers who are classmates during the school day but otherwise treat each other as objects of fear or ridicule. When commonality of experience—shared educational experience, shared lack of status in the adult world, shared concerns about the future—overbalances differences, opening a space for real dialogue and collaboration will almost always help to defuse tensions.

But where there is a pronounced imbalance in social power between conflicting parties, it may emerge that real, material interests cannot be reconciled. While members of a dominant group may come to appreciate the beauty of the culture of those they oppress, this will not necessarily lead them to moderate their own interests in favor of the oppressed (rather than, say, to start collecting artifacts). Practitioners must be aware of such imbalances and approach such situations with great caution, lest their efforts inadvertently lead to further discouragement and exploitation.

This typically happens when very real power differentials are glossed over to produce a superficial unity. For example, real estate speculators and homesteaders, extractive industry moguls and environmentalists, organic farmers and chemical-intensive manufacturers might all be invited by planners in a rural community to take part in some sort of community visioning process, sharing stories and ideas. If the dialogue is pitched at a sufficiently general level, a vague consensus might be reached: everyone prizes the place's scenic beauty and wants to preserve it, for instance. People leave the meeting with a feeling of having communicated successfully across real barriers. Then, as time passes, it emerges that for the more powerful faction, preserving rural beauty means turning the community into a posh resort and subdividing

agricultural land for homes, while for the other, it means instituting policies that preserve family farming and public access to nature. Those on the less powerful side end up more wary of participating in such events. They feel that they have been exploited by a pre-emptive process aimed at "cooling out the mark,"[7] to use Erving Goffman's useful phrase: they have been engaged in a process the real purpose of which was to blunt their anger at being excluded from social power.

ARTIST'S ROLE

Organizing skills are crucial to community cultural development, but the work cannot realize its full potential in the hands of organizers lacking artistic ability and understanding. Vibrant creativity, a wide cultural vocabulary, the capability of conveying information through imagery, sensitivity to subtle shadings of meaning, imaginative empathy, the craft to shape bits of social fabric into satisfying, complete experiences that cohere as works of art—these are the stock in trade of the skilled and committed artist. Without them, projects cannot rise beyond the level of well-intended social therapy or agitprop.

When a skilled artist-organizer is working to full capacity, that person is fully present—learning, growing, shining—as an artist, using him or herself as a gateway for everyone to come into full presence and creativity. I like the way choreographer Liz Lerman drew out this point in her description of the way her community work has contributed to her own growth as an artist:

> When I first began teaching dance in a senior-adult residence in 1975, I was struck by the number of well-meaning friends, colleagues and guests whose response upon visiting me at work was to pat me on the head and say, "Isn't that good for them?"
>
> Now actually, it was good for many of the older people who found their way into the class I taught for 10 years at Washington, D.C.'s Roosevelt Hotel for Senior Citizens. The physical range of their bodies increased as they found the joy in moving; their imaginations became animated as they learned new mind/body connections; their trust in each other grew as they partnered in dance; and their self-esteem blossomed as they made works of art. They were strengthened as a community as well: when the residents of the building staged a rent strike against the management, it was the dance-class regulars who organized it.

7 Erving Goffman, "On cooling the mark out: some aspects of adaptation and failure," *Psychiatry: Journal of the Study of Interpersonal Relations*, Vol. 15 No. 4, 1952, pp. 451–63.

But it puzzled me that while observers immediately recognized the social good of this practice, they never conceived of the possibility that my work at the Roosevelt was also good for me as a person, as a teacher and as an artist—and ultimately not only good for me, but good for the art form of dance as well.[8]

ARTS MEDIA AND APPROACHES

All artistic media and styles are amenable to community cultural development use. Powerful projects have employed visual arts, architectural and landscape design, performing arts, storytelling, writing, video, film, audio and computer-based multimedia in many different combinations and approaches.

For some people, the term "community arts" implies folk media: small-scale crafts, acoustic music, traditional storytelling. All of these are valued community cultural development resources, but nothing makes them intrinsically more appropriate to the work than digital stories, photomurals, electronic music or sculpture gardens. Community artists feel free to mix media, combine old and new forms, or borrow from any mode of creative expression. There are no limits other than a project's resources and needs.

PROCESS VERSUS PRODUCT

Although projects may yield products of great skill and power (such as murals, videos, plays and dances), the process of awakening to cultural meanings and mastering cultural tools to express and communicate them is always primary.

To be most effective, projects must be open-ended, leaving content and focus to be determined by participants. As noted earlier, action research—whereby the direction of a project is focused through experimentation with different approaches to gathering relevant material, each producing new learning—is a key element of community cultural development work. Social and cultural creativity are paramount. Freedom to experiment and even fail is essential to the process.

But optimal conditions are seldom found. Often, funders require that projects be mapped out in detail at the proposal stage, and funding can seldom be secured without a high degree of specificity: "Over the next 12 months,

8 Lerman, Liz, "Art and Community: Feeding the Artist, Feeding the Art," in *Community, Culture and Globalization*, p. 52.

working with a group of teenagers from Smallville High School, Joe Painter will coordinate a mural project focusing on working people in local history … the mural will be dedicated at a community festival on Labor Day."

In practice, then, most community artists must balance desire and necessity, remaining alert to the boundaries that can't be crossed without damaging the work. If they want a future grant, Joe Painter and his collaborators are obliged to work within the general guidelines and timeline they put forward to secure funding. But within that framework, participants must have ample support and scope to learn, explore meanings, form working relationships and shape the mural's content in ways that cannot be known at the outset. Attempts to make projects conform closely to predetermined models remove them from the category of authentic community cultural development.

EXPRESSION VERSUS IMPOSITION

Community cultural development projects draw on the cultural backgrounds and experiences of participants, which may be highly differentiated or richly multicultural, with many layered influences. If practitioners impose their own artistic or social agendas on participants or attempt to transfer the cultural values of other social groups to those with whom they work, they transgress the bounds of authentic community cultural development, which is a nondirective practice, undertaken voluntarily and co-directed by participants and professional practitioners.

In her book on community-based performance, Jan Cohen-Cruz calls this principle reciprocity:

> Applying the criterion of reciprocity alleviates several misconceptions. For example, community-based arts is in distinct contrast to "community service," bringing to mind a soup kitchen with the well-fed on one side ladling out soup to the hungry who receive it on the other side. This one-directional model is not reciprocal; it does not support meaningful exchange. Nor is the field a monolithic celebration of human commonality, erasing very real differences which may exist between artists and local partners. Reciprocity rests on dialogue, which refers to "two or more parties with differing viewpoints working toward common understanding in an open-ended, face-to-face discussion." Artists must be as sensitive to their differences from community participants as to the common ground they share. All involved must genuinely appreciate

what the others bring to the collaboration, or why do it?[9]

While projects often involve people from multiple cultural backgrounds, necessitating a sharing of contrasting meanings and expressions, such exchanges must always be grounded in genuine equality and reciprocity in order to aid in community cultural development.

RESPONSIBILITY FOR PARTICIPANTS

Community cultural development techniques often cross boundaries of intimacy, as when participants are asked to share elements of their life stories or their deepest feelings about the way a problem affects themselves and their communities. It is the practitioner's responsibility to ensure that participants are not coerced into a premature or unprotected intimacy, which can have disastrous effects on the individual and the group.

For example, young people who feel themselves to be very different from their culturally conservative home communities' norms are often extremely vulnerable to exposure. Over the last decade, I've worked on several projects that engaged teenagers in online dialogue about social issues. These attracted quite a few gay and transgendered kids who felt isolated in their small towns or suburban communities. Online, they could be anonymous and form friendships at a distance, talking things over with peers who were unable to prejudge them based on appearance or manner of speech. A typical comment from these young people was "I live online," by which they meant that talking to others via computer occupied more meaningful space in their lives than face-to-face relationship. When I asked whether they thought the same quality of experience would be available face-to-face, some shared brave tales of steps they had taken to form gay-straight alliances at their high schools or speak up for gay rights. But many said no, that they faced teasing and bullying in school which would increase beyond bearing if they were to be more self-disclosing with their classmates.

The community artist who works with young people like these has to take the risks very seriously, allowing those who feel vulnerable to exposure to set their own boundaries. Often, there is value both for the individual and the community in sharing difficult stories, providing a space of safety has been created. It is true that secrets' power to wound can sometimes be weakened

9 Jan Cohen-Cruz, *Local Acts: Community-Based Performance in the United States*, Rutgers University Press, 2005, p. 95.

by bringing them to light. But pressuring people to reveal their secrets repeats the bullying that kindled their fears in the first place. Creating safe space takes time. Trust must be earned gradually, violations of trust must be pointed out and corrected and there must always be opportunities for individuals to opt out of situations they experience as intrusive or unsafe.

LEGAL CONTRACT VERSUS MORAL CONTRACT

It is in the nature of community cultural development work that criticism of existing institutions and social arrangements will emerge along with visions of change. Because community cultural development work is often financed or sponsored through existing (and imperfect) institutions, practitioners frequently face conflicts between the interests of their funders or sponsors and those of the participants. For example, participants in a municipally sponsored project may wish to protest a policy of the municipality adversely affecting their community.

Such dilemmas have been described as conflicts between the "legal contract" and the "moral contract" of the cultural organizer. Adherence to a legal contract is honorable and vital to preserving community access to resources in good faith with funders and sponsors; but when forced to choose, practitioners must align themselves first with their moral contract with participants or risk that their work will be perceived as a form of manipulation or imposition, leading to deep demoralization for participants.

To avoid such situations, the best defense is to protect projects with clearly written agreements specifying the responsibilities of all parties and ensuring practitioners and participants the right to determine project direction.

The toughest dilemmas involve two different types of moral contract. Consider what happens when conservative community mores come into conflict with liberatory values. James Bau Graves writes of one such dispute that turned on seating arrangements at a community event at the Center for Cultural Exchange in Portland, Maine:

> [D]uring the Center's first tentative program in partnership with our local Afghan community, a dispute arose about sexually segregated seating at a public event. Some of the elder Afghans felt that, in accordance with their custom, women should be seated separately from the men; in this case, restricted to the small balcony in our facility. Younger Afghans laughed at this idea, saying that it was old-fashioned. One suggested that only the Taliban would enforce such an archaic restriction. As the mediators, we wanted to honor the insiders' customs but also held concerns for the general audience that would be in

attendance as well as the Afghans. How would American feminists feel about being herded into the balcony? Regardless of what choice we made, we were certain to irritate one segment or another of the Afghan community.

In the end, the featured artist, a master *rebab* player, saved us from embarrassment by refusing to perform if the audience was segregated. The elders demonstrated their disapproval by staying away, but the onus did not devolve to the Center. When the Afghan Association planned their next event, the audience was segregated, and the event was well attended by all generations.[10]

Graves doesn't say what he would have done if the onus had indeed fallen on the Center, but when there is a conflict between tradition and liberatory values in any community project, the master *rebab* player and I agree: basic values of freedom and equity must predominate. My own views are very much like those of Mordechai Kaplan, leader of a liberal religious movement: "The past," he said, "has a vote, not a veto." At the very least, any such conflict is an opportunity for a deep and honest dialogue about what is at stake.

In the example I cited in the previous section, online dialogues with teenagers were monitored and moderated by a group of high school students who had taken on the project for extra credit, to meet friends, and to learn more about computers and about social issues. Most of them were first-generation Americans, with hard-working, conservative, religious parents from the Caribbean and Latin America. They were sensitized to racial discrimination and anti-immigrant prejudice, but many were strongly disapproving of homosexuality, abortion and other things that transgressed the dictates of their religion.

Some of their parents, learning that their sons and daughters were facilitating dialogues about such topics as same-sex marriage, expressed outrage, threatening to withdraw permission to participate. The adults overseeing the program invested a great deal of time and care in thoughtful conversations with teens and parents about the controversy, but some still decided to leave the program. It was a deep disappointment, but the only ethically and democratically defensible choice.

MATERIAL SUPPORT

Support for community cultural development in the United States is a patchwork: bits of local, state or federal government funding, bits of contributed

10 James Bau Graves, *Cultural Democracy: The Arts, Community & the Public Purpose*, University of Illinois Press, 2005, p. 158.

income from individuals, bits of foundation funding, strung together with attempts at entrepreneurialism, sometimes successful, often not. In other parts of the world, public funding is a larger (but seldom sufficient) slice of the pie, and support may also be available from international agencies such as health, development or agriculture-related divisions of the United Nations or international funders such as the British Council or Germany's Goethe Institute. The situation is not the same for everyone; but for everyone, it is far from ideal.

Community cultural development is a social good, analogous to the provision of emergency health care or the establishment of public parks and universal education. It relies on individual creative workers who cannot be replaced by machines and who cannot adopt economies of scale that might reduce the need for their work. It cannot reliably be arranged so as to generate mass-marketable products nor to earn substantial revenues through such mainstream arts approaches as subscription ticket sales. Indeed, rather than being subject to commercial criteria, community cultural development work should be seen as an element of protected public space within culture, guarded from the depredations of commercial exploitation.

As a social good—part of the cultural commonwealth, just as protected lands are part of the environmental commonwealth—community cultural development cannot be sustained by market-oriented means. Beyond the in-kind contributions of participants, its main sources of support should always be public funds, appropriated for the work's role in advancing the aim of animated, democratic community life, and private philanthropy, granted for the work's role in advancing cultural vitality and social justice.

But in the United States for the past several decades, public funding has been a small and dwindling source of support for community cultural development and there is no sign of reversal. From what I can see, most American practitioners have become so inured to the state of things that they cannot imagine it changing, and so preoccupied with patching together adequate funding they have little energy left for speculative social imagination or long-term thinking. As I write, there is no organized movement to radically rethink and recast this state of affairs by creating a substantial public funding presence for community cultural development. In fact, some practitioners are now so skeptical about the values and practices of the public sector that they question whether it would be wise to promote greater public funding, thereby risking further federal intrusion into free expression. So for the time being, the ideal remains just that, a far-off dream. (Several of my own dreams about how it might work are featured in Chapter Eight: The Field's Developmental Needs.)

INDICATORS OF SUCCESS

Some enterprises can be evaluated by reviewing facts and figures: a company's profit and loss statement, the total box office revenues for a blockbuster film, the number of copies of a recording sold. But because it is essentially participatory and collaborative, because the question of success has to more to do with process than product, the evaluation of community cultural development work must be grounded in conversation among practitioners and participants. The judgment of success rests with the participants. Community cultural development projects are perceived to be entirely successful if:

— Practitioners and participants develop a mutually meaningful, reciprocal and collaborative relationship, useful and instructive to all;

— Participants enter fully into roles as co-directors of the project, making substantial and uncoerced contributions to shaping all aspects of the work and setting their own aims for the project;

— Participants experience a deepening and broadening of their cultural knowledge, including self-identity, and a greater mastery of the arts media deployed in the project, with openings to further learning and practice as desired;

— Participants feel satisfied with what they have been able to express and communicate through the project;

— Participants' self-directed aims for the project have in their own estimation been advanced and any aims for external impact (e.g., sharing or distribution of products) have been achieved; and

— Participants demonstrate heightened confidence and a more favorable disposition toward taking part in community cultural life and/or social action in future.

While not every project will meet all these benchmarks, they should be consciously considered at the outset so they can help to shape the project as it unfolds and so evaluation plans can be designed with them in mind.

There is a second order of evaluation above and beyond the success of a single project. Funders and policymakers often pose questions of relative value. If money were no object, they say, they could support community-based projects even if their impact were modest—directly benefiting only a small number of participants, say, one particular neighborhood or rural area. But

when there is a perceived scarcity of funds in relation to requests, how can grantmakers justify allocating resources to community cultural development projects? Can it be demonstrated that community cultural development work will be more effective than other means in meeting a specific social goal (for example, educating citizens about the consequences of alcohol abuse)? Can it be demonstrated that funds invested in community cultural development work will produce lasting value for a community, help to bring about lasting change?

My own response to these questions is complicated. First, at the practical level, there is a Catch-22: if social policy is to be judged by quantifiable results, it would be nice to be able to point to such results for community cultural development work. But thus far, U.S.-based funders have not been willing to make the sustained investment in evaluation necessary to answer such questions. To assess lasting social impact requires tracking results over a long period of time, and so far, no one has come forward to underwrite that effort.[11]

Second, there is the fact that such questions are posed differentially. In the arts, for instance, mainstream institutions are seldom (if ever) required to justify their existence in such terms. Indeed, the intensity and complexity of evaluative demands seem to rise in inverse proportion to the resources at risk: small, marginal, experimental projects are much more often expected to quantify and substantiate effects than are their red-carpet counterparts. When it comes to long-established, prestigious institutions, many funders are willing to settle for presumptive value. Consciously or not, some funders impose additional requirements as a form of preemptive rejection: some groups are funded almost as form of gift, while others are expected to meet difficult standards of proof as a prerequisite for consideration.

Third, especially when it comes to quantitative assessment, evaluator's aims are often irrelevant or in contradiction to community cultural development practice. The underlying values of community cultural development are humane, fluid and relational: they are grounded in the convictions that participation is better than isolation, that pluralism makes more sense as a positive value than as a problem statement, and that equity is an essential goal of meaningful democracy. Judged by quantitative measurement, a drama project may indeed prove effective in transmitting information about alcohol abuse: participants may be demonstrated to comprehend and retain information and to be likely to pass it on, and the cost of achieving this objective may be

11 In contrast, see for instance Council of Europe's "Culture and Neighborhoods" project, which produced a four-volume comprehensive study and many other resources: <http://book.coe.int/EN/recherche.php>.

deemed affordable. But whether or not the work is valid as community cultural development depends on the more subjective standards outlined earlier in this section. So I am often left feeling that an evaluative approach may have satisfied a funder's aims—which may have been crafted so as to reassure a benefactor that he or she has not been fooled into allocating funds for suspect purposes—without providing any truly useful information about the validity of the work per se.

Finally, I question an underlying premise of many evaluative approaches, in which real results are compared with ideal ones rather than actual current practice. Take education, for instance. Often, the people who care for children will understand that the best education offers both material and immaterial benefits, the latter in the currency of fulfilling social relationships, fluent self-expression, curiosity and enjoyment in learning, burgeoning creativity, and so on; they also note how far short of the best much existing education falls. Seeing so many existing schools functioning in cutback mode, altogether lacking arts education, it makes sense to believe that any arts experience during school would be an improvement. Meanwhile, our schools are held hostage to standardized tests that completely leave aside education's immaterial benefits. The same is true in the community cultural development field. Almost any community cultural development initiative would be an improvement over cultural provision in many communities. But subjected to top-down assessment, programs are often vetted in light of the idealized standards rather than actually existing reality.

So, yes, if the sustained resources were present for meaningful longitudinal analysis, if assessment standards were applied fairly, and if they were grounded in the humane values of the practice, I would be glad to see the results. For funders and policymakers interested in exploring some of the standards and perspectives that would enable this type of evaluation, please see Chapter Nine: Planning for Community Cultural Development.

TRAINING

Advancing knowledge of community cultural development values and approaches is a permanent, ongoing commitment. With experience, all participants—not just professional practitioners—continuously improve their ability to explore and apply the meanings embedded in cultural traditions and arts practices.

Yet effective work needs skilled and dedicated practitioners, individuals

who make the field their life's work, bringing wholehearted commitment and seriousness of intention to the practice. Training for these professionals must be grounded in direct experience, for it is not the transfer of a particular set of techniques which is required so much as the development of an outlook infused with culturally democratic values. Ideally, training should employ the methods it is designed to teach. Accordingly, the training of practitioners in this field should incorporate the methods of community cultural development. Apprenticeship and internship are prized as means to achieve this, even as new formal training programs are being created at colleges and universities.

When I began to investigate community cultural development more than 30 years ago, I discovered that a good deal of careful thought had already been given to the problem of training by practitioners and others associated with international cultural agencies. This is from a 1975 essay by Jean Hurstel on "The training of animateurs," subsequently published in book form by the Council of Europe:

> Herein lies the complexity of training for animateurs. It is not enough to establish a centre for institutionalized technical and theoretical training: a training place for cultural democracy must be created in keeping with the spirit of animation. Here, starting with the desire to question and to act, people capable of tolerating contradictions, militants of social change, creative minds, are educated.[12]

One risk in establishing "a center for institutionalized technical and theoretical training" is that it will not be able to resist institutional pressures to quantify and standardize curriculum and assessment, sacrificing community cultural development's fluid, improvisatory character. Another is that resources and attention will flow to academic institutions which appear to funders as safer repositories for their grants than more marginal, controversial community-based groups. For any formal training program, then, four commitments are necessary to ensure that programs reflect the field's core values:

— Community knowledge and practical experience should be respected as much as scholarly analysis. Good academic community cultural development programs will be based on mutuality, on partnership between both valid forms of knowing.

— Community and institution should be deeply linked through strong working relationships between academic and community programs. Experienced community artists who are not core faculty members should be given roles as

12 From *Socio-cultural animation*, Council of Europe, 1978, p. 190.

advisors, helping to shape and inform projects and taking part in meaningful evaluations. Students' need for practical community experience shouldn't overwhelm community needs, and projects should be planned collaboratively, to avoid making community members feel they are there only to provide students with subjects.

— Faculty should be strongly grounded in the field. Institutions attentive to the bottom line sometimes try to save money by deploying existing arts faculty to teach community arts. But many artists aren't suitable, whether by disposition or personal preference, just as many community artists wouldn't be suited to teach studio art.

— Institutions will be supported if they in turn support the development of the field. Expanded academic programs could be good for everyone, in that community cultural development graduates will need jobs, and the creation of those jobs will require increased resources to the field. Universities can also convene practitioners for conferences and seminars, publish documentation and analysis and sustain debate.

Many current practitioners received training in specific art forms from mainstream schools of visual arts, drama, dance, broadcast media and arts administration, as others will continue to do. Artists will graduate from degree programs in theater or filmmaking, and facing existing choices of livelihood, some will decide to turn toward community work rather than commercial cultural industries. It has long been a complaint of college-educated community artists that they were not able to learn much about the precedents and practices of their future work while at university, as if the history of community cultural development had been excised from the curriculum. Practitioners feel strongly that the curricula of conventional arts programs should include history, theory and practical applications of community cultural development, legitimating the work of community artists as part of the arts.

Continuing education is needed as well. To facilitate ongoing advancement of skills and knowledge throughout the field, there should also be regular opportunities for experienced practitioners to share and compare experiences, thus challenging fixed ideas and encouraging new approaches.

PROFESSIONALIZATION

Full-time community cultural development practitioners constitute a unique category of professional practice, increasingly acknowledged in many parts

of the world. In a few places there is formal accreditation, generally linked to training. For example, the Community Arts Network of South Australia <www.cansa.net.au> offers a training program granting a "Graduate Diploma in Community Cultural Development: Community Based Arts Practice," and there are other Australian degree programs as well as smaller-scale training projects, some of which earn participants certification.

There are dozens of training institutes throughout Great Britain, based in many different regional community cultural development programs, as well as a variety of degrees and certificates available at the university level. All of this adds up to increasing formalization of community cultural development terminology and conceptual infrastructure. For example, in 2003, three British groups—Animarts, the Guildhall School of Music & Drama and the London International Festival of Theatre—undertook to study the work of community artists in educational settings, with the aim of formalizing and assessing an approach that had been going forward under many different names (they chose "animateur"):

> By no means all professional artists who work in schools and/or communities call themselves 'animateurs.' Depending on the art form, more specific terms such as 'Community Dance Worker' or 'Arts Education Facilitator' are commonly adopted. Use of the animateur word is more prevalent in music than in any other art form—in the visual arts it is rarely used. In the interests of one-word consistency and because there seems to be no better generic name or phrase—not yet anyway—Animarts has opted for 'animateur,' using it throughout this report to embrace all types of arts education practitioner.[13]

Outside the United States, there are associations of animateurs and community workers, and there has been extensive discussion over the years of professional ethics, methodologies, training and even unionization. Many community cultural development practitioners in other parts of the world are paid employees of development authorities, cultural authorities or other public agencies and are therefore accountable to the same standards applied to other public employees. The requirements and benefits attaching to such public-sector jobs often influence the definition and working conditions of their counterparts in the private sector, concretizing recognition of community arts as a profession. This in turn has set in motion debates about whether what is essentially an activating and liberating enterprise can be institutionalized without a loss of integrity and connection to community.

13 Animarts in partnership with Guildhall School of Music & Drama and LIFT, *The Art of the Animateur*, 2003, p. 9.

Where community cultural development work has been recognized as a profession, associations are formed to facilitate learning and mutual support. For instance, Canada's Creative City Network <www.creativecity.ca> is "an organization of people employed by municipalities across Canada working on arts, culture and heritage policy, planning, development and support," linked to the Centre of Expertise on Culture and Communities at Simon Fraser University in Vancouver. It includes community artists and community cultural development projects. There are community artists associations in every region of Australia, set up to network and support practitioners and communities. In late 2004, in response to proposed changes in public funding programs, Australian community artists formed the National Arts and Cultural Alliance (NACA, mentioned in the first chapter), "a national coalition of individuals, organizations, agencies and community groups involved in what is currently known as community cultural development, the community arts, arts in a community context, community-based art, etc."

In addition, there are transnational associations supporting various types of work related to community cultural development, such as Augusto Boal's Theatre of the Oppressed and its variations, supported by the International Theatre of the Oppressed Organisation <www.theatreoftheoppressed.org>, which features news, a directory, training opportunities and many other resources for practitioners. Likewise, Playback Theatre, a popular dramatic format for telling and discussing meaningful individual and community stories through improvisational theater, has its International Playback Theatre Network <www.playbacknet.org> to support training and networking among practitioners. While these groups don't offer professional certification (and may even find the idea antithetical to their values), they do assert unifying values and principles their members are expected to espouse.

That community artists occupy a distinct professional category has seldom been recognized in any official way in the United States. Here, they are most often seen as part of the professional category "artist," which is remarkably unburdened by professional ethics or expectations. No credentials, licenses or permits are required to practice as an artist; and no professional association or external authority has been set up to articulate standards. Indeed, the idea seems ridiculous. Add the fact that most community cultural development practitioners are deeply skeptical of institutions, and it seems unlikely that professionalization of community artists per se will become a focus in this country for some time, if ever. It's doubtful (and understandable) that U.S.–based practitioners would welcome any development that increases bureaucratization or regulation. But this difference widens the gulf between practitioners in those parts of the world where professional recognition has been

granted and U.S.–based community artists, whose self-definition sometimes makes a virtue of necessity, prizing an ad hoc, unfettered, guerilla style.

Whether they see themselves as members of a distinct professional category or not, most community artists continue to hold themselves to the moral contract that puts communities first. As Augusto Boal put it in his December 2005 message to the International Theatre of the Oppressed Organisation:

> We cannot condemn anyone because of being funded by capitalistic companies, private Universities, NGOs or governments, if this is done within clear ethical principles. Most of our governments are right-wing governments, and yet they are forced to subsidize groups that neither think nor act like them. The problem is not funding itself, but the uses one makes of funding.

True Story Theater uses a form of improv called Playback, dramatizing the real stories of audience volunteers to reveal our common humanity, creating deeper personal connections.
Photo © Nancy Capaccio 2005

TO belongs to the Oppressed and has to be controlled by the Oppressed. If a group does not accept directions from eventual donors, if they remain in full control of their work, we have nothing against funding.

This is different from those who accept the condition of taxi-theatre, groups that only work for money and obey their sponsors.

If a critical mass of attention and resources someday go into community cultural development in the United States, making professionalization a real possibility, a primary commitment should be to avoid creating a special class of community cultural development workers at some remove from the community members with whom they work. Under all circumstances, volunteers and those whose community cultural development work is only part-time or sporadic must continue to be mainstays of the field. No effort to separate them from professional practitioners would be consistent with the democratic values of the field.

However these questions translate into action, they will involve negotiation and complexity. For example, there has been considerable movement across the boundaries between commercial and not-for-profit cultural enterprise, which are becoming much more permeable. Younger artists, who never experienced a time when public funding could be relied upon to provide essential support, have been more willing than their elders to experiment with market-oriented approaches or to try to "infiltrate" commercial cultural industries or academia. Because community cultural development has been so little recognized as a profession in the United States, many community artists of all ages have found themselves working the borderlands between the better-funded art world and their own community-based practice. There, issues of professionalization can be vexed. What happens when a community artist makes a splash in the establishment art world, when a collectively produced play wins an Obie or when a recording born of a community project becomes a hit?

Unequal status has sometimes been perceived as an untenable threat to egalitarian values, unfairly elevating one member of a group above the rest. When community artists trade war stories, one hears tales in which such success is problematized, where the person who has achieved some sort of commercial or mainstream reward must be purged from the group. But if the field grows and continues to attract accomplished artists, it will almost certainly be necessary to work out a more complex relationship to the idea of mainstream recognition. Inklings of this are already evident in the pride people take in MacArthur Foundation "genius" award winners from the field, such as Liz Lerman and Amalia Mesa-Bains, who have remained in the nonprofit sector and still received major financial rewards for their work.

CHAPTER 7
The State of the Field

In Chapter Three: A Matrix of Practice, I explored the ways one judges the success of an insurgent idea. Is success establishing a distinct and widely recognized body of work grounded in the new idea? Or is it influencing and permeating many forms of practice, creating a general, albeit subtle, shift?
My own hope for the community cultural development field has been that it would become one of those phenomena that generates "Yes!" answers to both questions. But I now suspect that we are seeing a generational shift, a move away from establishing a defined and bounded practice and toward a tendency—an energy, philosophy and orientation—that manifests in many places.

THE ROLE OF FUNDING

Money doesn't make art, but funding shapes the environment that supports community artists' work, with the result that the work is deeply affected by the terrain those artists must traverse to accomplish it. The question of funding is an enduring feature of the community cultural development landscape, visible from almost any location in this chapter.

Of course, it's impossible to generalize usefully about the state of a field so widely dispersed and various. In some places, the work is firmly rooted as a distinct practice. In Australia, as noted earlier, as the 21st century opens, practitioners are trying to hold onto gains in funding and policy made over several decades, now threatened by a conservative national government's cul-

tural policy. In the developing world, circumstances differ tremendously, conditioned on the tenor of national government and the interest of international aid agencies in a particular culture and economy (aid agencies being almost as susceptible to trendiness as teenagers). In Europe, community cultural development's influences have become integrated to a large extent into public provision. Local authorities employ community arts officers and make fairly reliable, ongoing grants to community artists to support their work, understood as an intrinsic part of public provision. European Community funding and initiatives like Britain's National Arts Lottery have been boons to groups able to marshal the plans and credentials to compete on that level, with the result that in some places, there are megaplex community cultural development organizations, comparable in scale to mainstream art centers. But such schemes favor ambitious groups with stable, solid organizations, while others have often been left out of the competition.

In the United States, since community cultural development has seldom been recognized as a field per se by anyone other than its practitioners, there are deficiencies in many of the infrastructural elements that typically characterize a field of not-for-profit endeavor: almost no dedicated funding programs; few overarching organizations and publications to facilitate dialogue and cooperation within the field; and few training programs and professional standards that reflect the best thinking of practitioners. The significant achievements of the community cultural development field must thus be viewed as uphill victories. The greatest success is that so many convincing demonstrations of art's mobilizing power have been created with so little material encouragement.

These deficiencies stem not only from a lack of recognition and support—a withholding of these essential constituents of a field—but from a legacy of outright opposition by right-wing politicians and vested interests in the establishment arts. Sometimes debate has been so vociferous, the issue has emerged into general awareness. For example, even people who don't follow cultural policy news were aware of the opposition that arose around congressional appropriations for the National Endowment for the Arts (NEA) in the last two decades. Federal budget-cutting was used as an excuse to eliminate controversial projects; community cultural development work, which relied far more on public funding than had prestige arts organizations, but claimed far fewer advocates with status and access to members of Congress, was hit hard by these cuts. The same vocal, well-financed minority continues to oppose any use of public funds to support arts work; should its views prevail, the result would be a kind of social Darwinism in the arts, with market success and the ability to woo private donors becoming the sole traits selected for survival of artists and groups. But another sort of opposition has been

stymieing the field for far longer.

Let me cite an example I witnessed firsthand. In October 1980, in our capacity as editors of a newsletter for community artists, Don Adams and I covered a meeting of the policy and planning committee of the National Council on the Arts (the NEA's presidentially appointed advisory council), convened to discuss a study it had commissioned on cultural development in local communities across the country. The study recommended that the NEA support a policy of cultural democracy vis-à-vis local communities, making grants and providing technical assistance to local arts councils. It's hard to choose which committee members' responses to quote, because so many were remarkable, but two should suffice to provide a flavor:

> I resent "cultural democracy" as a term, because it seems to use "democracy," which we all swear by to our flag and to our faith; it subverts the term "democracy" into an autocracy of the uninformed—cultural democracy meaning that we have to be dictated to by those for whom we toil ...
>
> [People] understand education, they understand amateurism, they understand community events—but they don't for a moment confuse what they're participating in with art itself. ... Are we really in the business of supporting amateurism? ... Where does it all end? The neighborhoods? With the streets? ... The result can only be dilution, confusion and chaos.[14]

The underlying values of community cultural development have long been perceived as a threat to interests invested in maintaining the arts as a special preserve of privilege. As the above quotations illustrate, some established professional arts advocates are appalled by the democratic idea that culture and creativity belong to everyone. On the most practical level, they fear that funds heretofore reserved for their own constituencies will be "diluted"—that is, shared with community cultural development practitioners. In the political arena, the liberatory nature of community cultural development is perceived as threatening the established order. And in the sociocultural arena, adopting certain positions (such as asserting cultural diversity as an asset and opposing a hierarchy of cultures) can be read as an affront to those holding fast to the notion of an elite heritage culture that ought to take precedence over all others.

While they have typically rejected the strongly democratic values of community cultural development as insufferably impertinent, establishment arts funders have sometimes been susceptible to appeals to "cultural equity"—pro-

14 The first speaker is Theodore Bikel, musician, actor and president of Actors' Equity at the time; the second, Martin Friedman, was then head of Minneapolis' Walker Art Center. Quoted in *NAPNOC notes*, No. 6, November 1980.

viding a fairer share of resources for institutions focusing on non-European cultures. Here and there, one can find African-American repertory theaters, Asian art museums, Latino media projects that have been able to win substantial shares of arts funding, thus gaining standing and visibility within their art forms and mainstream art worlds. This is undeniably a positive development, as progress toward true equity is so long overdue and far too modest in relation to need and justice. But when an organization that resembles conventional, top-down institutions in every particular except ethnicity receives funding, this should not be mistaken as a victory for the values of community cultural development. Cultural equity does not automatically equal community animation. While it may be moving and healing to witness presentations of diverse works of art—while it may be essential for the inclusion and validation of cultures that have been disparaged by the establishment—it is not intrinsically mobilizing. A museum of African diaspora art may be as far removed from the cultural lives of ordinary people in surrounding communities as any elite European institution; an Asian-American repertory theater may have no more connection to empowering local community members than its non-Asian counterpart. The choice to advance community cultural development—or to be concerned with different goals—exists regardless of ethnicity.

As discussed earlier, community cultural development projects have often been targets in the "culture wars" between advocates of free expression and those who find certain forms of expression objectionable. The contest almost always turns on funding. For example, in 1997, right-wing Christian fundamentalist groups successfully pressured the City of San Antonio to eliminate what had been substantial, reliable funding for the Esperanza Peace and Justice Center. The primary focus of this debate was Esperanza's sponsorship of San Antonio's annual gay and lesbian film festival. Esperanza's 1998 funding application quoted the city's Mayor Howard Peak as follows: "That group flaunts what it does—it is an in-your-face organization. They are doing this to themselves." The politics of the situation are clotted with complexity: opposition to Esperanza was joined by representatives of several gay men's organizations who condemned the group's radical politics; the final decision to defund Esperanza was made by a Latino-majority City Council; six months later, the City's Department of Arts and Cultural Affairs (DACA) recommended that Esperanza receive new funding; and six months after that, DACA rescinded its recommendation because Esperanza would not withdraw its lawsuit against the city of San Antonio.

In May 2001, citing John Stuart Mill's "On Liberty," U.S. District Judge Orlando Garcia ruled in favor of Esperanza, affirming that the City's deci-

sion to eliminate the group's funding constituted viewpoint discrimination in violation of the First Amendment, as well as a violation of Esperanza's Fourteenth Amendment equal protection rights; and that the City violated the Texas Open Meetings Act. In October 2001, San Antonio's City Council agreed to pay Esperanza US$550,000; the settlement included a consent decree that prohibits the city from engaging in "viewpoint discrimination" for such funds and requires it to establish clear criteria for future art projects.

FROM GENERATION TO GENERATION

Even when such skirmishes have a happy ending for the community artists involved, they absorb large amounts of time, energy and money that might instead go to the work or to stabilizing the organization that supports it. And much of the public funding that used to support community cultural development has become a casualty of the culture wars. Two decades of holding artists and arts groups hostage to this cultural combat go a long way to explain why a movement that was so robust and promising in the 1970s has not since been able to grow and develop into a widely recognized field. Indeed, looking back at the literature of the movement at the time the first significant blows fell over two decades ago—the election of Ronald Reagan, the elimination of public service arts employment, drastic funding cuts in other agencies and the demonization of art with a social purpose—one realizes that the majority of organizations that seemed to hold so much promise at that time have succumbed.

This encapsulates a generational story. The countercultural energy that infused the community cultural development movement of the 1960s and 1970s was nourished by steadily rising hopes and expectations. In the very real achievements of the civil rights and anti-war struggles of that period, activists acquired a heady sense of their own agency. Within social-change movements, the line between healthy optimism and exalted delusion sometimes blurred, as when activists were lulled by their isolation from mainstream society into fantastic exaggerations of their own numbers and strength. (As a "Sixties person," I speak from personal experience, owning my own delusions as I acknowledge others' in my generational cohort.) The feeling that social arrangements were ripe for remaking was pervasive, but it seemed inconceivable that they would be remade to the specifications of the right. It is difficult now to grasp what a shock the election of Ronald Reagan was to this system of belief. The resulting demoralization was profound and has persisted. From members of my generation, one hears powerful messages like the opening

lines of poet-organizer Alice Lovelace's address to the 21st Annual Meeting of the National Performance Network <www.npnweb.org> in December 2005:

> When I huddle with friends I have known for more than three decades, the conversation eventually turns to the good old days—the years 1977, '78, '79, even 1980. The final years I can remember when community artists were valued, funded, and even appreciated in some circles. I'm talking about the days before we were abandoned and betrayed by those we thought were our allies.

Disappointment doesn't equal people subsiding into defeat. To the contrary, many activists' energy has not diminished. I'm tempted to say that the watchword might be Antonio Gramsci's famous epigram, "pessimism of the intellect, optimism of the will." In the very same December 2005 talk, Alice Lovelace announced that she had accepted a position as organizer of the first U.S.–based World Social Forum in 2007, a massive gathering of activists and organizers to explore unifying visions and strategies.

Over the last decade or so, Don Adams and I conducted dozens of intensive interviews with cultural development practitioners, sometimes as part of evaluations and reports, sometimes as preparation for speaking or teaching. Taken as a whole, the meta-theme of our interviews with the generation of practitioners that came into the field in the 1970s and early 1980s has been this: We survived.

This may be changing; survival may be giving way to sustenance. In fact, in recent years, as recognition of the effectiveness of community cultural development practice has grown, as it has increasingly been seen as addressing the need for greater social equity, dialogue and participation in shaping community life, some community cultural development groups have been quite successful in attracting support and expanding their programs. Even a slight lessening of survival fears has allowed surviving groups to begin engaging with the question of what the field as a whole needs in order to flourish. As the old arts orthodoxies fray at the edges and the right's grip on cultural politics begins to loosen, as social activism in other fields expands, we once again begin to hear harbingers of resurgent activism and interest in community cultural development.

While there are fewer organizations dedicated entirely to community cultural development today than there were 25 years ago, a significant cohort of surviving groups have now been working continuously for 20 or 30 years. They report a tremendous upsurge in interest in this field, especially from young people attracted to work that is meaningful (despite its few material compensations), as this veteran practitioner explained:

No one understands how many people are wanting to do this. I meet so many young artists who want to do meaningful work—to work on issues and do something meaningful in communities. There are more every day. I just wish I had [paying] work for them.

Given the rise of activism in recent years, one hears the optimistic view that the recovery of hope is just beginning. But I wonder whether it isn't more a matter of sticking around to see what the next generation does. I am reminded of an answer offered to readers of the Hebrew bible who asked why the Israelites who left Egypt had to wander for forty years in a tiny patch of wilderness before they were permitted to settle down. The answer? The generation born into slavery had to die out, making way for a culture not shaped by such terrible oppressions. Perhaps my generation, so deeply disappointed at the loss of both its youthful optimism and the public subvention that sustained pioneering community cultural development work, has to make way for a younger cohort born into a time of reduced expectations but just as determined to make its way despite obstacles.

The pioneering U.S.–based community artists who came of age professionally when public funding was understood as a mainstay are now in their fifties and sixties. Some of the longest-lived groups have been led continuously by the same charismatic individuals. Some have been able to maintain their roles despite the economic demands of increased family responsibilities, healthcare costs, the need for decent living conditions, and so on, by taking teaching posts or otherwise supplementing generally rock-bottom nonprofit arts salaries. Others have simply continued to work hard without expectation of reward. Often, the sacrifices they have endured have become normalized, part of the mise-en-scène of community cultural development work under conditions of economic scarcity. One result is that younger artists may see no place for advancement in the work, or simply may not wish to wind up like their older counterparts, unable to afford to retire. As the Building Movement Project's study of generational leadership succession in American nonprofit organizations of all types (based on extensive dialogues with nonprofit staffers) tells it,

Baby Boomers love their work and it is not clear if they will be leaving any time soon. The fact that they are glued to their organizational seats means that the next generation has a hard time finding a voice and a place, even as their experience and skill levels rise. As one participant wryly noted, "I have an associate director position. Our ED founded the organization, and has

been there for 16 or 17 years. So it's a challenge figuring out my role and her role. ...[15]

Along with a sense of movement, the Baby Boom generation brought a sense of vocation to their work that frequently obscured relationship needs and personal health. The younger leaders view that lack of balance as deeply problematic, tending to see it as ultimately ineffective and self-destructive.[16]

Pioneering community cultural development leaders tend to be youthful middle-agers and as noted, in no rush to retire (leaving aside the question of whether or not they can afford to do without their paychecks). But in conversations, several leaders have acknowledged that such a time will come, expressing anxiety about first passing on what they know, an anxiety reflected across the nonprofit sector, according to the Generational Leadership Listening Project report:

Young leaders worried that if they didn't know the history of the sector, they would be forced to repeat its mistakes—and it seems a well-founded fear. Younger leaders were both concerned about leaders staying too long, but they were also worried they would leave without passing on the lessons they had learned.[17]

Many of the skills essential to the older generation of community artists are needed by their successors. I am concerned that there be adequate opportunities—and receptiveness on both sides—to transmit prior learning to a new generation.

The survivors of this earlier era have been able to endure because they possessed the dedication, resourcefulness and flexibility to constantly redefine their work so it could be legitimated as an adjunct to one or other better-established field. The most successful organizations have been able to simultaneously compete for funds from education agencies, argue effectively to arts agencies for their artistic excellence, persuade social-service agencies of their skill in advancing social-welfare aims and so on, as described by this veteran community artist:

15 Ludovic Blain, Kim Fellner and Frances Kunreuther, *Generational Leadership Listening Sessions*, The Building Movement Project, New York, 2005, p. 9.

16 Blain et al, *Generational Leadership Listening Sessions*, p. 20.

17 Blain et al, *Generational Leadership Listening Sessions*, p. 24.

I made the decision to speak in many tongues to get the support we needed. I spoke the professional artistic language and made sure all the artists are on that level. I got a degree in social work to get into the elder facilities, because they'd say "we don't want artists"; and recently I learned the educational and school-reform language.

This reality has set the threshold for success very high. It is not enough that the work itself be of real quality, demonstrably living up to its claims. To keep afloat, groups have had to be able to bring remarkable effort, diligence, skill and adaptability to the task of finding support, very often requiring them to distort their aims or methods to do so. Understandably, many complain that it takes a prodigious investment merely to stay in place, that at times it feels as if the tail is wagging the dog, the quest for funding driving the work. In 2003, the Community Arts Network <www.communityarts.net> convened a gathering of community artists to confer about the state of the field and its prospects. The resulting report was written in part as an update of the first edition of this book, published in the spring of 2001:

> Participants at the Gathering would agree that in terms of financial support and marginalization by arts funders, relatively little has changed since 1991, when public arts funding dropped precipitously after the launch of the so-called "culture war" between political liberals and conservatives. Indeed, the situation has worsened, for economic crisis has caused a drastic drop in arts funding across the board. The crisis in state arts agencies has had the widest impact. The CCD practitioners at the Gathering showed an acute awareness that much foundation funding is reducing as well. Some foundations are withdrawing from the arts to a great degree. Some foundations that have shown interest in supporting CCD have withdrawn that support. Funding for some prominent initiatives is either coming to an end or changing...
>
> [P]articipants agreed that "framing their work in the language of social-service or arts funders" is still a major challenge: that social-service funders often fail to see the importance of the arts in addressing social change. The arts community itself may be marginalizing the field; a common complaint among community-based artists is that their work is not seen as art, but as social work. The artists at the Gathering maintained that this is still an issue.[18]

18 Linda Frye Burnham, Steven Durland and Maryo Gard Ewell, *The CAN Report, The State of the Field of Community Cultural Development: Something New Emerges*, Art in the Public Interest, July 2004.

THE NEW HYBRIDITY

Sometimes cultural phenomena can only be explained by resort to the zeit-geist. Surely it is the spirit of the times—the current conditions described at the beginning of this book, urgently demanding democratic response—that ac-counts for the speed with which community cultural development approaches have spread within the arts community and beyond. But the evident trend is that these approaches are propagating most vigorously in hybrid contexts—in partnerships with social service agencies, schools, community development organizations, activist groups and other non-arts groups, even, less often, in specific initiatives undertaken by conventional arts organizations and institu-tions—rather than spinning off more and more new groups dedicated entirely to community cultural development.

Not all of the artists involved in such projects may think of themselves as community artists, and not all of their projects would be identified by their originators as community cultural development (as opposed to, for example, "a site-specific experimental performance" on one end of the continuum, or "a health education project" on the other). Certainly, not all are consciously guided by the field's implicit consensus on values and approaches as described in earlier sections. But with or without conscious intent, growing numbers of artists are being pulled toward community cultural development, and that pull is anchored in the influence of community artists who have consciously identified with this field.

The result has been a number of vigorous, popular projects attractive to funders particularly because they straddle so many fields, the work's hybrid character earning it attention and legitimacy in better-resourced, more visible arenas, arenas less accessible to creators of smaller scale, locally focused com-munity cultural development work.

viBE Theater

Consider New York's viBE Theater <www.vibetheater.org>, created in 2002 by Dana Edell and Chandra Thomas. Executive director Edell characterizes it as "a performing-arts/education organization self-described as 'a safe, creative space for underserved young women to share their stories and use their voices to build and transform themselves and their communities...'"[19] The program comprises five project elements beginning with viBE Stages, a ten-week pro-

19 Dana Edell, "Ripples of the Fourth Wave: New York's viBePoetry," Community Arts Network Reading Room, <www.communityarts.net>, February 2006.

gram that engages a group of young women in learning writing and performing skills while focusing on the issues closest to their own lives; participants create and produce a play that is performed for community audiences. Successive program elements offer viBE Stages veterans ways to become more deeply involved in theater, music and/or writing.

Edell has written of three girls who had participated in viBE's workshops approaching her to start a performance poetry project. Her response strongly reflected community cultural development's participatory values:

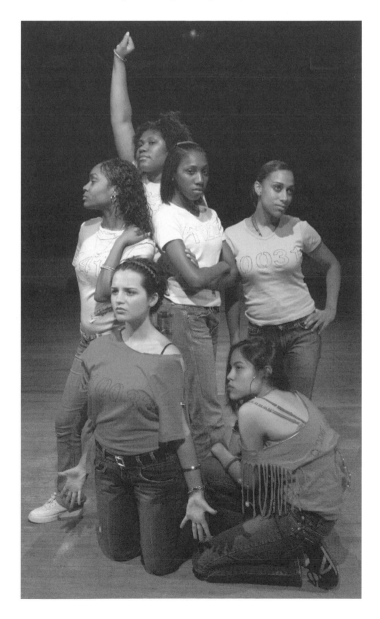

Dinnel, Uwa, Judyta, Alina, Yarissa and Iemi in viBe Theater experience's production of "dot dot dot and nothing but the truth" at HERE Arts Center, New York City. Photo by Tom Ontiveros 2005

I began to construct a new program called viBeGirlsInCharge. This potential poetry project would be the pilot round for this different leadership model.

I drafted a set of guidelines and challenged the interested girls to articulate a mission statement for the project, define their roles, devise a week-to-week curriculum, draft a budget and conceive a fundraising strategy. I guided their thinking by drawing a basic sketch, though they were responsible for filling it in and making it sparkle....

From inception, the program design, recruitment, hiring teaching artists, planning fieldtrips, developing a curriculum, securing a performance venue, budgeting and fundraising, these three young women have created their own youth-arts program.[20]

The experience for the seven girls who make up the viBeGirlsInCharge project resembles that of most groups shaped by community cultural development values, as does the experience of girls participating in the core viBE Stages project. Yet in writing about the project, Edell's framework draws more on education theory and developmental psychology and speaks more to the concept of "youth leadership" than to community cultural development per se. The organization's modest support has come almost entirely from non-arts sources, primarily social services and youth-oriented funders, or from exchanges of services with other nonprofits such as Planned Parenthood. Although commercial considerations are not at all primary in viBE's program, a CD of music produced by participants has had radio play and music store sales, generating attention if not major income. The organization's funding base doesn't reflect any sort of opposition to arts funding on viBE's part, rather the realities of a depleted funding climate for community-based arts work. Edell sees support coming primarily because viBE offers "an educational experience. We really hope funders come to performances, because they really need to see to believe. They can see how it affects girls, and experience how audiences are affected through talkbacks after the show, how energized everyone is."[21]

Edell describes herself as a community artist, specifying that "the work I make is always in collaboration, always in response to something that's happening in the community right now" and clarifying that "I consider viBE part of my work as an artist." As viBE projects are organized, the deepest collaboration is with and between young participants, rather than a larger community, though Edell and Thomas "challenge girls to have at least one moment of

20 Edell, "Ripples of the Fourth Wave: New York's viBePoetry."

21 This and the remaining quotations in the following paragraph are from a conversation with the author in February 2006.

interaction with the audience," which can be "question and response, bringing audience members onstage, holding a talkback after a performance," and other such elements. While Edell clearly sees viBE as a community cultural development project, the overall container for viBe's impressive, multifaceted program more resembles a performing arts school. Although not all girls continue in the work, and viBE's leaders are careful not to foster illusions about commercial success, for those who exhibit the requisite desire and commitment, the group may be a portal to professional performing arts involvement. Its hybrid character combines community cultural development with youth service, education and mainstream performing arts.

Project Row Houses

Or consider Project Row Houses in Houston, Texas's Northern Third Ward, a longstanding African American neighborhood designated by the City of Houston as a "pocket of poverty." The Project, created in 1993, began with a row of abandoned shotgun houses—long, narrow, inexpensively built one-story houses on small lots, front porches almost touching, a form of low-income housing frequently built in the American South in the late 19th and early 20th centuries, often to house freed slaves. Project Row Houses has grown to include a public art program, workshops and summer programs for local youth, as well as the Young Mothers Residential Program, providing free housing and training programs for single mothers. The Project has been so successful, it has spun off a sister organization, the Row House Community Development Corporation (RHCDC), to develop low- and moderate-income housing, public space and facilities to preserve and protect the historic character of the neighborhood against the pressures of gentrification. The project has received prestigious awards from architectural and planning associations such as the National Trust for Historic Preservation, the Rudy Bruner Silver Medal for Excellence in the Urban Environment and the Keystone Award of the American Institute of Architects.

A group of row houses has been converted to blank canvases for art installations, white-painted gallery-like interiors. Installations selected from submitted proposals rotate through row houses in half-year shifts. Artists are invited to submit applications for site-specific projects, with preference given to those that are "interactive as well interdisciplinary. What we mean by interactive is that the installations encourage the viewer to participate in ways that are both thought provoking and sustain excitement during the course of the round. It does not however, mean more Hi Tech ideas that would require more security or high maintenance. Interdisciplinary, performance and collaborative works

can serve well to this need."[22] Past artists are an international, art world-oriented group leavened with graduates from Texas fine arts university programs, few of them defined as community artists per se.

Project Row Houses is the brainchild of Rick Lowe, who began life as the child of Alabama sharecroppers and went on to study art at university. His primary influences were German installation artist Joseph Beuys' concept of "social sculpture" and muralist John Biggers, whose art valorized African-American culture, and with whom Lowe studied at Texas Southern University. (Biggers' painting of Third Ward shotgun houses is in the permanent collection of the Smithsonian Institution in Washington, DC.) Lowe is the recipient of many honors for his work. He continues to work as an independent artist, creating commissioned projects such as "Latitude 32 – Navigating Home," a collaboration with Suzanne Lacy and Mary Jane Jacob for the Charleston, South Carolina–based Spoleto Festival in 2002; and more recently, the Delray Beach Cultural Loop, a walking tour of diverse cultural sites in a Florida town and a series of linked workshops, installations and events, with Lowe as the overall designer.

Project Row Houses is often characterized as "arts-based community development." Some elements of the work are highly participatory; for example, RHCDC's Retelling Our Stories Audio Project for young people teaches them to produce their own audio segments on history and current issues, to be broadcast on listener-supported radio. But the overall shape of Project Row Houses follows a "bringing art to the people" format, as Teresa Heinz Kerry recognized in the first quotation below when presenting Lowe with the 2002 Heinz Award (which he shared with Roadside Theater's artistic director Dudley Cocke), and as, in the second quotation, Lowe himself echoed in his acceptance speech:

> Rick Lowe transformed a formerly beleaguered area of Houston into a vibrant and thriving arts community. Instead of seeing blight, Rick Lowe sees opportunities. In founding Project Row Houses, he has transformed a distressed pocket of the inner city into a place of beauty, community and pride. His optimism and passion for bringing art into places where art is not normally found make him a most deserving recipient of a Heinz Award.[23]

Over the last 20 years I have found myself meandering in and out of the art

22 Extensive information about Project Row Houses is available at its website. These guidelines for artists appear at <www.projectrowhouses.org/visarts/index.htm>.

23 Texas Commission on the Arts, "Urban arts activist Rick Lowe wins Heinz Award for Arts and Humanities," ArtsTexas, Spring 2002.

world as I struggled to make work that reach the highest aesthetic goal and at the same time relevant to the people from backgrounds similar to mine.[24]

Without explicitly adopting core community cultural development values and approaches as its own, the Project has entered into collaborative relationships with many community organizations, added affordable housing stock, fostered community pride and attracted a tremendous amount of attention and funding (most from major regional and national foundations, far overshadowing public investment). It has contributed to community and cultural development by straddling mainstream art and community development worlds.

Holler to the Hood

Or consider Holler to the Hood (H2H) <www.appalshop.org/h2h>, which is described as "a multimedia human rights project designed to foster collaboration and communication between urban and rural communities." H2H currently comprises a weekly radio show, a documentary project and other initiatives. In 1999, H2H's young founders Nick Szuberla and Amelia Kirby were volunteer disc jockeys at WMMT-FM, "Listener-Supported, Consumer-Run Mountain Public Radio," the radio station of Appalshop, the aforementioned multidisciplinary arts and education center based in Whitesburg, Kentucky.

As co-hosts of the Appalachian region's only hip-hop radio program, Szuberla and Kirby received hundreds of letters from inmates recently transferred into nearby Wallens Ridge, a new prison built as part of one of the United States' remaining growth industries, building prisons in regions facing economic decline (in this case, new prisons and prison jobs were proposed as an antidote to Appalachia's shrinking coal economy). Szuberla told me that "We realized prisons were being built, and it seemed easy to predict there would be a lot of racial tension between local guards and prisoners from urban areas. We could see how it could unfold."[25]

Indeed, inmates' letters reported human rights violations and racial conflicts between prison staff and inmates, inspiring H2H's founders to investigate. With Appalshop's strong documentary orientation and what Szuberla describes as "a very supportive art-making culture, very fluid," he told me, "it seemed a natural process to start to document what's happening, and from there the film kept unfolding, driven by communications from prisoners.

24 Go to <www.heinzawards.net> and click on "Recipients."

25 In conversation with the author, March 2006. Unless noted otherwise, all quotations from Szuberla are from this conversation.

Dirk Powell and DanjaMowf in Whitesburg, Kentucky, producing the musical score for *Up the Ridge: A U.S.Prison Story*, Holler 2 the Hood's documentary.
Photo by Preson Gannaway 2006

When they shipped in people from Connecticut to Wallens Ridge, we went up to Connecticut to see what was happening there." Szuberla's and Kirby's one-hour documentary film, *Up the Ridge: A U.S. Prison Story*, explores the domestic prison industry, particularly the social impact of moving large numbers of inner-city prisoners of color to distant rural settings. The film connects human rights violations at overseas detention centers like Abu Ghraib with physical and sexual abuse in American prisons.

The film's creation was supported by small, short-term grants from regional sources and arts and humanities funders. "We did a lot of proposal writing," Szuberla told me, "and small grants came quick enough to capture what was happening." Throughout, Szuberla and Kirby were motivated by prisoners and their families: "Folks kept calling us to ask if there was something they could do for the radio show. We wanted to bring the work down into a cultural piece that people could get their hands around, something people could use." Arts and humanities grants "have been really helpful, letting us have a sense of a future. But our job is not to see that as the only source." Instead, Szuberla and Kirby have sought contract work, conducting community digital storytelling workshops underwritten by foundations, for instance, to tide them over while they work on the film. "If grants don't come in," Szuberla told me, "there's this other sphere of folks where we can bring our skills and earn income."

At this writing, they plan to convene a group of policy experts in the criminal justice field who will help create a white paper translating the film's lessons for funders who care about prison reform and related issues, in the hope they will fund another H2H initiative. *Thousand Kites* (in prison jargon, to "fly a kite" is to send a message) is a joint multiyear project between H2H and Appalshop's Roadside Theater, collaborating with prisoners and prison

employees, their families and their communities. Roadside has a long track record of collaborative play creation and presentation, grounded in story circles with those directly involved; H2H's specialty is innovative use of digital and broadcast media. Working together in 2006, they are scripting a play to premiere in 15 communities housing prisons. Audio of live performances will be mixed in the studio with narration by a spoken-word artist. The resulting audio production will be part of end-of-year holiday broadcasts at 150 community radio stations around the U.S., and also distributed via CD and on the World Wide Web, with further phases of the collaboration to follow.

I asked Szuberla to compare his own orientation to the work with a previous generation's disappointment about the loss of public funding and forward progress. "I've sensed that," he said, "an underlying current with the founders' generation, a caution when we're trying to conceptualize and build up programs. It's hard for me to imagine a different world. I guess I could envision not having to spend so much time getting resources. But we have to accept what's here and keep our sanity. We're not riding high on the horse, but one thing I've learned is we should try to put a little money away for retirement."

Community cultural development practice has always drawn on multiple art forms and far-ranging partnerships, pulling in whatever funding might be available from both arts-oriented and non-arts grantmakers. But when public funding was more reliable, when key groups could reasonably expect core support to come from public agencies, practitioners perceived their organizations this way: as community-based arts groups spurred by necessity into ever-growing eclecticism and resourcefulness.

In contrast, the projects by younger artists described above are intrinsically cross-bred, conceived as fusions of conventional art and education or physical community development, or of independent media and activist organizing. In general, they don't place the same ultimate emphasis on process as typified core community cultural development practice in the previous generation; products matter more and are much more likely to be seen through specific professional lenses—as education, architecture or documentary film, for example. Yet they strongly share the previous generation's commitments to social justice and equity, to multiple aesthetics and social relevance.

My hunch is that hybrid work of this type will be the next generation's main influence on the U.S. field, that a community cultural development orientation will be threaded through many different types of work. Whether this foreshadows the end of organizations exclusively dedicated to community cultural development practice—whether it signals that the field's success will be more of the type that influences the mainstream than stands apart from it—it is too early to say.

Paula Simms and June Broughton in The Harmony Suite by Nicholas Kelly, produced by Collective Encounters, Liverpool, England. Photo by Leila Romaya and Paul McCann 2005

GLIMPSES OF THE GLOBAL FIELD

Looking beyond the United States, the landscape is very different, because community cultural development movements abroad have generally received enough reliable (usually public) funding to support the stable dialogue needed to develop their own approaches, methods and standards. This has remained true even in recent years, as funding has become more project-oriented and competitive with the trend to "privatization" described in Chapter Five: Historical and Theoretical Underpinnings.

New organizations are being founded by younger practitioners and being supported by public funders. Based in Liverpool, England, Collective Encounters <www.collective-encounters.org.uk> was created in 2004; the group is dedicated to what its mid-thirties artistic director Sarah Thornton calls "theater for social change." Its work is grounded in deep research into community realities and community myths. "What's different about what we're doing," Thornton told me, "is that we're trying to look at a political and social situation and trying to see how theater can tackle those issues." The goal is to create continuing work rooted in local communities, rather than "parachuting

in," Thornton told me, "we want to work in this community a long time."[26] Thornton, who has been teaching theater at the university level, has strong ideas that animate her work. In several of her papers and presentations, she quotes this charge to theaters from John McGrath, a pioneering advocate of engaged, popular theater:

> In all areas central to the working of a democracy, theatre has its role to play:
> * In celebrating and scrutinising the values within the borders of the demos;
> * In contesting these borders, external and internal;
> * In giving a voice to the excluded;
> * In giving a voice to the minority;
> * In constantly guarding against the tyranny of the majority;
> * In demanding the right to speak publicly, to criticise without fear;
> * In giving a voice to the oppositional;
> * In seeking true and balanced information;
> * In combating the distorting and anti-democratic powers of the mass media;
> * In questioning the role of large corporations, national and transnational, to influence both the law and the government of the day;
> * In defining and re-defining freedoms for the age;
> * In questioning the borders of freedom;
> * In giving a voice to the less equal;
> * In demanding impartial justice and equality of all citizens before the law, rich or poor.[27]

Collective Encounters' work has two related strands. Participatory workshops with community members use Boal's Forum Theatre and Legislative Theatre approaches, leading to public performances, described by Thornton as "local people using theater to articulate their own concerns for themselves." In parallel, formally innovative professional theater, scripted, integrating multimedia and other adventurous elements, is performed in non-traditional spaces for community audiences: "We work in alternative spaces for people who don't usually go to theater," says Thornton. She emphasizes that she is "very interested in pushing theatrical form," noting that political theater grounded in community "tends to stay very naturalistic."

The group's initial work was an integrated program of initiatives—the Living Place Project—organized around a single theme, the government policy of "regeneration" (what in the U.S. would be called "urban renewal") and

26 In conversation with the author, March 2006. Unless otherwise specified, all quotations from Sarah Thornton are from direct conversation.

27 John McGrath, *Naked Thoughts that Roam About: Reflections on Theatre*, Nick Hern Books, 2002, p. 236.

how it affects people and communities in north Liverpool. Initiatives included extensive community consultation, with six different artists resident in six north Liverpool community centers, collecting stories, images, sounds and ideas from local residents affected by regeneration programs; an interactive children's show; intergenerational Forum Theater training; and *The Harmony Suite*, a company-created combination of live theater, multimedia spectacle and street party performed in a derelict street. The play dramatizes the company's research and consultation findings, which were also written up in a detailed, comprehensive May, 2005 report contextualizing the regeneration policy and its impacts, "Regeneration in Context."

The company's second round of work builds on the first, exploring policies promoting "social inclusion" through *(dis)connected*, a project comprising two main elements, "an intergenerational training programme for local people, resulting in a legislative theater performance event; and a satirical, site-specific, professional cabaret animating a de-commissioned library."

In describing her work at a theater conference in 2004, Thornton quoted from the manifesto of a 1930s political theater company, asserting artists' social responsibility in terms almost identical to Stuart Davis's exhortation to the 1936 American Artists Congress quoted in Chapter Five: "The theatre must face up to the problems of its time; it cannot ignore the poverty and human suffering which increases every day. It cannot, with sincerity, close its eyes to the disasters of its time."[28]

Support for this strongly political work comes from a variety of public agencies, including the regional arts agency, Arts Council England North West, neighborhood and housing associations and development-oriented sources such as the European Regional Development Fund, the Urban Cultural Programme and the Liverpool Culture Company, some of which are very much behind the regeneration strategy, but still evidently amenable to arts work that interrogates its assumptions. There is every indication that support will be renewed, and at this writing, with a brief track record, Thornton is applying for three-year funding from available public sources.

Where there is public support, there is often also a much higher level of support for networking, research, and other elements of field infrastructure. For example, the New Belfast Community Arts Initiative is a multifaceted partnership among public agencies, community arts groups, education and civic organizations, supported by funds from the European Union, the Belfast City Council, the Arts Council of Northern Ireland, a public education part-

28 Howard Goorney and Ewan MacColl, editors, "Theatre Union Manifesto," in *Agit Prop to Theatre Workshop*, Manchester University Press, 1986 p. ix.

nership and a couple of foundations. Initiatives carried out under its auspices by the ten groups that are part of New Belfast's consortium include a collaborative public sculpture depicting Belfast communities, an extensive poetry project producing anthologies of young people's poetry, a citywide fashion project, a mural project, a performance project focusing on mask, costume and float-making suited to community carnivals and festivals and a project engaging people in making short films.

Projects like this have multiplied across Europe as new resources have been made available for community development, because European funders generally accept culture as an integral aspect of development. There is often an element of civic boosterism: in March 2006, New Belfast sponsored a day-long series of workshops and performances entitled "Century City: A Showcase of Arts and Creativity in Belfast." New funds to address social problems are part of the mix: Belfast, long torn by sectarian violence, has in recent years received millions of pounds from the European Union Programme for Peace and Reconciliation (although community artists are worried because the current allocation is due to end in 2007). As one experienced community artist told me, with the advent of Tony Blair's Labour government in 1997, "There was a fairly massive shift toward acknowledging the importance of participation in the arts." The work of community artists is widely seen as an effective way to promote social participation and involvement for marginalized groups, as reflected in the way practitioners describe their work. This is from New Belfast's website <www.newbelfastarts.org>:

New Belfast Community Arts Initiative is a cross-community partnership of community arts development agencies and community artists and trainers from across the city.

We advocate, through the medium of community arts:
• Reconciliation between fragmented communities
• Providing the maximum possible inclusiveness, capacity-building and regeneration towards self sufficiency
• Sharing skills and resources
• Creating sustainable structures for the emergence of a New Belfast
• Targeting areas of greatest social and economic need
• Focusing on common aspiration and shared humanity
• Challenging sectarianism and traditional territorialism, through cross-community contact and facilitation
• Promotion of social inclusion and cohesion

New Belfast Community Arts Initiative is a member of the Belfast-based Community Arts Forum (CAF) <www.caf.ie>, formed in 1993 as a network and advocate for community artists, organizations and local authorities active in the field. It has more than 180 affiliated organizations and more than 120 affiliated community artists. This is from CAF's website:

> Situated in the heart of Belfast in the Cathedral Quarter, CAF is the natural first port of call for individuals, community groups and statutory agencies throughout Northern Ireland wanting to know more about community arts. We operate an open door policy and provide a warm, friendly welcome and a wealth of knowledge, resources and expert advice.

CAF maintains a database, publishes a directory of groups and resources, publishes a newsletter, offers training and consultation, conducts research and maintains a website and library. Its program description says that "We have been directly responsible for assisting over 100 locally-based community arts organisations into existence."

This is in a region with a population well under two million (roughly comparable to Nebraska), occupying 5,000 square miles (roughly the size of Connecticut). With a comparable degree of cultural provision proportionate to the population, the United States would have over 20,000 community cultural development groups organized and active enough to seek membership in a field-wide forum. (In contrast, current U.S. numbers are not yet sufficient to support a field-wide membership organization.) It would be silly to put much weight on a simple extrapolation like this—perhaps the scale doesn't translate directly, and 10,000 or 30,000 would be the magic number instead. Either way, simply stated, this gap illuminates the difference between a community cultural development field with active, substantial public sector subvention, and one without.

So does a look at individual groups' experience. Portland, Oregon's Sojourn Theatre resembles Collective Encounters in many ways, particularly in their shared focus on community engagement and commitment to aesthetic exploration. The company formed in 1999 and established its home in Portland the following year. Its mid-thirties artistic director, Michael Rohd, sees Sojourn as an ensemble theater whose work engages community. "As part of our personal journey as artists," he told me, citing as influences avant-garde artists such as Ping Chong and Pina Bausch, "we are interested in exploring innovation and making strong theater."[29]

29 In conversation with the author, March, 2006. Unless otherwise noted, subsequent quotes by Rohd are from this conversation.

Sojourn uses multimedia and different forms of engagement with audiences in deconstructing stories, so that the resulting work is often fragmented, with multiple layers and perspectives. "Historically," said Rohd, "a lot of work has been about honoring and voicing parts of a community that aren't heard in the dominant culture, celebrating that. That's part of our work, but it's not didactic. We're consistently trying to complicate issues, not putting forth a political point of view that must be heard. We don't look for subjects, themes or stories where we already know what we think about them. If figuring something out is compelling our work, we believe our work will compel others to dive into the heart of the matter."

The company's work entails two related streams. Some projects are staged adaptations of existing plays—the particular character of each production flavored by interaction with community members before the production is formalized and mounted—such as Durrenmatt's *The Visit*, performed as a journey, ensemble and audience moving through several spaces within a high school building, or Molière's *Tartuffe*, done in 2001 as a "response to the United State's post 9/11 political and culture climate." Others are civic engagement projects focusing on policy questions, such as the "Witness Our Schools" project on

Sojourn Theatre's "The War Project: 9 acts of determination." Photo by Steve Young, April 2006

public education in Oregon mentioned in Chapter Two: Unifying Principles, for which ensemble members conducted extensive workshops and interviews, then crafted a piece of documentary theater incorporating citizens' views. The "Witness Our Schools" project performance and dialogue toured the state, including a special performance at the Capitol for the State Legislature.

Sojourn's spring 2006 focus was The War Project, described on the company's website <www.sojourntheatre.org> as focusing on "how our nation chooses to go to war, who chooses to serve, and the connection between these conversations. It's a partially interview-based, poetic investigation of democracy and the most significant choice we make as a citizenry—what do we kill and die for?" In a program note from the company to audience members, Sojourn's intention was characterized this way:

> Perhaps our unstated mission, our goal, is to make a space where our curiosity moves into a public space to become your curiosity. That our engagement becomes your engagement. That what compels us, compels you.
>
> Not to agree, or take a certain action, or see the world the way we do, but compels you to connect for these minutes we share with the heart of the matter. And with each other.
>
> Today, it feels like there are few public spaces where that occurs.
>
> We aim for our theater, the place and the art, to be such a place.

In contrast to England's Collective Encounters, however, only small grants are available from state and local arts agencies, and after six years, Sojourn won its first small National Endowment for the Arts grant in 2006. Sojourn's projects have been well-received, visible and highly participatory, attracting significant support through private foundation-funded initiatives, all of which are time-limited and mostly non-renewable. Sojourn's track-record is strong, making its prospects as good as any U.S.–based group's, yet when I asked Rohd how it felt to look ahead to the prospect of replacing expiring grants, this was his answer: "Terrifying."

MORE ABOUT MONEY

Community artists will continue to be creative, resilient and resourceful, no matter what the funding climate. But in other parts of the world, they will be able to invest their most creative energy in building community relationships and carrying out projects, while in the United States, unless a campaign for democratic cultural policy kicks into high gear, a remarkably large proportion

of that energy will likely be spent finding financial support.

There are both narrow and wide definitions of the scope of financial need. Narrowly defined, community cultural development is a phenomenon of great, demonstrated promise, perpetually under siege. A strong argument can be made that surviving practitioners should be supported so that their influence can continue to spread. But the wide view of the field's scope is much more exciting: the aims of the field are nothing less than the enlivening of democracy in the face of globalization, the realization of pluralism, participation and equity. In relation to these aims, what's currently supported—the surviving remnant of the founders' generation and the most determined of the younger generation—is minuscule. Compounding the obstacles described at the head of this chapter, funding policies play a significant part in keeping the U.S. field underfed.

In a climate of funding scarcity, competition discourages the cooperation, networking and commitment to common cause necessary to solidify a field. Almost all of the U.S.–based community artists I've spoken with define their circle of connection rather narrowly: they name as their colleagues other theaters using Boal's methods, or other theaters focused on community engagement, or other public art programs. Crossing discipline boundaries to find support, comradeship and advice sounds like a good idea, but thus far, most of the time people get together this way, it's because a grantmaker or its surrogates decide to convene the multidisciplinary beneficiaries of a particular funding program. Unless someone with resources makes it happen, there aren't enough hours in the day for practitioners to do more than raise funds and maintain programs. Those who master this economy often find that the exigencies of fundraising encourage organizations to present themselves as unique, to the point that a few treat methodology almost as a form of proprietary knowledge. Success in this climate tends to swell existing organizations rather than encourage the proliferation of new ones, even when the latter strategy would be more in keeping with both the public interest and the values of the field.

As noted earlier, commercial cultural industries and academia often seem to young artists more attractive options than the realm of nonprofit arts organizations, which seem to entail a life of struggle and material deprivation. Given this tendency, it is remarkable that community artists report inquiries from large numbers of young people attracted to community cultural development. The challenge is to make meaningful room for these young people in the field, because there are too few existing groups and too few resources in the current configuration to employ them. Unlike the situation in the 1970s, support has not been easily available to young people to start their own orga-

nizations—despite the fact that doing so would advance even some establishment-arts aims.

For instance, one of the great obstacles to increased arts funding in the United States has been the participation barrier. There is simply a limit to many public and private funders' willingness to subsidize what benefits a privileged audience (although the income gap has largely been filled by individual donors and patrons). The audience for red-carpet arts institutions has remained largely white, middle-aged and older, educated and prosperous, despite elite arts institutions' substantial, continuing investments in "audience development" strategies, looking—as their European counterparts did in the 1960s and 1970s—for a magic formula to sell their offerings to ordinary people. Will busing them to performances work? Will they respond to discount passes to museums? Will high-profile advertising campaigns do the trick? Not so far.

Meanwhile, community cultural development practitioners have adopted the opposite strategy. Instead of trying to persuade the audience to change, they recognize that the form, content and aims of the artwork must change so that they matter more to the audience.

As a result, while the bulk of U.S. arts funding goes to establishment institutions, it is community cultural development work that is most often trotted out at legislative hearings to justify cultural subsidy. To people in non-arts fields, it is community cultural development that makes the most convincing case for the power of art.

A key question remains: will this situation will be recognized, leading to support for the field's developmental needs, and thus to a great leap forward? This is a challenge to the field, to become irresistible, articulate and tireless advocates. Few rise to it, feeling it is hopeless. But I wonder if this is a self-fulfilling prophecy: the obstacles may seem external—funders' blind spots, public policy's weakness—but to a great degree they are cemented in place by community artists' own discouragement, leading to resignation. How would things change if this were not so?

CHAPTER 8
The Field's Developmental Needs

This chapter has a dual purpose: to summarize the community cultural development field's primary needs and to suggest several things that can be done to help articulate and fill each one. In an earlier version of *Creative Community: The Art of Cultural Development*, published by the Rockefeller Foundation in 2001, three main areas of need were put forward: internal infrastructure and exchange, public awareness and material support. These remain key, but current conditions dictate that one aspect of the support environment must be singled out for special treatment, so I begin with a section on public policy.

PUBLIC POLICY AND SUPPORT

By now, quite a few people writing from within the U.S. field have made recommendations intended to secure attention and resources, propelling the movement over the threshold of its long emergence and into vigorous maturity. If only they were enacted! Why haven't they been?

Much of the answer lies in the funding culture. I've conducted many studies of alternative and emergent cultural fields—independent media, rural arts, community cultural development and others—in each case taking part in detailed confidential interviews with a range of practitioners and supporters. Often such studies are funded by private foundations or public agen-

cies. Unsurprisingly, in virtually every case, a chief recommendation has been that funders should provide greater resources, shaping their grant programs to each field's own needs (indeed, developing them in dialogue with practitioners), making longer-term commitments to advance the goal of stability, and coordinating their efforts with other funders to avoid the multiplication of trendy, short-lived initiatives. Here is a typical comment:

> The role of a national foundation is to shine a light on something. There should be a process of bringing in other partners and this takes more time. You need to look at how the projects could be more successful and help open doors.

More than once, having faithfully recorded and collated practitioners' recommendations, I have conveyed them to funders who received them with an air of "when pigs fly" skepticism. It's not that these individuals lack dedication, or that they don't see how much good greater resources could do. To the contrary, many are diligent, honorable and caring. But they understand their own institutional systems, which are perpetually preoccupied with the problem of slicing one pie thinly enough to feed a multitude of good causes. In the U.S. public sector, it is a meager pie indeed, dwarfed by vast larders of nourishing tax cuts for the rich and high-calorie defense industry allocations. In the private sector, even the largest philanthropies are overwhelmed by the scope and depth of need, necessitating appalling trade-offs: health care or culture? Environment or the arts? The root problem lies in accepting the mindset (and resulting economic priorities) that create such untenable choices.

Reading about culture and development twenty-five years ago, I came across a story that has stuck with me ever since:

> The old man is resting in his hammock after spending the day harvesting rice. We wish to ask him some questions. The sheet of paper on the clipboard is headed "Rural Needs Evaluation Survey" and lists five "improvements" designed to contribute to breaking the poverty cycle in rural Sierra Leone. What would be his order of preference, assuming funds are restricted, and immediate help is possible with only one of the following: roads, water supply, health centre, primary school and electrification? Yes, he will co-operate; but first he wants to set us a question—if he offered to build us a house, would we choose the walls or the roof?
>
> The answer is like a bucket of cold water—awakening us to an appreciation that his lived-in world is all of a piece; that a "sectional" approach may be worse than nothing; and that we think in these fragmented terms only

because his problems are external, and indeed peripheral, to our own lives.[30]

Even if there were enough money to bake a colossal pie, the funding problems faced by the community cultural development field would likely persist because the funding culture's own imperatives supersede grantmakers' current commitment to cultural democracy. The stock-in-trade of almost all funding agencies is the devising of new, promising, trademarked initiatives, launching them with high purpose and much enthusiasm, and a few years later, watching them disappear into the graveyard of good ideas. Often programs are ended for no other reason than that turnover in a foundation's leadership or a public agency's board and staff has anointed new grantmakers who want the same chance as their predecessors to feel creative and garner attention by generating their own new, new thing.

I was once consulted on this very question by an arts officer in England who had read some of my essays on cultural policy. Her agency was about to embark on a planning process aimed at revising their funding program for community artists. Did I have any advice? I asked a few questions. How long had the present program been in place? Five years. And the one before that? About the same time. Could she pull up a list of recipients from both programs? She could. We cross-checked them, finding them almost identical—just a few changes when groups had folded or new ones come into being. When she envisaged a new program, I asked the arts officer, did she imagine the grantee list would be markedly different from these? Not really, she said. Now we've clarified your purpose, I told her: to spend time and resources coming up with a new rationale to give more or less the same money to more or less the same recipients.

She was not amused, but neither did she deny it.

We need a new basis for cultural development, one less susceptible to individual and organizational whims. In recent years, I've made it a point to insist that it is essential to push hard and vociferously for strong, democratic public cultural policy in the United States—including truly adequate funding for community cultural development work—even though the prospects for immediate success are dim. Some who perceive themselves as pragmatists think it is better to accept public sector defeat, to focus instead on working the private sector, conserving scarce energy. But I am opposed to this view on philosophical grounds—because it accepts and ratifies the fragmented, pie

30 Michael Johnny and Paul Richards, "Playing with Facts: The Articulation of 'Alternative' Viewpoints in African Rural Development," in *Tradition for Development: Indigenous Structures and Folk Media in Non-formal Education*, edited by Ross Kidd and Nat Colletta, International Council for Adult Education, 1980, p. 332.

slice view of cultural provision—and on practical ones too. My pragmatic reason is that it will take a consistent, highly public, long-term effort to change those prospects and that effort must be grounded in a sense of possibility. No matter how steep and slow the uphill climb, postponing the start will only further delay the ascent, and believing the ascent is unattainable will make it so.

The Scope of Cultural Policy

Internationally, public cultural policy subsumes many areas that affect cultural development, including at a minimum the arts, education, telecommunications, sport, leisure and recreation, historical preservation and heritage, the built environment and regulation of the cultural industries. In countries outside the United States, awareness of community cultural development as a need and opportunity is advanced through the articulation of public cultural goals, embodied in cultural policy. Virtually every country has adopted formal cultural policies, laying out public aims for cultural development and creating mechanisms to channel support to artists and organizations whose work promises to advance those goals.

There is strong international support for widely encompassing cultural policy, broad in scope, reflective of regional, national and transnational goals for cultural development, coordinating all the agencies and initiatives touching on related areas. For example, below are the five objectives adopted by UNESCO's 1998 Intergovernmental Conference on Cultural Policies for Development as part of an "Action Plan on Cultural Policies for Development" to guide member states toward cultural policy as an integral aspect of development. They are predicated on the Conference's first principle, that "Sustainable development and the flourishing of culture are interdependent":

Objective 1: Make cultural policy one of the key components of development strategy

Objective 2: Promote creativity and participation in cultural life

Objective 3: Reinforce policy and practice to safeguard and enhance the cultural heritage, tangible and intangible, moveable and immoveable, and to promote cultural industries

Objective 4: Promote cultural and linguistic diversity in and for the information society

Objective 5: Make more human and financial resources available for cultural development[31]

31 For the report and other Conference documentation, go to <www.portal.unesco.org/culture/>, click on "Culture and Development," and follow the links. The entire conference final report, including its Action Plan, may be downloaded from the site.

Each objective is elaborated with up to a dozen or more specific recommendations, touching on countless areas of public policy and subvention.

In contrast, in the United States, these areas have almost always been treated as discrete concerns. Arts policy has its advocates, mostly the operators and beneficiaries of arts funding programs, producing and exhibiting organizations and related professional associations. Telecommunications policy similarly has its core grouping of interested parties, as well as a countervailing voice from advocates of democratic communications, such as groups monitoring the excesses of political appointees to the Federal Communications Commission or Corporation for Public Broadcasting. A few think tanks have declared an interest in cultural policy, but almost without exception they have misused the rubric to describe a more narrow interest in arts policy, and their role has been almost exclusively to study existing funding arrangements and existing patterns of consumption and participation, rather than to propose new policy approaches.

That propositional task has been left to sporadic initiatives by cultural development practitioners. For example, in the run-up to the 2004 U.S. presidential election, Dee Davis, Dudley Cocke and myself, with the support of many colleagues, devised the "Artists' Call for Cultural Policy" which appears below. More than 1,500 artists and organizations endorsed this cultural policy platform, delivered to the campaigns of both major political parties. It goes beyond narrowly defined arts policy, but it is still limited, in that it focuses mainly on funding initiatives rather than other aspects of policy. (It was not enacted.)

To: Presidential Candidates

Artists Call for Cultural Policy

We the undersigned artists and arts organization representatives come from all parts of the United States and reflect the heritage cultures of every corner of the globe. Our fundamental values are freedom of expression, diversity, equity, and a belief in art and culture as a means of building mutual trust and understanding, which is our best guarantee of peace and security.

We hereby call on all parties to the presidential election of 2004 to adopt the following principles: our nation's diversity is its renewable energy source; when kindled, it lights a beacon of freedom that illuminates the world. It is clearly in our national interest to end the cultural isolationism that has been policy for two decades, replacing it with a policy that secures the role of the not-for-profit arts in international exchange grounded in a domestic cultural policy that values our own national diversity. Our nation's cultural policy

goals should include broadening public participation, telling the stories the commercial cultural industries don't tell, creating understanding among and between different peoples, and supporting the efforts of communities (and nations) to solve their problems in ways that benefit humankind.

We call on all candidates for President of the United States to support the following cultural policy positions.

Support Artistic Creation and Presentation. At the federal level, we need full funding for the National Endowments for the Arts and Humanities at US$293 million each, the equivalent of US$1 per capita. NEA and NEH grants should reflect the diversity of our nation, channeling much-needed resources to artists and organizations in both rural and urban communities, rooted in the full range of heritage cultures, and experimenting with a multiplicity of approaches to creative expression, dissemination, and community cultural development.

Support Independent Voices in Media. To balance the omissions and biases of the commercial marketplace, there should be full federal funding of at least an aggregate US$30 million for public broadcasting-related initiatives through the Corporation for Public Broadcasting such as the Independent Television Service and the Minority Public Broadcasting Consortia, those helping to create and broadcast material that serves diverse local and national interests, that give voice to diverse artists and communities, both urban and rural.

Support the Means to Active Cultural Participation for the Entire Citizenry. Unincorporated and amateur organizations make enormous contributions to our country's cultural richness. Even a modest level of expenditure—US$200 million per annum through education, recreation, and arts agencies—in support of the means to participate can make a huge difference. National policy should support publicly accessible libraries, classes, rehearsal and performance spaces, studio spaces, equipment, and material and expert assistance needed to implement the universal right to participate in the cultural life of the community.

Support Distribution Mechanisms for Independent Voices and Visions in the Arts. Even in the age of the Internet, control of distribution systems for music, film, theater, and other art works make it difficult for localized, independent, and minority cultural expressions to reach their intended audiences, those who are hungry for stories that resonate with their own experience, or who wish to learn more about their neighbors. National policy should ensure that museums and other public cultural institutions reflect the full range of our nation's cultural diversity, honoring all cultural heritages. National policy

should support non-commercial distribution mechanisms, independent of the massive commercial cultural industries, for publications, moving image media, performing arts, and visual arts work.

Create Public Service Employment for Community Cultural Development. Cuts in state and municipal spending for cities, schools, parks, libraries, and arts organizations weaken social cohesion, endangering future generations rather than inviting them into cultural participation as a right of citizenship. Our nation needs a new federal initiative to underwrite public service jobs in cultural development, staffing local not-for-profit cultural institutions with citizens who are eager to be of community service. Funding should begin at US$300 million per annum through the Department of Labor and/or other appropriate agencies, to return public service arts employment to the current-day equivalent of its pre-1980 level of US$200 million federal dollars.

Restore Arts Curricula to Public Schools. Increasingly, the study of music, dance, theater, visual arts and other forms of creative endeavor are considered expendable by hard-pressed public school decision-makers. Yet the arts enhance quality of life, engendering civic culture and enabling people to communicate across divides; they improve academic performance by fortifying cognitive skills, increasing self-esteem, improving attendance, and rescuing at-risk youth; and they enable us to tell the stories that define us, even to heal our hearts. National policy should support the return of arts education to the curriculum as an integrated, essential component of education for citizenship.

Restore the Key U.S. Role in International Cultural Exchange. Animosity toward the United States is fed by lack of knowledge of the depth and diversity of our cultures. The free exchange of stories, songs, images, and other artistic expressions is needed to foster understanding, respect, and collaboration with other nations. National cultural policy should support full participation in the United Nations Educational, Scientific, and Cultural Organization (UNESCO) and other international cultural policy and development agencies. National policy should support a depth and breadth of cultural exchange that enables our artists to provide a full-spectrum portrait of our diverse nation: there should be support to send our artists and groups abroad, and visiting artists from other nations should be welcomed as cultural ambassadors, without inappropriate barriers.

Commit to Seek Innovative Financing to Bring U.S. Expenditure for Creativity and Cultural Development to Realistic Levels. If existing tax revenues are deemed insufficient to support implementation of an adequate national cultural policy encompassing these commitments, federal policy

should call for alternate sources of revenue, such as a tax on advertising to support live performance or a tax on commercial media to support independent media.

In this new era of global communication, issues pertaining to culture will increasingly play a leading role in our geopolitical discourse, both at home and abroad. The United States Congress has recently allocated an additional US$25 billion to Iraq. If enacted, the measures described above would cost a tiny fraction of that amount and make an enormous difference at home and abroad. We, the undersigned, therefore call on all candidates for the U.S. presidency in 2004 to endorse the foregoing principles and commitments.

The Policy Climate for Community Cultural Development

While the issues covered in the "Artists Call" focused mainly on resources, the cultural policy questions relevant to community cultural development practice go far beyond funding. Indeed, the goals of cultural development and cultural democracy—pluralism, participation and equity—could not be accomplished by a platoon of community artists (even an army), no matter how hard people worked. If the social climate is not conducive to ease of cultural participation, if it does not promote sharing and respect between groups, if access to creative and learning opportunities is limited for those without private means, if freedom of expression is not vigorously protected and promoted—if these social aims are not enshrined in policy and enacted through program initiatives, subventions and regulations—then artists and groups will always be working at cross-purposes to dominant social institutions.

Policy is a promise that citizens can push government to keep. Without that push, policy commitments can be empty lip-service: it's one thing to say we believe in democracy, and quite another to actually insist on practicing it. So there's no guarantee that a nation adopting democratic cultural policy will do as it says. On the other hand, without policy—without explicit commitment to certain values and aims—citizens have little basis to hold government accountable for its practice.

Sweden has long been in the forefront of cultural policy development. Here are the top-level aims of its current cultural policy:

1. The goal of freedom of expression: to safeguard freedom of expression and to create genuine conditions for everyone to use it
2. The goal of equality: to lobby to ensure that everyone has the opportunity to take part in cultural life, to come into contact with culture and to indulge in creative cultural activities of their own
3. The goal of diversity: to promote cultural diversity, artistic renewal and

quality, thereby countering the negative effects of commercialism

4. The goal of independence: to provide suitable conditions for culture to act as a dynamic, challenging and independent force in society

5. The cultural heritage objective: to preserve and make use of our cultural heritage

6. The goal of learning: to promote the drive towards learning[32]

A comparison with U.S. cultural policy is instructive. For generations, American officials have claimed that the U.S. has no national cultural policy. For example, in a June 2005 speech to the U.S. National Commission for UNESCO Annual Conference, National Endowment for the Arts' Chair Dana Gioia insisted, as his predecessors have done, that "In general, the United States has almost no federal cultural policy, which dictates that enterprise is decentralized and diversified. It is generally left up to local communities and the private sector, where unification and standardization are not seen as virtues but as potential problems."

Gioia's assertion is impossible, of course: even if federal cultural policy is fragmented, an aggregate of numerous decisions and initiatives rather than an overall manifesto, even if it must be deduced from federal action, it is still policy. To insist, as Gioia and his predecessors have done, that the U.S. position is to let the private sector lead, so that public actions ratify private decisions, is to state quite a clear policy. In practice, claiming that it is in the national interest that public policy should follow the lead of private subsidy, without independent goals, has made domestic cultural policy a catch-as-catch-can affair, allowing the bulk of federal subsidy to be channeled to wealthy institutions, those most capable of attracting large amounts of private funding.

When anti-arts funding debates gained momentum in the early 1990s, this no-policy policy left the public sector in a weak, defensive position, unable to articulate convincing reasons why the government should care about cultural development. (Arguing that ordinary taxpayers' priorities ought to obediently follow those of wealthy arts patrons isn't exactly a crowd-pleasing platform.) Arts advocates retreated to secondary arguments—arts activity contributes to the economy, Mozart is good for babies in utero, creative problem-solving skills can be transferred from the arts to other forms of human endeavor. The weakness of these arguments led to a de facto "squeaky wheel" policy: general appropriations were cut, but the institutions most able to mobilize major political donors in their defense suffered far less from public cuts than those whose constituencies were distant from seats of power. The result-

32 The full Swedish cultural policy objectives and other information can be accessed at <www.kulturradet.se/index.php?realm=357>.

ing disappointment has meant that many community cultural development practitioners have given up on the Arts Endowment, even while they see what a positive role it might play:

> The NEA should be doing all these things we're left to try to do ourselves—proselytizing, spreading information—to educate and inspire the country. To challenge arts professionals and organizations to proceed with local and regional efforts and reinforce all this with quality criticism.

The red-herring reasons put forward by Gioia for eschewing policy also carry a clear, if obsolete, message. Embedded in his demurral (a well-rehearsed position almost identical to every NEA Chair's statements on the subject since the agency's inception) is a clump of specious reasoning that seems to have lodged permanently in the federal government's teeth: that to articulate policy is to assert centralized control, or put more baldly (and fatuously), that public policy yields state art. But in truth, the principle animating almost every progressive cultural policy today is decentralization, encouraging a diversity of expressions.

The policy positions put forward in the Artists Call or the Swedish cultural policy are quite a distance from the official U.S. stance that cultural policy is un-American, yet they are by no means extreme. Indeed, some mainstream commentators advocate a much broader view. In his booklet on cultural development, Australian author Jon Hawkes puts forward four pillars of sustainability for a healthy society:

> Cultural vitality: wellbeing, creativity, diversity and innovation
> Social equity: justice, engagement, cohesion, welfare
> Environmental responsibility: ecological balance
> Economic viability: material prosperity[33]

Then he goes on to say that:

> [R]ather than the creation of a discrete Cultural Policy, the most effective way forward is the development of a Cultural Framework that can be applied to all policy. Ideally, every activity, program, policy and plan of an entity (for example, a local government council) should be evaluated as to its likely and/or achieved impact on each of the four sustainability domains (acknowledging,

33 Jon Hawkes, *The Fourth Pillar of Sustainability: Culture's Essential Role in Public Planning*, Cultural Development Network, 2001, p. 25. The 69-page booklet can be ordered online at <www.thehumanities.cgpublisher.com>.

of course, that there is significant overlap).[34]

Hawkes proposes a list of cultural indicators that could be used to evaluate policy initiatives. His view, that cultural policy should be very broadly understood and grounded in assessments of cultural impact, is gaining strength. It is a main point of Sweden's work on cultural policy development, carrying forward the international Plan of Action emerging from UNESCO's 1998 Intergovernmental Conference on Cultural Policies for Development mentioned earlier. In fact, in his report on new tools for cultural policy and development, arguing for a cultural indicators approach, Colin Mercer makes reference to an example I also find potent, the Narmada River dam project mentioned in Chapter One:

> In India the Narmada River Sardar Sarovar dam project has caused massive displacement and hardship to the communities in the area affected. The development project was no doubt subject to an Environmental Impact Assessment in order to gain funding and formal approvals. It is unlikely, however, that there was anything like a Cultural Impact Assessment that would measure its effects on the ways of living, lifestyles, identities, value systems and beliefs of the communities affected. Such factors are crucial to the acceptability and sustainability of any development process. We have learned this for the environment, can we also learn it for culture?
>
> We often forget that the land and environment are also cultural resources in which we invest with meaning and significance, can earn a living and consolidate a sense of place, often in profoundly spiritual and cultural terms. This is not a logic that is confined to traditional societies. But how can we persuade policy-makers and planners that there are "figures" in the field of culture and development that can be just as relevant as figures relating to industrial outputs, GDP, etc. How can we persuade them that, in the longer-term perspectives of sustainability and human development, these "figures" are likely to be even more relevant and meaningful than many of the current categories of National Accounts data?[35]

In cultural policy discourse, ideas percolate up from the grassroots as often as they drift down from the academy. I can't resist pointing out that in our contribution to a 1988 volume of policy proposals by the Institute for Policy Studies, Don Adams and I made much the same proposal:

34 Hawkes, *The Fourth Pillar of Sustainability*, p. 32.

35 Colin Mercer, *Towards Cultural Citizenship: Tools for Cultural Policy and Development* (Summary), Swedish International Development Cooperation Agency, 2002, p. 5.

A cultural impact report should be part of every government process to design legislation, plan programs, or regulate public and private initiatives. When a developer proposes to tear down an old neighborhood to make way for a new shopping center or factory, the residents' cultural rights must be given standing alongside economic, environmental, health and legal considerations. When a corporation applies for the franchise to lay cable in a community and offer subscription television, the requirements of local cultural development must be brought into negotiations from the start.[36]

Every community cultural development practitioner, theorist and supporter has the opportunity to engage with questions of cultural policy, putting forward ideas, advocating change, helping call to attention a rising chorus of voices for cultural democracy. In the previous chapter, I pointed out that there are both small and large arguments for doing so. They start with that narrowest of reasons, self-interest: community artists' own need for no-strings support to make the most of their work. It's wonderful to have private-sector grants, but they come and go. To truly recognize the value of community cultural development practice requires long-term general support of the kind offered by a public sector investing in cultural development because it advances larger policy goals. When such support has been withdrawn from U.S.–based practitioners, their work has suffered, as this veteran practitioner told me:

> We always tried for one-third public support, one-third private and one-third earnings. But with what's happening with the economy and government, no matter how hard we tried, we slid to 80 percent private in 2005. Our budget's about half what it was a decade ago. That translated into salary cuts and fewer people working.
>
> If I have hope, it's in the young people. The younger ones have a better grasp on the values of the work and its politics than the older generation. But are they going to get the support? A lot of the private funders just aren't connected to the field. They have a tendency to follow the latest thinking in kind of a group-think way. It's a totally absurd situation, even for those on the inside track. It's very much closed down. I can't see how the field will make a significant leap without federal funding, but we're stalled out at the federal level.

The large reasons have to do with the global prospect of cultural democracy as a response to—an antidote to the negative effects of—globalization, as the ex-

36 Don Adams and Arlene Goldbard, "Cultural Democracy: A New Cultural Policy for the United States," in *Winning America: Ideas and Leadership for the 1990s*, edited by Marcus Raskin and Chester Hartman, South End Press, 1988.

pression of pluralism, participation and equity within and between cultures. It seems highly unlikely that the present American government will adopt a policy of cultural democracy, but a long view is necessary for advocates of any positive social change. It is good to recall that child marchers in the 1903 "Children's Crusade" of labor organizer Mary Harris "Mother" Jones did not see federal laws against child labor passed until 1938. Unions had been demanding a federal minimum wage for decades (and Britain had one since 1909) by the time the U.S. instituted one that same year. One of my deepest disappointments in following the community cultural development field for the past three decades has been seeing so many activists defer to federal intransigence and drop this fight. I hope we can pick it up again.

MATERIAL SUPPORT

Public policy entails one type of material support, government subvention. But as will by now be evident, whether the subject is public or private funding, the most pressing need perceived by U.S.–based community cultural development practitioners, a chronic problem that has become more serious over the past twenty-five years, is finding the wherewithal to continue their work. This is from the Community Arts Network's report on its 2004 Gathering:

> The impact of a shrinking funding pool goes far beyond the budgetary bottom line. Some participants described allocating so much time to fundraising that their creative work is being diluted. Some described the precarious existence of individual artist-practitioners, living with minimal or no insurance, retirement plans or other safety nets. Times are especially precarious for CCD practitioners supporting nonprofit organizations with salaries and operating expenses to meet—including several of the "elder" institutions in the field. Some described shrinking company size and shrinking administrative staff, leading to the increasing overextension of artists and administrators. Some described the curtailing of program offerings.[37]

Conscientious funders are concerned to reduce the "who you know" character of grantmaking, sometimes introducing innovations to prevent grants officers' personal relationships and proclivities from determining philanthropic choices. Nevertheless, familiarity often breeds reassurance. There is a revolving door between red-carpet arts institutions and arts funders, with individu-

37 Burnham et al, *The CAN Report, The State of the Field of Community Cultural Development*, p. 19.

als moving from jobs in producing or presenting organizations to jobs in the philanthropic sector (and back). This leads to ease of access and social compatibility.

In contrast, many community cultural development practitioners have enduring commitments to a particular region or organization, sticking with a job or group for long years, ascribing to the manners and mores of their home communities rather than the customs of the cultural-philanthropic complex. Many community cultural development groups diverge from standard corporate norms in terms of structure and management style: they may be worker-managed, make decisions collectively, assemble boards of community representatives (instead of emphasizing donors or social connections, as so many prestige arts groups do) or use idiosyncratic self-devised management systems rather than adopting the perceived "best practices" of the mainstream.

Funders' own cultural biases and blind spots have too often overshadowed the good results that should justify ongoing funding for community artists, which could release those with good track records from constant fears about survival. If funders' perceived signifiers of stability or trustworthiness are missing from a group's self-presentation, cultural differences can add up to fundraising trouble.

As noted in discussing public cultural policy, general operating support should be promoted as a critical fieldwide need. Even more than other types of arts-related organizations, community cultural development groups need reliable, ongoing support. Knowing their survival is not in immediate jeopardy frees them to collaborate with communities in an open-ended way, allowing each project's timeline and outcomes to emerge organically through collaboration. Ongoing operating support also reduces community artists' vulnerability to censorship or political attack, breaking the potentially punitive cycle whereby a group is only as secure as its last project.

Instead, the main way funders have expressed their discomfort with community artists, and thus hedged their bets, has been to channel money largely through time-limited project grants, necessitating a perpetual cycle of packaging, fundraising and repackaging that obscures the strong spine of the work, focusing attention on the superficial differences that make an attractive project package, as this practitioner described:

> One flaw in the funding system is the addiction to new projects—not supporting ongoing stuff. … My gut sense is that there's a crisis in confidence among funders about the management capacities of community-based organizations. They don't see the endowment, they don't see the cash reserves, they don't see the kind of stability they see in larger institutions they're funding. They feel

more comfortable working with organizations that look like them. They need to see that these groups are really well-run and should get support. Community-based groups are interested in accountability, so their board composition is different and they have a different relationship to fund-raising: it's just not the board's function. So we need to educate these people about what stability and good practice looks like in these smaller organizations.

Project grants are not only more labor-intensive, they lead to practices that—ironically—further shake funders' confidence in the field. Project grant guidelines often encourage inflated claims by requiring that proposed projects successfully resolve the problems or needs that brought them into being, usually within a specified time span (most often a year) and do so on the basis of measurable outcomes that can be predicted. As a result, many final reports on funded projects bear as little relationship to reality as did the proposals that got them funded. Truth-telling is obviously an option, but unless everyone practices honesty, it can also be a disadvantage: when performance almost inevitably falls short of impossible aims, "poor planning" (rather than unrealistic guidelines) is often blamed, with punishing results.

Without general operating support, funding is a patchwork of different modes and sources, often with different aims and evaluation criteria to satisfy. Fundraising occupies a disproportionate amount of time and creative energy.

The field needs to make its unique economics widely known. For example, earned income is a mainstay of mainstream arts organizations in the United States: Americans for the Arts' <www.artsusa.org> figures for overall non-profit arts' income in 2004 put earned income at 50 percent of the total, individual contributions and endowment funds combined at 35.5 percent, foundations at only five percent and government subsidy (federal, state and local aggregated) at just seven percent. Within the category of government subsidy, important sources are declining; for instance, state funding dropped by more than one-third from 2001 to 2005.

But community cultural development is different. When public funding programs such as CETA (discussed in Chapter Five, Historical and Theoretical Underpinnings) were active, they filled much of the gap created by community artists' distance from sources of private wealth. Similarly, at key points, private foundations with compatible social and aesthetic missions have provided much more than seven percent of some community artists' support. With few exceptions (mainly performing arts oriented groups that tour), earned income has not been a major source of sustenance for groups engaged in community cultural development. This is intrinsic to the nature of the work. By definition, market-oriented arts work is other-directed, focused on

producing those objects or services most attractive to buyers. It is antithetical to the process orientation and self-directed nature of community cultural development that it should be required to generate marketable products. Sometimes there is a fortuitous confluence of interests (as when the animating force behind a community's involvement in a project is the desire to tell its story to the larger world via a video, audio recording or publication for which there is ultimately a market, however modest). But as noted earlier, the labor-intensive enterprise of assisting communities in making their own cultural meanings and taking cultural action comes under the category of social goods, such as public education or environmental preservation, that cannot be market-driven.

Although their level of investment has been modest in relation to needs, the decline of public funding has thrust private foundations into the limelight as primary sources of support in the depleted U.S. field. The National Endowment for the Arts' 2005 budget of US$121 million was down forty percent (much more when adjusted for inflation) from its 1992 height of US$176 million. In contrast, the Arts Council of England had a FY 2005 appropriation equal to US$715 million. With a population one-fifth that of the United States, the disparity in funding levels is huge, with the United States attaining less than three percent of England's per capita national arts-agency funding. Adding in our state arts agencies' aggregate FY 2005 budget appropriations of US$294 million, as compared to England's massive arts lottery appropriations (£1.6 billion pounds—US$2.7 billion— to the arts since the lottery's inception just over a decade ago) along with substantial regional funding and European Union funding only increases the disparity.

Grantmakers' initiatives need to be grounded in actual conditions and aspirations of the field. A few highly visible national foundations have been involved in supporting the field at key points for time-limited initiatives. Most are associated in practitioners' minds with a particular approach, often driven more by the funder's internal culture and priorities than by systematic investigation of the field. Frequently, in exchange for funding, grantees are required to attend meetings, accept prescribed technical assistance and participate in prescribed evaluative activities, all in aid of testing the foundation's hypothesis driving the grant program.

For instance, defining the work of community artists as an extension of "the arts" per se, rather than as a distinct field, some have focused on "audience development," supporting community artists in the hope that their work will yield guidance about how to broaden nonprofit arts participation beyond existing barriers of race and class. The Lila Wallace-Reader's Digest Fund belongs in this category; the goal of its arts funding is "supporting effective,

innovative ideas and practices that bring the benefits and pleasures of the arts to more people, especially adults and children who might never otherwise experience them." Over the years, fairly substantial sums have gone to community cultural development groups to build participation, although recently, more of the Fund's resources have been channeled to mainstream institutions and public agencies.

Other foundations have supported community artists as an expression of interest in intercultural and multicultural projects. Until the creation of its Partnerships Affirming Community Transformation (PACT) program in 1995, with its emphasis on community cultural development and problem solving, this had been the primary rationale for the Rockefeller Foundation's support to community cultural development practitioners. Rockefeller's Multi-Arts Production Fund, placing high value on a diversity of cultural expressions, has supported some community cultural development projects oriented to performance. PACT itself was highly valued by groups in the community cultural development field (in fact, the 2001 edition of this book started life two years earlier as an evaluation of that program), but at this writing, except for a few grants to service groups, the program has been on hiatus since 2002.

Others have also been associated with limited-term funder-driven developments. For instance, until investing in 1999 in its "Animating Democracy" (ADI) initiative, a four-year collaboration with Americans for the Arts that awarded grants and technical assistance to 32 arts groups engaged in "civic dialogue" (including a number of veteran community cultural development groups), the Ford Foundation in the 1990s tended to invest in individual personalities. At one point Ford hitched its program to performance artist Anna Deveare Smith (a former Ford Foundation artist in residence) by underwriting her Institute on the Arts and Civic Dialogue project at Harvard for three years. As at many foundations, a turnover in program officers at Ford corresponded with a turnover in initiatives, and at this writing, ADI is no longer making grants (although in 2005, Americans for the Arts awarded substantial new grants to a dozen previous ADI recipients through its "Exemplar Program"). Meanwhile, Ford shifted comparable resources to "Leveraging Investments in Creativity" (LINC), oriented to individual artists' support.

Activists in the field find much to complain about in this picture. One theme is funders' attraction to celebrity artists and mainstream organizations, underwriting them to engage with community rather than supporting groups with demonstrated commitments to deep engagement, as this longtime community artist said:

One of my frustrations has been looking at people thinking they're inventing

this. Like all the Ford money going to Harvard, seeing if it's feasible: they think they're prototyping, even though everybody's saying, "You have people who've been doing this for years."

A perpetual complaint is the sheer volume of need in relation to available resources. Not all grants programs provide information on the number of applicants in relation to awards, but those that do indicate that a ratio of ten applications received to one funded is low, and often the ratio is double that or more. Given the scarcity of available resources, one might say the main problem facing funders is how to find reasons to reject a large number of perfectly worthy proposals. Unfortunately, given the power imbalances of this funding situation, too many of them also seem to want applicants to approve their verdicts or risk receiving black marks for bad sportsmanship.

At this writing, among national funders the Nathan Cummings Foundation stands out for its continuing commitment to arts work that advances social justice (including support for New Village Press publications, among them this book). With few visible national funders committed to community cultural development, many grantseekers' attention has turned to regional and local foundations and public agencies, which are extremely diverse in their aims and approaches. But as always, the only confident prediction to be made is that the situation is likely to change.

Suggestions for Material Support

While grantmakers and policymakers often resist advice from the field, hope springs eternal. Based on long observation of the field and countless conversations with practitioners and participants, I offer several ideas about how to transform the support picture for community cultural development.

First, despite the widespread resistance to focusing on public funding I mentioned earlier, supporters of community cultural development can begin to open a conversation on that topic by generating and exploring promising new ideas. Some funding mechanisms already in use have wider potential application. For example, the hotel and motel bed taxes levied by some municipalities tax visitors to support tourism promotion, often including promotion of local arts. Grants to the Arts, San Francisco's hotel tax fund, prides itself on awarding more money each year to local arts groups than the National Endowment for the Arts and the California Arts Council combined. Every state or municipality with substantial transient occupancy revenues could follow suit. Or consider Great Britain's National Lottery, which allocated £2 billion to the arts in its first decade; if revenues for a U.S. counterpart matched

the differential in population, they would top US$22 billion, more than 175 times the current National Endowment for the Arts budget.

Note though that none of these funds is dedicated to community cultural development per se, and community artists typically complain of receiving too small a share, even while they understand that something is better than nothing. Enlarging the pot does not necessarily help to correct for biases or blind spots in how it is divided.

The most exciting ideas turn on taxing commercial culture to support new noncommercial creativity. For example, a small tax on advertising revenues: a penny on each dollar spent to place advertising in the media and on billboards would yield a minimum of US$1.5 billion, twelve times the current National Endowment for the Arts budget. A small tax on movie tickets to support independent production or on blank recording media to support live non-commercial musical projects would also generate substantial revenues. The thinking that taxes enormous commercial cultural profits to benefit smaller, live and diverse creative efforts makes familiar sense, like taxing automobiles at the gas station to support public transportation. The underlying idea, that there is a public interest in cultural development that outweighs commercial industries' wish to retain all their revenues, is a mainstay of public policy. So what stands in the way? The power of the commercial cultural industries, with their legions of lobbyists and campaign contributions resisting all new taxes. Addressing the general problem of lobbyists' power of the purse through campaign finance reform would help here as with so many social issues; so would mobilizing a popular constituency substantial enough to counter the commercial cultural industries.

Moving on to private support, grantmakers can make many improvements. They should provide multiyear grants and general operating support, rather than stressing only project support. Indeed, several of the short-lived initiatives mentioned above offered two- or three-year grants while they lasted, a happy sign that there had been learning from experience. Every sector of nonprofit endeavor that has succeeded in developing adequate infrastructure, theoretical and critical frameworks, useful training programs and real visibility has been nurtured by public and private funders providing a base of reliable support, year in and year out. Project grants may make sense for special purposes, as part of a multifarious support structure. But longer-term funding commitments are needed to develop a field that has been "emerging" for decades without ever obtaining the wherewithal to arrive.

Grantmakers with community cultural development experience should share their knowledge with philanthropic colleagues, even though this goes counter to U.S.–based funders' appetite for trademarked, high-visibility ini-

tiatives. There have been some multi-funder collaborations in the last decade among the largest arts funders. Too many of these have supported funder-generated initiatives that could not be sustained, like the recently defunct arts policy think tank, the Center for Arts and Culture. But some have been signs of evolving partnership that could help the community cultural development field.

What they have seldom done is reach out to bring new sources into the field. It is a commonplace that the urgings of peers are more likely to be heeded than the entreaties of petitioners for support. What will it take to legitimate community cultural development work in the eyes of the larger philanthropic community? Sympathetic funders can help to answer this question by examining their own learning curves and finding ways to replicate them for colleagues.

Researchers should focus on the unique economic realities of the community cultural development field, creating a body of solid information to counter the application of ill-fitting generalities to the field. Naturally, community artists would rather be funded than studied; but many studies are done and most of these omit or gloss over community cultural development because it falls between the cracks of conventional arts disciplines. Indeed, the category of "the nonprofit arts" is so large and so strongly skewed by the dominance of prestige arts institutions that research on the entire nonprofit arts sector has had little useful application to the community cultural development field. Several approaches would help:

—Grantmakers should ensure that arts-related studies they help to fund make allowance for community cultural development practice. Designers of such studies usually assume that "the nonprofit arts" is a useful, all-purpose category. Because researchers have little experience with community artists, they don't even know what they are missing. It might be necessary to predicate grants supporting such studies on the guarantee of a more nuanced treatment of the nonprofit arts sector, one that explores useful distinctions within it; or to provide supplemental funding earmarked for the express purpose of adding a treatment of the community cultural development field to a study originally designed without it.

—Grantmakers should also underwrite new, tailor-made documentation and research into community cultural development history, theory and practice. A few decades of experience in the field and a great many conversations with practitioners may have led me to reliable conclusions about the field's conditions and needs. But most people have little or no access to the range of work and experience I've been able to observe. Part of the legitimation of community artists' work will be investing the resources and attention needed to study

them just as other elements of cultural activity are studied, beginning with adequate support for community artists' documentation of their own work.

—Grantmakers should allow well-considered research and genuine dialogue with members of the field to define the shape and direction of their support programs. Often, there has been some form of consultation by foundation or public agency staffers with their own grant recipients, but the desire to obtain future grants distorts such encounters, frequently limiting truth-telling to what seems politic. Internal training and dialogue opportunities for funding-agency staff members would help; presentations could be tailored to agencies' own priorities and focus, for example, stressing community cultural development in particular regions of the world or in the framework of particular aspects of community development.

The preceding recommendations rely on resource providers' goodwill. Community cultural development practitioners can help to elicit it by pressing strategically for what they want. Are there ways community artists can come together to help funders break the project-grant addiction? Case studies, presentations at grantmakers' meetings, special sessions with grantmakers—is there anything that can be done to influence funders away from the preoccupation with novelty and "sexy" packaging of projects and toward more realistic, reliable modes of support? How can community artists make funders aware of oversights in the way research is conceptualized and carried out?

There is a predictable caution about biting the hand that feeds, so perhaps a coalition of the most established and best-funded groups can together put forward critical and propositional messages, insulating themselves from backlash with a united front. Or perhaps this task will fall to commentators and mediators like myself who are not reliant on grant support.

INTERNAL INFRASTRUCTURE AND EXCHANGE

In the past, national organizations have been created with the aim of convening community cultural development practitioners to develop common language and theory, share experiences and pursue collective aims, as one experienced community artist pointed out:

> The chance to communicate about obstacles and solutions is really important, the chance for cross-learning. In the early days of [Alternate] ROOTS, people were working in isolation. That's what it's like nationally now. There needs to be training, since community cultural development implies certain methodolo-

gies, approaches and values. It seems to be a trend or a hot-button issue among funders: people are jumping on the bandwagon without having any notion of what the issues are. I don't want to restrict support to those who've been doing it for the last twenty years, but I do want there to be a sense of standards.

The organization most frequently mentioned in interviews with veteran U.S. practitioners carried out for this book was the Alliance for Cultural Democracy (ACD), formerly the Neighborhood Arts Programs National Organizing Committee (which Don Adams and I directed from 1979-83). ACD always struggled for survival and is no longer active as a national organization. Most speakers who cited the organization were referring to their own involvement in the 1980s:

> I got so much out of being on the Board of the Alliance for Cultural Democracy. I'd get so rejuvenated from the meetings—the networking, the ideas, funding suggestions. People would come from everywhere.

Other interviewees (like the one quoted a few paragraphs above) mentioned Alternate ROOTS, which has continued to provide similar common ground for practitioners in the performing arts, particularly in the southern United States. ROOTS' "Community Arts Revival," held in Durham, North Carolina, in January 1994, brought together leading practitioners and theorists from across the country, demonstrating the possibility and value of such gatherings. A meeting of the Rockefeller Foundation's PACT grantees in October 1998 was mentioned by several practitioners. The National Performance Network, a partnership of artists and organizations that annually convenes members including community artists, was mentioned by a couple of interviewees. The Animating Democracy Initiative repeatedly convened its grantees for learning and dialogue over a four-year period. A core group of practitioners and theorists came together in 2004 for the Community Arts Network Gathering referenced earlier.

CAN's report on that Gathering stipulated that participants "deem it undesirable (at least for now) to create a new professional organization." I feel certain this is because no one has the energy or resources to organize such a group, no matter how much they would appreciate what it might offer. Yet the field needs more face-to-face meetings of practitioners and theorists. There are many ways to communicate—and more are being introduced all the time—but so far, nothing can replace the synergy of face-to-face meetings, with time for formal exchange and debate as well as making the powerful informal connections we now call networking.

Practitioners will doubtless continue to use all available existing networks as host organisms, pulling together within larger frameworks caucuses and events that speak directly to community cultural development practitioners. This seems wise, but limited as a way to secure the space and time necessary for the type of sustained dialogue most needed. The tactic of piggybacking onto other organizations' agendas is more likely to be effective at broadening public awareness than advancing the field's internal dialogue and development.

An alternative is to build on the new hybridity discussed in the previous chapter, forming coalitions of existing organizations and networks within arts fields and beyond, so that the same initiatives serve to both solidify and broaden the community cultural development field, as this long-time activist suggested:

> I see a lot of start-ups, but they tend to be social service, organizing, labor—other areas of social activism, but using the arts. There were many such people at the National Organizers' Alliance [meeting] who wouldn't consider themselves arts organizations or artists, but they're doing this work. We need to broaden our notions of where this work is happening. We need stronger connections with people doing community animation in the broadest sense. It's a problem that the community arts idea has resided in the arts world rather than the greater social context. And it's still on the periphery of arts organizations, which are in turn peripheral to the wider society. In addition to continuing support to arts groups, encourage [community development organizations] to do this work. Over time, they'll incorporate this into how they work. Otherwise this will just remain a ghetto within a ghetto. We need to widen the notion and extent of this work, until it's included in the day-to-day, month-to-month, annual planning of non-arts organizations. Now, they usually just respond to invitations from the arts community; otherwise it doesn't come up.

Meetings are essential to create full human contact, but if real dialogue is a goal, they entail limitations of scale. No face-to-face meeting can ever serve an entire field. The field needs to sustain the broadest possible dialogue through print and online communications. Journals, websites and other methods of sharing and discussing ideas and experiences are needed.

For years, the journal *High Performance* served as the main such U.S. publication in the field. Interestingly, it began in 1978 with the intention of covering performance art; then, as its founders' interests and artists' focus began to change, reinvented itself in the late 1980s as an organ for community artists and their work. At what many in the field would call the height of its influence in 1997, the journal folded due to lack of funding. *High Performance*'s

parent organization, Art in the Public Interest (API) <www.apionline.org> teamed with Virginia Tech's Department of Theatre Arts' Consortium for the Study of Theatre and Community to produce an online community arts newsletter, *API News*.

Over the last half-dozen years, API's main project, the Community Arts Network (CAN) website <www.communityarts.net>, has expanded far beyond *API News* to become the community cultural development field's foremost single resource. While its attention exceeds community cultural development per se to include public art and other socially-conscious art projects, it is indispensable as a source for community cultural development information. Like almost every worthwhile project in the field, its fortunes wax and wane with funders' attention. It ought to be supported as an essential priority.

CAN has fulfilled some of the need for criticism tailored to the field's participatory values and diverse aesthetics, although in a perpetually embattled field, there is a strong temptation on the part of contributing writers to focus on beloved projects, stressing only their virtues and successes. To the extent that CAN serves as an entry point to the field for students and larger publics, this seems sensible: the website introduces the field's shining examples, inviting further investigation. But what about the sort of criticism needed by practitioners to improve their own work?

What values, processes and aims should shape a constructive, substantive criticism that really serves the field? Any inquiry should begin with Liz Lerman's excellent Critical Response Process with its stress on respect for the artist's intentions, which has gained wide use among performing artists in the field.[38] Beyond process, however, are vital questions of shared and individual standards, aesthetic judgment in the presence of multiple cultures and intentions and, always, the challenge of devising appropriate criteria for community cultural development processes as well as for any products they generate. As writer and dance expert Lily Kharazzi pointed out in her discussion of criticism for culturally specific dancers from many world regions:

> If their work were only seen as an aesthetic product, then the discussion would have similarities to other discourses of art critique. What is the intention of the dance? Does the choreography work? But the work of the ethnic dance artist is impossible to divorce from other factors as well, like the communities the dance exists in, or the political realities that drive artists to leave a home country, or issues of race and ethnicity that impact an art form, or visa prob-

38 Liz Lerman, *Critical Response Process: A Method for Getting Useful Feedback on Anything You Make, from Dance to Dessert*, The Dance Exchange, 2003, 64 pp., available online at http://www.danceexchange.org/store.asp.

lems that loom over artists, or a sense of responsibility that comes with the inheritance of an historical form, or the urgency in perpetuating a threatened form, or the spiritual or religious imperative in a dance. And then there is the creative drive of an individual artist who would like to stretch the tradition to create "new" work to consider.[39]

It continues to be true that the most reliable modes of criticism and evaluation are participatory, as with the "indicators of success" proposed in Chapter Six, Theory from Practice: Elements of a Theory of Community Cultural Development.

Recognizing that many community cultural development practitioners are part of an advance guard against the destructive impacts of globalization, opportunities for practitioners to exchange and learn across international boundaries is crucial. Looking back over several decades, I can point to international collaborations and exchanges as the seed stock for new techniques and approaches, and always as an opportunity for practitioners to deepen their understanding of other cultures and their issues, which in a world of multiplying identities inevitably benefits their work at home as well.

Today, practitioners aligned in a common focus (such as Theatre of the Oppressed and Playback Theatre, discussed in Chapter Six) have yearly or biennial international meetings. There are groups such as Minnesota's multiethnic Pangea World Theater that emphasize international collaboration, bringing artists from other parts of the world to the U.S.; or the Philippines Educational Theater Association, which sponsored a conference and festival of women's theater near Manila in 2003. Where there is public subsidy abroad, regional meetings sometimes bring together community artists across Europe or Africa. But such gatherings are unequally distributed, and there are not nearly enough opportunities for U.S.–based practitioners to take part.

Suggestions for Internal Infrastructure and Exchange

Infrastructure costs money, so funding is critical to building the field. There are many ways to support community artists' participation in meetings. Small stipends can be made available to community artists to attend, caucus and offer presentations at larger meetings relevant to their work. Regional funders can work with coalitions of community cultural development practitioners to pull together gatherings in their own regions. National funders can earmark

39 Lily Kharrazi, "Dance That Comes With Family, Village, Court and the Divinities: Eleven Days with the Regional Dance Development Initiative/San Francisco Bay Area," *The New Moon*, Alliance for California Traditional Arts, February 28, 2006, available at <www.actaonline.org>.

a pool of discretionary funds for use in underwriting the most promising proposals they receive.

As noted earlier, ongoing, reliable support is also needed to sustain networking, information exchange and dialogue. Grants ought to start with organizations that have proven most successful at such publishing in the past, beginning with the Community Arts Network.

Support could enable transnational exchanges and collaborations. For example, African, Asian and American groups focused on development-related issues in rural areas could compare methods and experiences and produce a publication or website useful to their counterparts around the world. Or a joint grant could go to two community cultural development groups—say, a North American and a Central American group working in a "cultural corridor" relationship (Néstor Garcia Canclini's rubric to describe two cities or regions linked by a well-established pattern of immigration)—for a project focusing on themes of shared heritage and migration.

Because the field's infrastructure is underdeveloped, practitioners have been preoccupied with survival, often to the point of neglecting important questions, the types leading to dialogues that can deepen practice. For example, in Chapter Six, I described several of the ethical challenges facing conscientious practitioners. From what I have seen, such issues haven't received much attention within the domestic field. Should the field develop codes of conduct, and if so, what are the essential ethical commitments that such codes should reflect? This conversation needs to start.

TRAINING

As noted earlier, ongoing, practice-based training is widely perceived as both the best approach and a crying need. Many experienced practitioners active today entered this work having been trained as conventional artists while simultaneously involved in social justice movements. Clearly, they prize the type of on-the-job training through which they formulated their own approaches, and when their organizations are able to add new community artists to their staffs, they try to replicate it. But no one has been able to obtain the resources that might enable them to formalize and extend this type of training beyond the few incipient community artists who receive training as newcomers to their own organizations. Yet there are recent developments on the training front. Here's how a practitioner characterized the situation in 1999, when an earlier edition of this book was being prepared:

Training is non-existent … We're still trying to figure this out. But at the formal level, it's still really early. For example, since Paulo Freire made such a big impact back in the '60s, we're just now seeing the first critical pedagogy PhD program in 1998. It's clearly still bubbling.

Things are changing. Interestingly, within the United States, the bubbling has been most vigorous at the university level. The Community Arts Network website lists over 70 academic programs and workshops (all but a dozen within the U.S.), nearly half of them leading to degrees. Not all of these are community cultural development-focused: in fact, almost all of them have a highly specific, discipline-based focus, such as "Performing Arts and Social Justice" or "Arts Management with a Community Arts Concentration." But they are indeed proliferating.

From the field, these developments are viewed with ambivalence. On the one hand, it is thrilling to recognize that the practice has progressed to the point it is being valued by mainstream institutions. Good programs could turn out well-qualified graduates eager to join existing groups or start their own, all to the good. The proliferation of academic programs could be a wonderful gateway to needed research, and it could focus more attention and resources on community cultural development practice training by conferring mainstream legitimation.

On the other hand, community cultural development training's values and approaches should be consonant with the field's. It is challenging to design training modes that embody the democratic, participatory values of the practice. The caution that attaches to university funding or academic politics can dampen the oppositional character of community cultural development work, eventually swapping its exuberant improvisational character for formulaic or merely technical approaches. And there is the fear that the increased resources academic interest is likely to draw to the field will benefit institutions of higher learning rather than community artists. One point of virtual unanimity among practitioners is that any academic program removed from "the trenches" of day-to-day community work cannot succeed, as this veteran community artist said:

People should get together for training in critical analysis of how change happens—power analysis, cross-cultural communications, conflict resolution, problem-solving, group process. … We need more discussion of experience: what's changing? What adjustments are needed? … People are coming out of university settings, getting a conservatory approach to the craft, just focusing on your chops. [To put them into commu-

nity-development work] is really dangerous for the communities being led by these artists, dangerous for organizations working with them.

As discussed in Chapter Six, several key commitments are needed to keep academic programs on track:

• Community knowledge and practical experience should be respected as much as scholarly grounding;
• Community and academic institutions should be linked through strong working relationships;
• Experienced community artists should be engaged to advise academic programs, helping to shape and evaluate curriculum;
• Students' service learning or practicum experience should be shaped to community needs, rather than exploiting communities to serve students;
• Faculty should be strongly grounded in community cultural development practice; and
• Academic institutions should support the development of the larger field.

Continuing education for practitioners—honing skills, encountering new situations through exchanges with other organizations, finding the opportunity to pull back and engage in self-examination and self-improvement—these typical self-development activities of a field are still merely dreams to most community cultural development practitioners, including this one:

> A real lack for me are some really good vehicles to record this work, much less to talk about it, theorize. ... There are a lot, a lot, a lot of artists operating as arts entities, trying to make linkages with community people. I'm interested in conferences, publications, exchanges of writing that create this all as a thing ... to raise the level of theory, based on practice, about working with the level of difference that we're talking about—every race, class, geographic distribution, gender, sexuality.

Suggestions for Training

Again, new resources are paramount. The field would welcome funding for apprenticeship and internship fellowships to established groups of proven accomplishment for on-the-job training. Imagine a program of one-year fellowships to support individuals chosen by the applicant organizations: in most situations, US$35,000 would support an entry-level annual stipend and attendant costs. Even ten fellowships per year would dramatically expand the

field's current training activity.

Because many practitioners continue to pursue academic training in a convetional arts discipline, it is essential that programs in areas related to arts and media practice, arts administration and research include the community cultural development field in their curricula. The conceptual laziness that treats "the nonprofit arts" as a fully encompassing category extends to academia as well. Students graduated without truly encountering community cultural development history, theory and practice will go on to repeat the omission when they go to work as arts administrators, funders or researchers.

It would also help to encourage academic interest and facilitate collaborations between practitioners and academics, thus deepening both academic programs and community artists' practice. Fellowships that allow practitioners time for study would promote interaction between practitioners and the academy. Fellows could pursue such projects as a critical analysis of a group's methodology; organizing documentation and carrying out interviews or other activities in aid of writing a group's history; or research into relevant historical periods, policies or social movements. However configured, partnerships between community artists and academics will help confer legitimacy on community cultural development practice and raise academic programs' standing in the field.

I would also like to see support for professional development projects allowing exemplary groups to work together for mutual self-development. Examples might be a weeklong training institute cooperatively mounted by oral history–based community cultural development projects, to work on practical and ethical issues relating to oral history and new media; or by producers of community cultural development programs for youth, involving both young people and adult practitioners; or an exchange program between two community video projects, placing a practitioner with needed (but different) advanced skills in each organization for a period of months, resulting in reciprocal training.

The multiplication of academic programs has highlighted the lack of consensus on curriculum. Obviously, not all curricula will or should be alike: the Maryland Institute College of Art's recently inaugurated M.A. in Community Arts focuses on visual arts, the specialty of the host institution; the University of North Carolina offers a B.A. in Dance with a Community Dance Concentration; the California College of Arts' Center for Art and Public Life focuses on community partnerships; and so on. But common ideas and practices form the armature for community cultural development training regardless of the art forms involved, and community artists should take the lead in articulating these. What do practitioners need to know about action research,

group dynamics, artistic skills, community organizing and other areas of knowledge? What are the consequences of imbalances in knowledge? Where is on-the-job training most effective and where does it fall short? Where is academic training most useful? How can each be appropriately supplemented with other forms of learning? That's a conversation that needs to happen, not just between faculty members or advisors of existing programs, but throughout the field.

PUBLIC AWARENESS

In an earlier version of this book, the section on public awareness led with this assertion: "Given the basic, formative help required to solidify the community cultural development field, its most fundamental need is legitimation: its recognition as a field, with all this entails." Once again, circumstances have changed without fundamentally resolving the need.

In the intervening years, several community cultural development projects and initiatives in arts-based community development have garnered significant public attention—not becoming household words, perhaps, but appearing much more frequently on the radar of arts participants and consumers of cultural news. Large-scale projects like Cornerstone Theater's bridge initiatives of related projects throughout Los Angeles, each culminating in a mammoth production, and the Liz Lerman Dance Exchange's national Hallelujah Project have been the leading wedge, attracting publicity along with hybrid projects incorporating prominent elite art elements, like Houston's Project Row Houses. This is how the report on the 2004 CAN Gathering put it:

> The challenge, now, is to transform this situational awareness into more general awareness in these fields. In the world of business and government, this challenge would be met with a public-relations campaign to "sell" the value of this work to the broader public, but such a task would most likely be undertaken by a dedicated service organization, which the CCD field lacks at the moment.[40]

It is generally accepted that greater public articulation of community cultural development's claims—that the practice is powerful and effective, possessing its own values, standards, aims and methods, which can and should be ana-

40 Burnham et al, *The CAN Report, The State of the Field of Community Cultural Development*, pp.17–18.

lyzed, communicated and taught—will help to advance the field. But many seem to feel that this attention must be conferred by outside sources. One interviewee for the earlier version of this book made this point in relation to the Rockefeller Foundation, calling for help from a highly visible, respected resource provider:

> To become a field, this would need a lot of developmental attention in a lot of different ways…. Rockefeller has cachet, so … their recognition through convening people, naming this work, giving grants, to produce learning and circulate it, that would be of enormous help…. Anything they can do to keep the doors open, to keep the conversations open, to keep supporting those who are doing this very difficult border-crossing work is very important.

The animating idea behind greater public awareness is expanding community cultural development practice to every community. That every community should have access to empowering creative experiences, that this work should not be reserved for a lucky few—this is an article of faith in community cultural development circles. Indeed, one particularly enlightening way to look at the goals of community cultural development is to see them as making a human right of what was once considered a privilege:

> [I]ts aim is to arrange things in such a way that culture becomes today for everybody what culture was for a small number of privileged people at every stage of history where it succeeded in reinventing for the benefit of the living the legacy inherited from the dead. …[41]

Realization of this aim would require providing the means of cultural development in every community—facilities, skilled practitioners, materials and equipment and so on—making such programs as commonplace as public libraries. (In the U.S. context, where many libraries have been forced to cut back on hours and collections, perhaps it would be more accurate to say "as public libraries used to be.") The gap between the present reality and this vision of the future is a yawning Grand Canyon. To bridge it will require a huge effort to stimulate public awareness of the right to culture, which is now so obscured by denial and neglect that it is essentially invisible.

Such an effort would require skilled communications and coordination. Like the process of internal exchange described in the previous section, these could

41 From Francis Jeanson's "On the Notion of 'Non-public,'" quoted in *Cultural Democracy* Number 19, February 1982.

be undertaken by an overarching organization created to solidify the field or—if it is true that the will and resources are not present to support such an organization at the moment—by multiple groups working in concert to guide a joint campaign. But it is a stretch to imagine even this being accomplished as a voluntary, decentralized add-on to the work of existing community cultural development practitioners, whose hands are full with the tasks of surviving and making their own direct community work as effective as possible with too few resources.

Suggestions to Expand Public Awareness

Focused efforts to legitimate a field can bring public recognition and influence. An example from the museum field is instructive. In 1988, when the Rockefeller Foundation focused its considerable influence on intercultural relations and multicultural development, its Arts and Humanities Division cosponsored two major conferences with the Smithsonian Institution on "The Poetics and Politics of Representation," specifically highlighting museum practices in exhibiting non-European cultures. *Exhibiting Cultures*, the 1991 Smithsonian Institution Press volume that emerged from these gatherings, is still considered one of the most influential texts on the subject and is widely used in museum-education and curatorial-training curricula. It has helped immeasurably in increasing the cultural sensitivity of museum practice and has also legitimated important voices that would not otherwise have influenced that field.

In similar fashion, supporters of community cultural development (singly or jointly) could convene a series of meetings aimed at consolidating lessons learned from the last four decades of practice and producing a similarly influential publication. Possible cosponsors include educational institutions, major foundations, regional arts agencies or community development–oriented think-tanks. Such an effort could start with a representative planning group to develop a framework, participant lists, cosponsors and publication partners, then move into wider participation.

The earlier discussion of training is relevant here as well. Acknowledging and including the history and accomplishments of the community cultural development field in related curriculum and research will expand visibility. This would also serve as an effective reality-check against ivory-tower distortions. Too often, academic departments privilege a certain sector of relevant professional fields, as if all visual arts students will become successful gallery artists, all theater students will find work in New York or regional repertory, all media-makers are headed for successful careers in feature films, all arts

administrators will fill cozy niches in major institutions organized on the corporate model. As noted earlier, omitting community cultural development from curriculum denies students potentially useful information about alternative modes of creativity and livelihood; it also tends to perpetuate the field's marginality, as lack of acknowledgement begets future neglect.

An encouraging aspect of the new hybridity is an upsurge in collaborative projects introducing and demonstrating the strengths of community cultural development practice to activists and organizations in other realms. Consider the environmental health-related work of El Teatro Lucha por la Salud del Barrio, or the arts workshops at the 2006 National Conference on Organized Resistance, both mentioned in Chapter Three; or the Liverpool-based Collective Encounters' community redevelopment-related research and Sojourn Theatre's work on public education in Oregon, mentioned in Chapter Seven.

Community cultural development techniques can be instrumental for many types of organization and activism. For example, many funders invest in strengthening non-arts nonprofit agencies by supporting such activities as participatory planning, organizational development assistance and entering into strategic alliances. These suggest a natural match with community cultural development practitioners, who could animate such processes using arts and cultural media. Similarly, funding programs that address fundamentally cultural issues such as race relations could support community cultural development practitioners collaborating with grantees to bring powerful new cultural tools to their efforts. Partnerships like these, involving community artists with activists and organizations in better-networked and more visible social-change sectors, can help raise the profile of the community cultural development field as they enhance the effectiveness of social-issue organizing.

Thus far, partnerships have tended to evolve from individual interests or fortuitous encounters: someone who works at a health agency is interested in Forum Theatre, bringing it into the agency's work; a community artist is invited to speak at a scientific conference and a project is cooked up after the luncheon speeches. But collaborations could be more intentional, starting with purpose-built training and dialogue opportunities. For example, a funder could bring groups of non-arts grantees together with a range of community cultural development practitioners for a meeting to get acquainted, discover potential applications of community cultural development practice to the grantees' work and explore possible collaborations. Funding agencies with divisions in the arts and in social-issue areas would be the logical entities to support such activities, drawing on the expertise and contacts of both arts and non-arts divisions.

To promote public awareness (in addition to the other reasons laid out

earlier), everyone concerned about cultural development in the United States should focus freshly on the question of democratic public cultural policy. The times demand fresh response. The current debate is hemmed in by defeatism, expectations lowered to the point of invisibility and tired special-interest pleading by the supporters of prestige institutions. Surely, making common cause with broader publics is necessary to move the debate beyond its current narrow status as a conversation internal to the art world. No real change in cultural policy or provision is possible if ideas such as public-service employment in cultural development, supporting community artists for their roles in raising awareness of public issues and providing community cultural facilities in every locality are never seriously put forward or immediately dismissed from consideration as too ambitious for the realpolitik of the moment. Community cultural development supporters' contributions to the creation of helpful public policies is essential. It would also have the added benefit of greatly enhancing the movement's visibility, a rising tide lifting all ships.

CHAPTER 9
Planning for Community Cultural Development

Much of this book focuses on the work of small groups—community artists singly or in teams, community cultural development organizations, and so on. In Chapter Eight, I described the need for democratic cultural policy, particularly at the U.S. national level. In between the micro and macro sit communities large and small and their surrounding regions. What could community cultural development mean for them?

In every community, public officials and private citizens make countless decisions affecting their neighbors' lives. Here in the United States, certain types of initiatives come with planning requirements attached: from time to time, I receive notice of a public hearing to discuss new construction proposed for my neighborhood. Because I live nearby, law and custom require that I have the opportunity to be consulted (if not necessarily to be heeded) in considering how much more traffic or industrial pollution might affect my health and safety and how to balance such risks with promised economic advantages such as new jobs.

But my fellow citizens and I are seldom invited to consider the cultural implications of such decisions. If we complain that a new freeway will bisect a longstanding neighborhood, complicating people's access to the community centers, houses of worship or street life that have been integral to their cultural

identities and connections, who is listening? As pointed out in the previous chapter, in the U.S., we have no basis in law to demand a "cultural impact report" assessing the cultural footprint of a proposed development. There is no formal value placed on cultural rights, no standing for the aggregate of groups, facilities, opportunities and relationships some students of society have come to call a community's "cultural capital."

IMAGINE THIS

What would life be like if cultural considerations, broadly defined, were as much a part of local and regional planning as are economic concerns? I was wondering that just this morning as I walked along the water in the imaginary community of Bayside, the setting for Chapter Four: An Exemplary Tale. Spring sunshine ricocheted off the bay, electrifying a profusion of pink rockroses just bursting into bloom. A cloud of small birds swooped past, looping above the water, white wings glowing as they traveled away from me, suddenly turning black as they reversed in perfect unison. Walkers and joggers greeted each other, most of us wearing headphones, lost in our music. As I walked, I imagined.

I thought about Bayside's public library, forced by reductions in city funding to cut back on hours and services. If culture were given due consideration, the libraries would be open long hours every day, of course, with plenty of readings and storytelling hours and book groups—as many as Bayside residents needed. The computer room would be full of people who'd taken one of the city's frequent digital storytelling workshops, adding their own tales to the ever-growing archive of Bayside stories.

Our community centers would be thriving, with classes, workshops and exhibits for all ages, inviting everyone to appreciate Bayside's rich cultural diversity. Our public buildings and businesses would offer an ever-changing array of art exhibits and noontime performances. When people gathered for holidays and special events or at ongoing programs like the farmers' market, they would also have the chance to hear music, to learn about community events that might interest them and to sign up for classes.

Main Street's many vacant stores—they've been a permanent eyesore as long as I've lived here—would be offered by enlightened public officials to interested artists who would animate them as studios, galleries, screening rooms and performance spaces. There would be a great virtual Bayside art installation threading through our streets, showing where the blues clubs and other gathering-places of a once-vibrant culture stood; passers-by could interact with

sound kiosks, stopping for a moment to hear a story of music and social life in Bayside in decades past. An outdoor concert series at the civic center would remind people of what they'd been missing, and eventually, launch Bayside's music-driven nightlife revival.

As such initiatives brought people back downtown, restaurants and shops would begin to fill the long-disused spaces. But even years from now, here and there the City would support storefronts dedicated to community cultural development, where local people could drop in to create digital stories, contribute to Bayside's local history archive, or to access online repositories of local cultural material for their own use.

Bayside would have a great tradition of town meetings, and a roster of town artists and organizers to help make them fun and productive. When there's a big question to be considered—like the proposal to let a new big-box store be built within city limits—we'd have many ways to engage people. The community corps of teenagers would have after-school jobs administering questionnaires to their neighbors to get useful information about how new proposals are perceived and what should be done in response. There would be video booths in strategic locations like the library, where people could record their views, and these would be edited at the local community-access video center into discussion-starter tapes we can use to stimulate dialogue at town meetings. Public officials would take part because their constituents demanded it; they would know that accountability is a requirement of public service. (If they forgot, they shouldn't be surprised to see their homes on the evening news, picketed by giant puppets or serenaded with a musical parody.)

Bayside's town artists would have public service jobs helping people with whatever their communities need: designing a community garden, creating a mural or monument, turning public housing into someplace attractive, safe and distinct, creating a neighborhood newsletter or a holiday pageant.

Our public high schools would have good working relationships with some of the cultural industries based in this region, so that local young people could get a head start on careers as engineers, sound recordists, animators and the like. Small start-up companies would begin to find Bayside a good place to locate, prizing its affordable space and enthusiastic skilled workers.

Bayside's cultural climate—its close attention to cultural values and meanings in nurturing a vital, welcoming community that promotes participation—would inspire the leaders of institutions and organizations within the larger community. So when the Boys' and Girls' Club wanted to learn more about how involve Asian and Latino immigrants' kids, they would enlist community artists in engaging immigrant families. They'd set up a wonderful booth at the Cinco de Mayo celebration, where kids could come to draw

pictures of their favorite pastimes or try capturing each other in digital video. While the kids played, the parents would talk. The Boys' and Girls' Club would work with the childcare providers at neighborhood health centers, engaging kids and parents in art projects during waiting time for appointments and tests. When they had visual and audio documentation of their findings, they'd invite neighborhood families to an indoor picnic to share the information and talk about the kinds of programs that would be most welcome.

And if the state education department were to back funds for art and music classes, the entire community would mobilize, collecting signatures for an initiative campaign, planning a "children's crusade" costume parade in the state capital, and working with young people to create giant graphics. Creative shame would prove so effective (and so conducive to TV and newspaper coverage) that the Bayside Cultural Coalition would start a trend. Then, when anti-immigrant forces tried to promote a ballot proposition to eliminate multilingual information at state offices (where people register to vote, obtain driving licenses and so on), Bayside folks would spearhead statewide opposition.

All of these things would enliven Bayside's commitment to cultural democracy—pluralism, participation and equity—improving the life of every neighborhood and every resident. Integrating cultural values into planning would transform community life, creating opportunities for everyone.

Every community is different. What is your vision of the transformation of your own community? If you have trouble bringing it to mind, consult some useful resources. For instance, the "Culture Shapes Community" website <www.culture-shapescommunity.org> is an interesting source of real-world examples, although not every case cited there fits my own sense of community cultural development.

CULTURAL PLANNING AND CULTURAL CITIZENSHIP

Whether we are talking about a multinational organization or a single institution, bringing community cultural development consciousness to planning is a huge step toward cultural democracy, with great promise for improving quality of life and social relationship.

If you are interested in closely detailed discussion of the instruments and methods of cultural policy (including planning), I highly recommend Colin Mercer's study, *Towards Cultural Citizenship: Tools for Cultural Policy and Development*, created under Swedish auspices to improve "Tools for the Planning, Reporting and Assessment of Cultural Policies for Human Development." I very much like the way Mercer conceives cultural planning:

[C]ultural planning does not mean the "planning of culture." Rather, it means ensuring that cultural considerations are present in all processes of planning and development. It has been defined as a "strategic, integrated and holistic" approach to cultural resources in the context of community development and planning and, while initially formulated and applied in urban contexts, its underlying philosophy is an "anthropological" approach to cultural resources that links them to broader agendas for economic development, sustainability and quality of life.[1]

Within the framework of Mercer's study, which is directed toward national and transnational public cultural ministries and the like, a main challenge is how to describe, inventory, assess and improve the conditions leading to "cultural citizenship," meaning all the ways that people understand, claim and assert their distinct identities within the society. At one point, Mercer characterizes these as "vectors of connection and translation between culture, identity, lifestyles, values and the economic and social systems in which they take shape." More concretely, cultural citizenship comprises the extent to which institutions, events and activities are grounded in cultural identities, promoting mutuality of understanding and appreciation between cultural groups; the extent to which artistic expressions rooted in a particular culture are visible and integral to a society's cultural industries and communal life; the extent to which a minority cultural identity may be freely expressed and shared in public contexts and public discourse; and the extent to which these things matter to policymakers and ordinary citizens alike.

Are we all equally welcome in our society? Does what matters to each of us matter equally to our society? Does our well-being, our multiple belonging, count for as much as the feelings of others, especially the inheritors of power and entitlement?

For example, in the United States, despite its rich and multiplying cultural diversity, members of minority cultures typically report a shared experience: the mingled ecstasy and discomfort they experienced in childhood on the rare occasions when a positive element of their own heritage cultures commanded a few moments on national television.

I vividly remember my grandmother weeping in front of our little black-and-white 1950s TV each year when variety show host Perry Como (who was not Jewish) put on a yarmulke and sang *Kol Nidre*, a sacred Yom Kippur melody, during his primetime show each year. It took me some time to under-

1 Colin Mercer, *Towards Cultural Citizenship: Tools for Cultural Policy and Development*, The Bank of Sweden Tercentenary Foundation & Gidlunds Förlag, 2002, p. 7.

stand that her tears had two sources: the pleasure of experiencing familiar and touching music in a highly public (even "all-American") context; and pain that this happened so rarely, perhaps no more than once each year.

My father served in the U.S. Navy during World War II; he and my grandparents proudly became citizens, taking care to vote in every election. Yet in the privacy of our own home, when speaking of our neighbors, we casually called them "the Americans," understanding that was an identity we would never be entirely welcome to inhabit.

I was born in this country, unlike my father, and I'm certain that to the casual observer, I present an image of utter assimilation. But my heart pounds when I feel impelled to remind colleagues that a glance at the Hebrew calendar before planning major conferences would avoid the offense of scheduling them on the holiest day of the year for Jews; or when I am called upon to help a young friend protest his school's decision to schedule Homecoming on Yom Kippur. Coldly calculated, I am fully a citizen, but the fullness of cultural citizenship is denied; indeed, the question of cultural citizenship is not even in the minds of those who unthinkingly shape my experiences of exclusion.

How much more so for my Latino neighbors, who have limitless opportunity to see actors of Latin American heritage portraying gang members and drug-runners, and almost none to see portrayals reflecting their own experiences and cultural values! How much more so every year, when our local police tangle with people on the street during Cinco de Mayo celebrations of Mexican independence, arresting numbers for jaywalking or drinking in public!

How much more so for my Muslim neighbors, who every day must face pervasive fear and mistrust which has nothing to do with the actuality of their own social roles, their own desire to live in peace?

How much more so for my Pomo Indian neighbors when I lived in the northern California countryside, whose traditional grounds for the gathering of basket materials were flooded to make way for a man-made lake, without even lip-service to their cultural rights! How would your community be different if the same presupposition of cultural citizenship were given to every person as to its wealthiest citizens?

THE BASIS FOR CULTURAL PLANNING

Whether planning is undertaken by a public authority exploring some communitywide initiative or a single agency or organization seeking guidance for its own work, some essential elements are needed.

Aims and Indicators

Planning needs a framework. What are planners aiming for? How do they know if they find it? In Chapter Two: Unifying Principles, I put forward values unifying the community cultural development field: active participation, diversity, equality of cultures, commitment to culture as a crucible for social transformation, prizing cultural expression as a process of emancipation, an encompassing understanding of culture, and valuing artists as agents of transformation. An even briefer list appears in a capsule definition of cultural democracy: pluralism, participation and equity. How can such values be translated into practice guides, yardsticks that can be used to assess ideas and actualities against aims?

City planners and policymakers talk of "social indicators." For example, some of the United Nations' social indicators of health are life expectancy at birth, infant mortality rate and child mortality rate. In old-school social science, indicators tend to be concrete factors that can be directly translated into statistics. Increasingly, though, in other arenas as with respect to culture, researchers and policymakers are recognizing that this type of "hard" data cannot successfully convey the richness and complexity of human societies. They are learning what community cultural development practitioners have always known, that if we are going to devise social arrangements that make it possible to meet each other fully and create collective well-being, it is necessary to interact, to talk openly and listen deeply, to include subjective feelings as well as whatever can be counted, weighed and measured, and that both "hard" and "soft" information must be given equal weight.

This learning has been slow and halting, impeded by conceptual obstacles. Tom Borrup, a writer and consultant on community development grounded in culture, has observed that the gap between community development and culture persists:

> I have also found that many of those in the community-development profession who have embraced an asset-based philosophy and who are personally inclined towards the arts still keep the two separate in their own lives. Arts-and-culture practices and institutions have largely remained apart from community-based work. Art remains something separate from the daily work of community building or community organizing. It's almost like seeing one as work and the other diversion, albeit meaningful diversion. This has come about partly by the elitist positioning of arts and culture by its advocates, and by the long-dominant Eurocentric cultural institutional models in America.

Substantial bridges between art and community building have still not been built, intellectually or institutionally. This asset-based paradigm shift still has not been made in the arts but in isolated circumstances. [2]

As Borrup notes, an important dimension of this discourse focuses on "asset-based" planning, seeing a community as a rich trove of abilities, resources and meanings rather than a collection of problems and deficiencies. An underlying idea is "social capital," popularized by Robert Putnam in his 2000 best-seller *Bowling Alone*, but first introduced in the 1960s by Jane Jacobs, who wrote in a wonderfully deep and nuanced way about the life of cities. I like this economical definition from Helen Gould of London's Creative Exchange:

> Social capital is the wealth of the community measured not in economic but in human terms. Its currency is relationships, networks and local partnerships. Each transaction is an investment which, over time, yields trust, reciprocity and sustainable improvements to quality of life. [3]

Gould goes on to point out the intrinsic relationship between culture and social capital:

> At its simplest, culture is itself a form of social capital. When a community comes together to share cultural life, through celebration, rites and intercultural dialogue, it is enhancing its relationships, partnerships and networks— in other words, developing social capital. Conversely, when a community's heritage, culture and values (in all their diversity) are overlooked, social capital is eroded, since it is often within these roots that the inspiration for people to act together for a common purpose can be found. [4]

How, then, are we to know whether culture as social capital is thriving or eroding? There has been a great deal of discussion of "cultural indicators" in recent years. The following division of indicators into four parts synthesized by Mercer from quite a few experts' work makes sense to me:

2 Tom Borrup, "Toward Asset-Based Community Cultural Development: A Journey Through the Disparate Worlds of Community Building," Community Arts Network Reading Room, <www.communityarts.net>.

3 Helen Gould, "Culture & social capital," in *Recognising Culture*, François Matarasso, editor, Comedia, the Department of Canadian Heritage and UNESCO, 2001, p. 69.

4 Gould, "Culture & social capital," *Recognising Culture*, p. 71.

1. Cultural Vitality, Diversity and Conviviality

Measuring both the health and sustainability of the cultural economy and the ways in which the circulation and diversity of cultural resources and experiences can contribute to quality of life. Indicators in this set should evaluate the following elements:

- The strength and dynamics of the cultural economy.
- The diversity of the forms of cultural production and consumption.
- The sustainability of the cultural ecology including relationships and flows between commercial, public funded and community sectors.
- The extent to which these factors contribute to overall quality of life and the capacity to 'live together' (conviviability).
- The existence, or otherwise, of policy settings, measures and instruments to enable and evaluate the above.

2. Cultural Access, Participation and Consumption

Measuring, from the point of view of users/consumers/participants opportunities for and constraints to active cultural engagement. Indicators in this set should evaluate the following elements:

- Access to opportunities for creation through to consumption.
- Evaluation by demographics of uses and users, non-uses and non-users of cultural resources.
- The ends to which cultural resources are used.
- The existence, or otherwise, of policy settings, measures and instruments to enable and evaluate the above.

3. Culture, Lifestyle and Identity

Evaluating the extent to which cultural resources and capital are used to constitute specific lifestyles and identities. Indicators in this set should evaluate the following elements:

- The extent, diversity and sustainability of uses and non-uses of cultural resources for lifestyle and identity purposes.
- A recognition and assessment of the reality of sub-cultures that are currently below or beyond the policy purview including ethnic, gender, regional/local and age-based sub-cultural forms.
- Inequalities by demographics, location, income, etc. of access to opportuni-

ties and resources for lifestyle affirmation.
- The existence, or otherwise, of policy settings, measures and instruments to enable and evaluate the above.

4. Culture, Ethics, Governance and Conduct

Evaluating the extent to which cultural resources and capital can contribute to and shape forms of behaviour by both individuals and collectivities. Indicators in this set should evaluate the following elements:

- Evaluation of the role of culture and cultural resources to personal and community development.
- The contribution of culture and cultural resources to community cohesion, social inclusion and exclusion.
- The contribution of culture and cultural resources to the understanding of diversity and diversities.
- The existence, or otherwise, of policy settings, measures and instruments to enable and evaluate the above.[5]

How important are such indicators? It depends. Academic and other official cultural policy experts often face the challenge of rationalizing and justifying cultural expenditure to legislators and bureaucrats who prefer their evidence quantifiable, which means using survey instruments, social science jargon and numeric assessments—the lingua franca of the government agency. In recent years, developing such indicators has become an obsession. In the eyes of foundation officers who've underwritten U.S.–based indicator projects, I've seen a passionate gleam of hope: *Now we've got them,* they seem to be saying, *this will produce the undeniable proof Congress has been demanding!*

I don't think so. My observation is that for the past two decades, legislators in this country have been operating from an a priori decision to deprioritize cultural funding. Their preferred method of refusal is to ask for quantifiable proof, as if daring advocates to spin straw into gold. So far, even when the indicators are assembled, legislators find other reasons to do what they've already decided (e.g., invoking budget crunches, competing priorities or the claims of more powerful constituencies). So while I see value in the research that has led to indicators and elegance in some of the sets put forward, I think they will serve most community cultural development advocates better as inspiration than as a blueprint for legislative action.

Cultural planning is important because it gives the members of a com-

5 Mercer, *Towards Cultural Citizenship: Tools for Cultural Policy and Development,* pp. 60–61.

munity a say in that community's development. It should be done with all the above-listed considerations in mind: vitality, diversity, conviviality, access, participation, consumption, lifestyle, identity, ethics, governance and conduct. Consulting a list of indicators or benchmarks gives planners practical guidance, a way to judge whether they have asked all the important questions and raised all the important discussions. But unless there is a specific, concrete and practical benefit in framing planning efforts like social science projects, the risk of making people feel like experimental subjects seems too great.

Bringing It All Back Home

If I were responsible for organizing communitywide cultural planning in Bayside, then, I would certainly want to do conventional research, reading up on the community through the historical record, census data, reports by various agencies; talking with movers and shakers as well as the aggrieved, all those who have made themselves visible as community leaders; and devising survey instruments that could be widely distributed to produce detailed results. I would want to inventory cultural organizations and facilities, learning how people interact with them. I would want to explore the informal networks, the traditions and celebrations, the customs and characteristics shared by each cultural group with a presence within the larger community. I would want to find out what efforts had already been made to promote cross-culture interaction and respect, and look into the way resources are differentially distributed within the larger community: who has power and who doesn't? Who has access and who doesn't? I would want to ask people what is needed to enhance their own immediate communities' cultural and social capacities.

That would require quite a few interviews, meetings and other conventional research initiatives. But it wouldn't cohere unless I also emphasized several types of participatory and action research into the health of local culture and cultural citizenship. Given my community cultural development orientation, I would understand that using a range of art forms and practices would deepen the research, yielding a much thicker description of Bayside's culture than merely reading and talking.

Here are a few examples of planning elements I might include:

- Offering people temporary use of digital or disposable still cameras or digital video to collect images of their own community, organized along thematic lines (e.g., for young people, the chosen theme might be "What helps and hurts youth in Bayside?"), the resulting images to be edited into media

that can be shared with others as part of the planning process.

• Using Forum Theatre to enact situations brought forward from the community (e.g., living next door to a crack house) and devise possible responses.

• Convening story circles to share thematic tales relevant to planning needs (e.g., times you felt honored by the community; times you felt dissed).

• Sending a video team to a local shopping street to interview people about community cultural life; transcribing and editing what's learned into an oral-history–based skit about what works and what needs work.

Every one of these initiatives would complement more conventional means of eliciting input—interviews, community meetings, questionnaires—putting a human face on cultural information and creating give-and-take between planners and other community members, a dialogue rather than a poll. They could be used by a parks department to plan a neighborhood park, by a planning commission to consider a new housing or industrial development, by a school to plan a mural, by an art center to plan next year's program, by a local newspaper to plan its coverage of a community, by an ethnic community organization or a neighborhood association to plan a campaign—in short, by any entity committed to community cultural development.

Seven watchwords for community cultural development planning (whether carried out by communitywide agencies or focusing on a single organization or project) are that it should:

— Be deeply participatory, with community members helping to shape the inquiry as well as providing the answers;

— Reflect the entirety of the community, taking care to extend a real welcome to everyone, meeting people wherever they are;

— Be multifaceted, providing a range of ways for people with different learning and communication styles, customs and comfort zones to take part;

— Use arts media as well as conventional means of eliciting response, yielding many types of information that can build a thick, accurate description of what is and stimulate creative ideas of what could be;

— Acknowledge people's participation and share the learning openly, both in process and at the end of the process;

— Be fearlessly truthful in conveying community truths to the powers-that-be without dissembling or running from healthy controversy; and

— Follow through to implementation, working to ensure that decision-makers understand their accountability and results are consonant with the process.

Assembling in constume amidst community-created sculptures for the Village of Arts and Humanities'
annual Kujenga Pamoja festival in Philadelphia. Photo © Matthew Hollerbush 2000

CONCLUSION
Time to Rise and Shine

Every person and every age may ... be said to have at least two levels: an upper, public, illuminated, easily noticed, clearly describable surface from which similarities are capable of being profitably abstracted and condensed into laws; and below this is a path into less and less obvious yet more and more intimate and pervasive characteristics, too closely mixed with feelings and activities to be easily distinguishable from them. ... [W]hat we know on this level of half-articulate habits, unexamined assumptions and ways of thought, semi-instinctive reactions, models of life so deeply embedded as not to be felt consciously at all—what we know of this is so little ..., to claim the possibility of some infallible scientific key where each unique entity demands a lifetime of minute, devoted observation, sympathy, insight, is one of the most grotesque claims ever made by human beings.[6]

Technologies rooted in the 20th century have been a tremendous boon to advocates of cultural democracy: the ease of communication and collaboration is astounding, the feeling that we are working together grows stronger every day, even between individuals who have never met face-to-face. I can honestly say I love my computer. I would probably choose it without hesitation if I had the terrible misfortune of rescuing only one object from a burning building. Yet also thanks to the development of technology, which has enabled vast applications of social-engineering principles—laws of manifest destiny, of racial purity, of industrialization, of corporate agriculture—the century that ended a half-dozen years ago was also one of vast mistakes, exacting huge costs in human and other life on this planet.

6 Isaiah Berlin, *The Sense of Reality*, pp. 20-21.

Today, I see encouraging signs that many of us are learning the lesson that the quotation from Isaiah Berlin suggests: that it is foolhardy to base a program of social change on quasi-scientific laws or principles that might be deduced from the "upper, public" level of reality—what he called the "clear layer"—when the deep, unknowable "dark layer" of human experience exerts just as much force on the course of events.

These days, I take my encouragement from the emerging global realization of culture's centrality to any hope of a viable future. This key generative theme of our epoch has been beautifully articulated by the writer Carlos Fuentes:

> [T]he emergence of cultures as protagonists of history proposes a re-elabora-tion of our civilizations in agreement with our deeper, not our more ephem-eral, traditions. Dreams and nightmares, different songs, different laws, dif-ferent rhythms, long-deferred hopes, different shapes of beauty, ethnicity and diversity, a different sense of time, multiple identities rising from the depths of the polycultural and multiracial worlds of Africa, Asia and Latin America. ...
>
> This new reality, this new totality of humankind, presents enormous new problems, vast challenges to our imaginations. They open up the two-way avenue of all cultural reality: giving and receiving, selecting, refusing, recognizing, acting in the world: not being merely subjected to the world.[7]

"The emergence of cultures as protagonists of history" has driven the last hun-dred years of human history. One has only to consider the multiplication of independent nations: at the start of World War II, there were 72 independent states; today, the United Nations' membership comprises 191. Merely listing a few of their names evokes the epic struggle for self-determination they exem-plify: Armenia, Bangladesh, Brazil, Croatia, Eritrea, Uzbekistan.

An incredible diversity of cultures has always existed. But it is in our time that they have taken center stage, become the driving force of history. It is in our time that the "dark layer" of reality—people's attachment to language, customs, community, meanings and relationships—has become a reason to live and die with as much weight in determining the world's fate as the "clear layer" of macroeconomics, strategic alliances and political agendas.

To respond to these new conditions, we need tools that relate to the whole person, that take cultural values and meanings as seriously as do these new protagonists of history.

Clearly, many different types of effort can advance social change: in a con-text of vibrant democratic discourse and action, grassroots movements and

7 Carlos Fuentes, *Latin America: At War With The Past*, Massey Lectures, 23rd Series, CBC Enterprises, 1985, pp. 71–72.

policy wonks are symbionts. But among all of these, community cultural development practice is uniquely suited to respond to current social conditions, uniquely powerful in its ability to speak to the whole person, the whole community, nurturing and supporting communities' resilience, especially in the face of globalization:

— The heart of the work is to give expression to the concerns and aspirations of those who have been silenced and excluded from social power, stimulating creativity and action, advancing pluralism, participation and equity.

— It asserts the value of diversity and fosters an appreciation both of difference and of commonality within difference.

— In valuing both material and nonmaterial cultural assets of communities, it deepens participants' comprehension of their own strengths and agency, enriching their lives and their sense of possibility.

— It brings people into the civic arena with powerful tools for expression and communication, promoting democratic involvement in public life.

— It creates public, noncommercial space for full, embodied deliberation of policies affecting citizens.

— The work is inherently transnational, with strong roots in immigrant communities and deep commitments to international cooperation and multidirectional sharing and learning.

To be allowed to do its work in the world, all the community cultural development field lacks is sufficient will, recognition and resources. In our Information Age, when livelihood depends increasingly on mastery of cultural tools and ability to provide useful service, supporting this field will also help to develop an essential new form of sustainable livelihood for community artists and organizers, one with impressive potential for growth as its efficacy is demonstrated to the many public and private agencies in a position to support community cultural development projects in their own sectors.

The effort to counter the effects of globalization is not an equal fight. The forces of globalization have virtually unlimited capital and influence on their side. Yet on the other side we have the relentless resilience of spirit that characterizes human cultures. I am betting on the underdog.

How we live depends to an astounding degree on the narratives we create to contextualize and interpret raw experience. People make art even under the most extreme conditions of deprivation and oppression: in refugee camps, prison wards, homeless shelters. Even without material resources, with only their bodies as tools, humans demonstrate wonder, agency, strength and creative power, giving meaning to the past and present, reimagining the future.

An essential task now is to mobilize those damaged by globalization—a category that encompasses most of the world—to realize and act on the causes of our suffering. Capital and influence are needed to turn the promise of community cultural development to this task. I conclude with a remark made by a veteran community artist I interviewed in preparation for this book, a simple truth we ignore at our own peril:

> Artistic practice in combination with almost any human activity increases the possibility of having depth in that human activity.

In that possibility resides almost every reason to hope for humanity. This book is dedicated to the realization of those hopes.

GLOSSARY:
COMMUNITY CULTURAL DEVELOPMENT

Action Research describes an approach of learning by doing. Community artists experiment with different ways to gather relevant material for a project, each of which produces new learning—different types of interactions, different results. In action research, studying conditions also entails collaborating with others to change them. Based on the results of early action research, a project's focus and core methods are refined.

Arts-based Community Development. This rubric has been used in several ways: to denote community economic or physical development projects centering on the work of arts organizations and enterprises within that community; to denote all arts work that shares the aim of contributing to community economic development; or very generally, as in William Cleveland's definition: "Arts-centered activity that contributes to the sustained advancement of human dignity, health and/or productivity within a community."[1]

Community describes a unit of social organization based on some distinguishing characteristic or affinity: proximity ("the Cambridge community"), belief ("the Jewish community"), ethnicity ("the Latino community"), profession ("the medical community") or orientation ("the gay community"). The word's meaning becomes more concrete closer to the ground: "the gay, Jewish, academic community of Cambridge" probably describes a group of people who have a passing chance of being acquainted, whereas many of the more general formulations are ideological assertions. As Raymond Williams has put it,

1 See "Mapping the Field: Arts-Based Community Development" in the CAN Reading Room, <www.communityarts.net/readingroom>.

Community can be the warmly persuasive word to describe an existing set of relationships or the warmly persuasive word to describe an alternative set of relationships. What is most important, perhaps, is that unlike all other terms of social organization (state, nation, society, etc.) it seems never to be used unfavorably and never to be given any positive opposing or distinguishing term.[2]

In the context of community cultural development, "community" describes a dynamic process or characteristic. There is general recognition that to be more than an ideological assertion, the bonds of community must be consciously, perpetually renewed.

Community Animation. From the French *animation socio-culturelle*, this is the common term for community cultural development in Francophone countries. There, community artists are known as *animateurs*. This term was used in much international discussion of such work in the 1970s and continues to be used by enough English speakers to appear occasionally as an English word.

Community Arts. This is the common term for community cultural development in Britain and most other Anglophone countries; but in U.S. English, it is also sometimes used to describe conventional arts activity based in a municipality, such as "the Anytown Arts Council, a community arts agency." While in this book I use "community artists" to describe individuals engaged in this work, to avoid such confusion, I have chosen not to employ the collective term "community arts" to describe the whole enterprise.

Community Cultural Development describes a range of initiatives undertaken by artists in collaboration with other community members to express identity, concerns and aspirations through the arts and communications media, while building cultural capacity and contributing to social change. Sometimes abbreviated CCD.

Conscientization, from the Portuguese *conscientizao* of Brazilian educator Paulo Freire, is an ongoing process by which a learner moves toward critical consciousness. This process is the heart of liberatory education. It differs from "consciousness raising" in that the latter may involve transmission of preselected knowledge. Conscientization means breaking through prevailing

2 Raymond Williams, *Keywords: A Vocabulary of Culture and Society*, Oxford University Press, 1976, p. 66.

mythologies to reach new levels of awareness—in particular, awareness of oppression, having been an "object" of others' will rather than a self-determining "subject." The process of conscientization involves identifying contradictions in experience through dialogue, thereby becoming part of the process of changing the world.

Critical Pedagogy is one name for the educational approach espoused by Paulo Freire; liberating or liberatory education is another. (See "conscientization," above.)

Cultural Action comes very close to being a synonym for cultural development: action undertaken through the arts for education, development and social impact. It is also employed by practitioners of critical pedagogy such as that proposed by Paulo Freire to describe educational interventions for development that make use of culture, such as reconceiving folktales to advance educational goals.

Cultural Capital. Derived from "social capital," the aggregate of cultural resources—institutions, creations, creators, relationships, knowledge, customs and so on—in possession of a given community. M. Sharon Jeannotte of the Department of Canadian Heritage has offered this more technical definition based on the work of French sociologist Pierre Bourdieu:

> Bourdieu's conceptualization of cultural capital is complex, but in its simplest terms consists of three elements: (1) embodied capital (or habitus), the system of lasting dispositions that form an individual's character and guide his or her actions and tastes; (2) objectified capital, the means of cultural expression, such as painting, writing and dance, that are symbolically transmissible to others; and (3) institutionalized capital, the academic qualifications that establish the value of the holder of a given qualification.[3]

Cultural Democracy is the term for a philosophy or policy emphasizing pluralism, participation and equity within and between cultures. Although it has roots in anti-Ku Klux Klan writings of the 1920s, it did not come into common usage until introduced as a policy rubric in Europe in the 1960s.

Cultural Equity describes the goal of a movement by artists and organiz-

3 M. Sharon Jeannotte, "Just Showing Up: Social and Cultural Capital in Everyday Life," Department of Canadian Heritage, July 2004.

ers, most from communities of color, to ensure a fair share of resources for institutions focusing on non-European cultures. The goal of cultural equity organizing is to redress and correct historic imbalances in favor of European-derived culture.

Cultural Policy describes, in the aggregate, the values and principles that guide any social entity in cultural affairs. Cultural policies are most often made by governments, from school boards to legislatures, but also by many other institutions in the private sector, from corporations to community organizations. Policies provide guideposts for those making decisions and taking actions that affect cultural life.

Cultural Work. This term, with its roots in the panprogressive Popular Front cultural organizing of the 1930s, emphasizes the socially conscious nature of the arts, stressing the role of the artist as cultural worker, countering the tendency to see art-making as a frivolous occupation, a pastime as opposed to important labor.

Culture in its broadest, anthropological sense includes all that is fabricated, endowed, designed, articulated, conceived or directed by human beings, as opposed to what is given in nature. Culture includes both material elements (buildings, artifacts, etc.) and immaterial ones (ideology, value systems, languages).

Development (with its many subsets such as "economic development," "community development" and "cultural development") describes a process of analyzing the resources and needs of a particular community or social sector, then planning and implementing a program of interlocking initiatives to rectify deficiencies and build on strengths. The community cultural development field stresses participatory, self-directed development strategies, where members of a community define their own aims and determine their own paths to reach them, rather than imposed development, which tends to view communities as problems to be solved by bringing circumstances in line with predetermined norms.

Participatory Research is an approach to social change—a process frequently used by and for people who are living with exploitation and oppression. This approach challenges the way knowledge is produced through conventional social-science methods and disseminated by dominant educational institutions. Instead of distinguishing the subjects of research from the researchers, it puts

the gathering of knowledge into the hands of the people being studied.

Social Capital. Helen Gould's definition is concise and useful: "Social capital is the wealth of the community measured not in economic but in human terms. Its currency is relationships, networks and local partnerships. Each transaction is an investment which, over time, yields trust, reciprocity and sustainable improvements to quality of life.[4]

Social Indicators. Traditionally, these are measurements policymakers use to assess a society's well-being, such as life expectancy, literacy rates and per capita income. More recently they have been expanded to include subjective indicators, such as level of attachment to a community or level of participation in voluntary organizations.

Transnational refers to activities or systems that transcend national borders. The word embodies recognition of dynamic cultural processes that connect human societies regardless of official boundaries. In contrast to international, it also implies multidirectionality, rather than one- or two-directional exchange.

4 Helen Gould, "Culture & social capital," *Recognising Culture,* p. 69.

Roadside Theater conducts music circle at Haysi Senior Citizens Center with seniors and high school students, Haysi Virginia. Photo by Jeff Whetstone 1990

SELECTED BIBLIOGRAPHY: COMMUNITY CULTURAL DEVELOPMENT

ADULT EDUCATION

- *Adult Learning and the Challenges of the 21st Century.* UNESCO Publishing/UIE, 1999.

 A series of 29 booklets documenting workshops held at the Fifth International Conference on Adult Education (CONFINTEA 1997). The booklets cover ten main subjects: democracy and cultural citizenship; the quality of adult learning; literacy and basic education; empowerment of women; world of work; environment, health, population; media, culture; groups with special needs; economics of adult learning; and international cooperation.

- International Council for Adult Education, Toronto, Ontario, Canada. ICAE's website: <www.icae.org.uy>.

 Many adult-education related documents, plus links to Freire and other critical pedagogy sites.

CRITICAL PEDAGOGY

- Freire, Paulo. *Pedagogy of the Oppressed.* Continuum, 1982.

 First translated from Portuguese in 1968, this is the seminal work of the theorist who has been tremendously influential not only in education, but in all forms of democratic cultural work throughout the world. *Education*

for Critical Consciousness (Continuum, 1981), published in 1973, is more concrete and straightforward. Also see *Pedagogy of Hope: Reliving Pedagogy of the Oppressed* (Continuum, 1994), published late in Freire's life.

- Giroux, Henry. *Pedagogy and the Politics of Hope: Theory, Culture and Schooling: A Critical Reader.* Westview Press, 1997.

Part of a series on critical pedagogy (entitled "The Edge: Critical Studies of Educational Theory," edited by Joe Kincheloe, Peter McLaren and Shirley Steinberg), this compilation draws from 15 years of the author's writing, typifying the postmodern tone and vocabulary of much critical pedagogy writing. Giroux, McLaren and others have made a minor industry out of critical pedagogy, but much is unfortunately self-referential, dealing more with the academy than with community-based applications. Freire's own writing remains the most important source for people doing community-based work.

CULTURAL POLICY AND CULTURAL DEVELOPMENT

- Adams, Don and Goldbard, Arlene, editors. *Community, Culture and Globalization.* The Rockefeller Foundation, 2002.

Anthology of essays by community cultural development practitioners and theorists from 15 countries. Out of print, but may be downloaded from the Rockefeller Foundation's online library at www.rockfound.org/OnlineLibrary/Announcement/136. See also *Crossroads: Reflections on the Politics of Culture* (DNA Press, 1990), collected essays from the 1980s, most on aspects of cultural policy and community cultural development. Out of print.

- Alvarez, Maribel. *There's Nothing Informal About It: Participatory Arts Within the Cultural Ecology of Silicon Valley.* Cultural Initiatives Silicon Valley, 2005.

Argument for the development of informal arts, drawing on examples from a single region.

- Borrup, Tom. "Toward Asset-Based Community Cultural Development: A Journey Through the Disparate Worlds of Community Building." Community Arts Network Reading Room: <www.communityarts.net>.

Good resource on connections and gaps between community development and culture, with links to useful reading list.

- The Communication Initiative website : <www.comminit.com>.
An extensive international database of development-related projects and resources.

- Council of Europe, Council for Cultural Cooperation (CCC), Strasbourg, France.

See <www.coe.int/T/E/Cultural_Co-operation> for complete listing. A few foundation texts of cultural democracy and community cultural development:

— *Towards Cultural Democracy* (1976) is a dense, thorough history of the development of cultural policy in Europe in the postwar period, commissioned for the pivotal Oslo Conference of the CCC in 1976 along with *Cultural Policy in Towns* by Stephen Mennell, an overview of the CCC's "Fourteen Towns" project. The latter work was subsequently updated with *Urban Life in the 1980s* (1983), edited by Brian Goodey, a collection of essays by participants in the CCC's expanded "Twenty-one Towns Project."

— *Socio-Cultural Animation* (1978) contains very interesting essays on community animation including policy, training and practice (an updated reprint of "Information Bulletin number 4," 1975). Also look for *Animation in New Towns* (1978) and Finn Jor's *The Demystification of Culture* (1976, also commissioned for the Oslo conference).

The U.S. distributor of Council of Europe publications on cultural policy and cultural development is Manhattan Publishing (468 Albany Post Road, Croton-on-Hudson, N.Y. 10520; 914/271-5194), which maintains a website at <www.manhattanpublishing.com>.

A compendium of facts and trends in European cultural policies prepared for the Council by ERICarts can be found at <www.culturalpolicies.net>.

- *Culturelink* (Zagreb: Institute for International Relations). Subscriptions from: Culturelink/IMO; Ul. Lj. F. Vukotinovica 2; P.O. Box 303; 10000 Zagreb, Croatia; US$20/year for individuals.

This quarterly offers the best ongoing information about developments in cultural policy worldwide. Published by Culturelink, which was established in 1989 as a joint initiative of UNESCO and the Council of Europe to serve as a "network of networks for research and cooperation in cultural development." A searchable database of back issues is also available at Culturelink's website, www.culturelink.org. You will also find access to databases on cultural policy and organizations worldwide. An excellent source of international links.

- Girard, Augustin with Gentil, Geneviève. *Cultural Development: Experiences and Policies*, Second Edition. UNESCO, 1983.

 Originally published in response to UNESCO's first world conference on cultural policy in Venice, 1970, this intentionally definitive text provides a good overall introduction to international cultural policymaking, with extensive reference to cultural democracy and *animation socio-culturelle*.

- Graves, James Bau. *Cultural Democracy: The Arts, Community & the Public Purpose*. University of Illinois Press, 2005.

 Especially useful for leaders of community cultural development groups, by the head of Center for Cultural Exchange in Portland, Maine.

- Hawkes, Jon. *The Fourth Pillar of Sustainability: Culture's Essential Role in Public Planning*. Cultural Development Network, 2001.

 From the Cultural Development Network of South Australia, an argument for a universal approach to cultural policy.

- Matarasso, François, editor. *Recognising Culture*. Department of Canadian Heritage and UNESCO, 2001.

 Collection of briefing papers on culture and development.

- Mercer, Colin. *Towards Cultural Citizenship: Tools for Cultural Policy and Development*. Bank of Sweden Tercentenary Foundation & Gidlunds Förlag, 2002.

 Excellent resource for cultural policy tools.

- UNESCO Reports:

 — *Final Report*, 1982 World Conference on Cultural Policies, Mexico City, Mexico, 26 July to 6 August 1982. UNESCO, 1982.

 Summarizes global thinking on cultural issues among policymakers just prior to Reagan's withdrawal of the United States from UNESCO. A number of reports issued in preparation for this World Conference take up such topics as the "Training of Cultural Animators."

 — *Our Creative Diversity: Report of the World Commission on Culture and Development*, Second Edition. UNESCO Publishing, 1996.

 This background document for the most recent world conference on cultural policies (held in Stockholm in March-April 1998).

 — *World Culture Report 1998: Culture, Creativity and Markets*, UNESCO World Reports. UNESCO Publishing, 1998.

Presenting comparative data on culture and development and stressing the complexity of cultural indicators, this report addresses issues of globalization and identifies international trends, emphasizing the stimulating impact of intercultural contact.

— de Ruitjer, Arie and Tijssen, Lietke van Vucht, editors. *Cultural Dynamics in Development Processes*. UNESCO/Netherlands National Commission for UNESCO, 1995.

A collection of essays on the cultural dimensions of development in such areas as education, health, sustainable agriculture and environmental quality, as well as issues such as ethics, governance and power relations and the role of women, prepared in connection with an international conference in June 1994 in Zeist, The Netherlands.

— Many documents can now be downloaded in PDF form from UNESCO's website at <www.unesco.org>.

This is the leading international source for cultural policy publications. A good place to order publications, search for links and read about international cultural development initiatives.

• Webster's World of Cultural Democracy website: <www.wwcd.org>.

Don Adams' text-only archive offers background materials on cultural policy and cultural development practice.

INTERGENERATIONAL CULTURAL PROJECTS

• Lerman, Liz. *Teaching Dance to Senior Adults*. Charles C. Thomas, 1984.

A compendium of approaches to working with seniors developed by the Dance Exchange and its intergenerational performance company, Dancers of the Third Age, also proceeding from theory through workshop practices to performance and concluding with priorities for continuing development.

• Perlstein, Susan and Bliss, Jeff. *Generating Community: Intergenerational Partnerships through the Expressive Arts*. ESTA, 1994.

A guide for community leaders to establish intergenerational arts programs, proceeding from general philosophy to creating partnerships and carrying out and evaluating programs. See additional publications at <www.creativeaging.org>.

ORAL HISTORY

- Grele, Ronald J. *Envelopes of Sound: The Art of Oral History*, Sec. Ed. Praeger, 1991.

 Originally published in 1975, then enlarged in 1985, this reprinted collection of essays was inspired by a 1973 meeting of the Oral History Association (OHA). It opens with Grele's interview of Studs Terkel and a transcript of a radio panel of oral historians distributed before the OHA meeting, then proceeds with essays on the issues they raised. Introduction for the general reader to methods and problems, and discussion of larger theoretical issues in the field.

- Portelli, Alessandro. *The Death of Luigi Trastulli and Other Stories: Form and Meaning in Oral History.* State University of New York Press, 1991.

 The most poetic of the general introductions to oral history, providing an introduction to the field with extensive reference to material gathered by this leading practitioner and academic, concentrating especially on extended case studies of the author's work in Terni, Umbria, Italy and Harlan County, Kentucky, U.S.A. More recently, Portelli has published *The Battle of Valle Giulia: Oral History and the Art of Dialogue* (University of Wisconsin Press, 1997), focusing on "multi-vocal" approaches to oral history.

- Thompson, Paul. *The Voice of the Past: Oral History*, Sec. Ed. Oxford University Press, 1988.

 First published in 1978, a presentation of oral history from general principles through collection and use of oral sources by historians. Considered the field's basic text and also, to quote Grele in introducing *Envelopes of Sound*, its "fairly traditional view of the historical enterprise."

- The Oral History Association can be found at <http://omega.dickinson.edu/organizations/oha>. Link to events, projects and publications such as:

 — "Oral History Evaluation Guidelines: Guidelines and Principles of the Oral History Association," Pamphlet Nov. 3, 1992. Out of print, but available on the Web at <http://omega.dickinson.edu/organizations/oha/pub_eg.html>.

 — "Using Oral History in Community History Projects," by Laurie Mercier and Madeline Buckendorf. A solid introduction for the community practitioner.

POPULAR THEATER AND OTHER PERFORMANCE

- Boal, Augusto. *Theater of the Oppressed*. Urizen Books, 1979.

 Boal's 1974 work was published in English with this edition and has become widely influential among those leading community cultural development projects using theater. Boal's more recent publications include *The Rainbow of Desire: The Boal Method of Theatre and Therapy* (Routledge, 1995), a more extensive discussion of practical approaches, and *Legislative Theatre: Using Performance to Make Politics* (Routledge, 1999), describing Boal's use of Forum Theatre to involve the public in his legislative role as *Vereador* (member of the municipal Parliament) in Rio de Janeiro.

- Boon, Richard and Plastow, Jane editors. *Theatre Matters: Performance & Culture on the World Stage*. Cambridge University Press, 1999.

 A presentation of projects where Theater for Development has made a social or political impact and of the issues raised by such work. Includes chapters on Nigeria, South Africa, Eritrea, Caribbean, Canada (Native American), Jamaica, India, Brazil and Argentina.

- Cohen-Cruz, Jan. *Local Acts: Community-Based Performance in the United States*. Rutgers University Press, 2005.

 Excellent survey of community-based theater.

 See also *Radical Street Performance: An International Anthology* (Routledge, 1998), a collection of 34 essays portraying a wide variety of community-based theater projects in the Americas, Europe, Africa and Asia. Cohen-Cruz also co-edited with Mady Schutzman *Playing Boal: Theatre, Therapy, Activism* (Routledge, 1994) and *A Boal Companion: Dialogues on Theatre and Cultural Politics* (Routledge 2006).

- Coult, Tony and Kershaw, Baz. *Engineers of the Imagination*. Methuen, 1983.

 Handbook of Welfare State, pioneers of community spectacle.

- Gard, Robert. *Grassroots Theater: A Search for Regional Arts in America*. University of Wisconsin Press, 1999.

 Story of pioneer of arts extension and "The Wisconsin Idea."

- Kidd, Ross. *The Popular Performing Arts, Non-Formal Education and Social Change in the Third World: A Bibliography and Review Essay*. Centre for the Study of Education in Developing Countries, 1982.

A comprehensive survey of published material on the international Third World popular theater movement, including a 24-page essay by Kidd, a leading exponent of this movement, outlining the history and development of "theater for development." Indices identify sources by country as well as by theatrical genre and issue area (e.g., politics, family planning, health and nutrition and agriculture).

• Leonard, Robert H. and Kilkelly, Ann. *Performing Communities: Grassroots Ensemble Theaters Deeply Rooted in Eight U.S. Communities.* New Village Press, 2006.

Best selections from the research project of the same title that profiles eight well-established ensemble theater companies. Features analytic descriptions, excerpts of interviews and plays, and an introduction by Jan Cohen-Cruz.

• McGrath, John. *A Good Night Out.* Methuen, 1981.

Lectures on new approaches to theater by a pioneering British director. Also see *Naked Thoughts That Roam About: Reflections on Theatre* (Nick Hern Books, 2002).

• The Applied and Interactive Theatre Guide website: <www.tonisant.com/aitg/index.shtml>.

"A resource for those who use theatre techniques for other or more than arts or entertainment purposes and for those whose theatre styles incorporate other than traditional presentation styles." This site contains links to just about every Boal-inspired, community or instrumental-theater approach.

THE NEW DEAL AND ANTECEDENTS

• Baigell, Matthew and Williams, Julia, editors. *Artists Against War and Fascism: Papers of the First American Artists' Congress.* Rutgers University Press, 1986.

Collection of papers from the 1936 American Artists' Congress.

• Flanagan, Hallie. *Arena.* Duell, Sloan & Pearce, 1940.

A fascinating first-hand account by its dynamic national director of the Federal Theatre Project (FTP), a vibrant, though short-lived, experiment in a truly public American theater. Apart from the underlying philosophy and aims of the FTP, *Arena* offers one of the most detailed accounts of the

activities of the dozens of local companies which the Project comprised.

- Mangione, Jerre. *The Dream and the Deal: The Federal Writers' Project, 1935-1943*. Avon, 1972.

A complete presentation of the longest-lasting of the New Deal cultural programs, the Federal Writers' Project.

- McKinzie, Richard D. *The New Deal for Artists*. Princeton University Press, 1973.

A complete historical account of the Federal Art Project (FAP) and its antecedent New Deal programs for visual artists.

- Meltzer, Milton. *Violins & Shovels: The WPA Arts Projects*. Delacorte, 1976.

A general introduction to all the component projects of Federal One, less detailed than each of the other resources listed here, but inclusive.

- O'Connor, Francis V., editor. *Art for the Millions: Essays from the 1930s by Artists and Administrators of the WPA Federal Art Project*. New York Graphic Society, 1975.

First conceived as a national report on the FAP (compiled in the '30s but never published), then retrieved, reworked and published for the first time by an archivist of New Deal visual arts material. A fascinating collection of first-person sources from the Project, along with a contextualizing essay by the editor.

- The New Deal Network website: <http://newdeal.feri.org>.

An "educational website sponsored by the Franklin and Eleanor Roosevelt Institute and the Institute for Learning Technologies at Teachers College/ Columbia University." This site has links to information about every New Deal-related cultural project.

OTHER COMMUNITY ARTS

- Animating Democracy's website can be found at <www.americansforthearts.org/animatingdemocracy>.

Website promoting civic engagement through the arts.

- Art in the Public Interest's website: <www.communityarts.net>.

This website of the Community Arts Network features a community arts "reading room," links to the online newsletter *API News* and to many cultural development-related sites.

- Burnham, Linda Frye, Durland, Steven and Ewell, Maryo Gard. *The CAN Report, The State of the Field of Community Cultural Development: Something New Emerges*. Art in the Public Interest, July 2004.

 Based on a gathering of community cultural development practitioners in May 2004. See also Burnham, Linda Frye and Durland, Steve, editors, *The Citizen Artist: 20 Years of Art in the Public Arena* (Critical Press, 1998), an anthology of writings from the journal *High Performance*, focused on the changing role of the artist.

- Cleveland, William. *Making Exact Change: How U.S. arts-based programs have made a significant and sustained impact on their communities*. Community Arts Network, 2005.

 Case studies, analysis and recommendations. Download free from the bookstore at www.communityarts.net.

- Cockcroft, Eva, Weber, John and Cockcroft, James. *Toward a People's Art: The Contemporary Mural Movement*. E. P. Dutton, 1977.

 Still the best overview of community-based mural-making.

- Elizabeth, Lynne and Young, Suzanne, editors. *Works of Heart: Building Village through the Arts*. New Village Press, 2006.

 A visual treat that profiles nine community-based arts projects in color.

- Lerman, Liz. *Critical Response Process: A Method for Getting Useful Feedback on Anything You Make, from Dance to Dessert*. The Dance Exchange, 2003.

 Detailed process for critical feedback, widely used by performing artists.

- Lippard, Lucy R. *The Lure of the Local: Senses of Place in a Multicentered Society*. The New Press, 1997.

 A extended treatment of the sense of place and its many manifestations in culture and politics, focused by extensive material on site-specific, community-based art. See also *Get the Message? A Decade of Arts for Social Change* (E. P. Dutton, 1984) and *Mixed Blessings: New Art in A Multicultural America* (Pantheon, 1990).

- Mailout's website: <www.e-mailout.org>

 British portal for community arts information and links.

- National Arts & Cultural Alliance website: <www.naca.org.au>.

 Australian national organization for community cultural development.

- O'Brien, Mark and Little, Craig, editors. *Reimaging America: The Arts of*

Social Change. New Society Publishers, 1990.

An anthology on social change-oriented arts work, featuring essays by practitioners on many aspects of community cultural development practice.

• Patten, Marjorie. *The Arts Workshop of Rural America: A Study of the Rural Arts Program of the Agricultural Extension Service.* Columbia University Press, 1937.

An interesting account of arts extension programs and approaches in the early 1900s, with detailed information about each state's programs. Republished by AMS Press in 1967.

• The Power of Culture website: <www.powerofculture.nl/uk>.

Internet portal for culture and development.

• Raven, Arlene. *Art in the Public Interest.* UMI Research Press, 1989.

An anthology of essays on public visual artwork, featuring essays from several community artists.

• Schwarzman, Mat and Knight, Keith. *Beginner's Guide to Community-Based Arts.* New Village Press, 2005.

Lively illustrated how-to guide to practice, featuring ten project profiles.

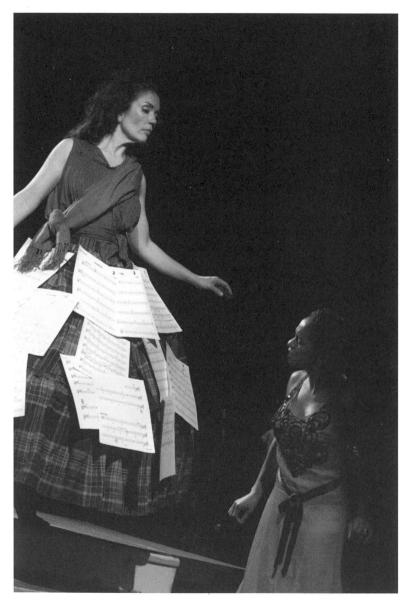

Roadside Theater and Pregones Theater perform BETSY, New York City, April 2006.
Photo by Erika Rojas

AUTHOR AND APPROACH

This book began with modest ambitions: to produce an updated version of *Creative Community: The Art of Cultural Development*, a book by Don Adams and myself, published by the Rockefeller Foundation in 2001. Happily, that volume was widely used in both university and community settings to teach community cultural development theory and practice. But five years on, I saw that the earlier material needed not only updating but major augmentation: new chapters, new sections, new stories and examples, new thinking on a field that constantly changes along with the times. I was thrilled to discover New Village Press just as the first of its community-based arts titles was being released. I see great significance in the fact that the community cultural development field is generating a coherent (yet diverse) body of written work through New Village; having "our own imprint" suggests a welcome coming-of-age. I applaud Lynne Elizabeth and Karen Kearney of New Village for their vision and commitment; and Claudine Brown of the Nathan Cummings Foundation for her faith and foresight in supporting this much-needed body of writing, including this volume.

The seed of this book was a study commissioned to assist the Rockefeller Foundation's Creativity & Culture division in formulating the best approaches to supporting community cultural development, given the basis, scope, significance and potential of that work. In the original study carried out by Don Adams and myself and submitted in December 1999, we drew extensively on the projects and community artists funded by the Foundation's PACT program (Partnerships Affirming Community Transformation).

As part of our research, we reviewed the complete archives of the Foundation's PACT program, as well as other materials provided by Foundation officers, PACT participants and others who agreed to assist us. Online and library searches supplemented these investigations. In addition, having worked with this field for nearly 30 years, we maintain our own extensive archive of documentary materials and publications on which I was able to draw.

Direct contact with community artists and organizations continues to be paramount as a basis for my writing on the field. In preparing the aforementioned study on which this volume is based, we conducted confidential telephone interviews with key individuals involved in the field, including PACT grantees, other community artists and theoreticians and Foundation staff and consultants currently or formerly involved with PACT. We also drew on other interviews we had previously conducted for several earlier studies of the field. I have augmented these with yet more recent interviews. (Interviewees are listed in the next section.) I was also able to draw on three decades of personal experience consulting with, writing about and organizing community artists.

My driving interest as a writer is the convergence of culture, politics and spirituality. I believe that in these times, real social possibilities rely on the integration of these realms, and that this integration has manifested most fully in community cultural development practice. For readers who may be interested in pursuing my other essays and books, please visit my website <www.arlenegoldbard.com>.

Arlene Goldbard

ACKNOWLEDGEMENTS

Thanks to the following individuals who gave so generously of their time and thoughtful observations in interviews over the last decade. (Organization affiliations were current at the time of interviews.)

Anne Arrasmith and Peter Prinz, Space One Eleven, Birmingham, AL
Alberta Arthurs, consultant, New York, NY
Caron Atlas, consultant, Brooklyn, NY
Judith Baca, Social & Public Art Resource Center, Venice, CA
Elizabeth Barret, Appalshop filmmaker, Whitesburg, KY
Martha Bowers, choreographer, Brooklyn, NY
Linda Frye Burnham, Art in the Public Interest, Saxapahaw, NC
Ron Chew, Wing Luke Asian Museum, Seattle, WA
Mary Marshall Clark, Oral History Research Office, Columbia University, New York, NY
Dudley Cocke, Roadside Theater, Appalshop, Whitesburg, KY
Kathie deNobriga, consultant, Atlanta, GA
Steve Durland, Art in the Public Interest, Saxapahaw, NC
Dana Edell, viBE Theatre, New York, NY
Pat Graney, choreographer, The Pat Graney Company, Seattle, WA
Juana Guzman, Mexican Fine Arts Center Museum, Chicago, IL
Karen Hayes, Youth for Social Change, Durham, NC
Maria-Rosario Jackson, The Urban Institute, Washington, DC
Lillian Jiménez, consultant, New City, NY
Bill T. Jones, choreographer, New York, NY
Rhodessa Jones, Cultural Odyssey, San Francisco, CA
Annie Lanzillotto, performance artist, Brooklyn, NY
Valerie Lee, Minneapolis Foundation, MN
Liz Lerman, The Dance Exchange, Silver Spring, MD
Ruby Lerner, Creative Capital Fund, New York, NY
Julia Lopez, Director, Equal Opportunity, Rockefeller Foundation, New York, NY

Linda Mabalot, Visual Communications, Los Angeles, CA
Lian Hurst Mann, Labor/Community Strategy Center, Los Angeles, CA
Beni Matías, Center for Arts Criticism, Minneapolis, MN
Laurie McCants, Bloomsburg Theatre Ensemble, Bloomsburg, PA
Robbie McCauley, performance artist/teacher, Boston, MA
Keith Antar Mason, performance artist, Los Angeles, CA
Lisa Miller, theater/media activist, Brooklyn, NY
Doug Paterson, Theater Department, University of Nebraska at Omaha
Peter Pennekamp, Humboldt Area Foundation, Eureka, CA
Susan Perlstein, Elders Share the Arts, Brooklyn, NY
Mimi Pickering, Appalshop filmmaker, Whitesburg, KY
Marty Pottenger, community artist, New York, NY
Bill Rauch, Cornerstone Theater, Los Angeles, CA
Michael Rohd, Soujourn Theatre, Portland, OR
Graciela Sanchez, Esperanza Peace & Justice Center, San Antonio, TX
Suzanne Sato, AT&T Foundation, New York, NY
Linda Shopes, Pennsylvania Historic & Museum Commission, Harrisburg, PA
Nick Szuberla, Holler to the Hood, Appalshop, Whitesburg, KY
Leslie Tamaribuchi, Cornerstone Theater Company, Los Angeles, CA
Jack Tchen, Asian/Pacific/American Studies Program & Institute, New York
 University, New York, NY
Sarah Thornton, Collective Encounters, Liverpool, England
Roberta Uno, New WORLD Theater, Amherst MA
Martha Wallner, community media activist/consultant, New York, NY
MK Wegmann, National Performance Network, New Orleans, LA
Marc Weiss, Web Lab, New York, NY
Lily Yeh, Village of Arts & Humanities, Philadelphia, PA
Steve Zeitlin, City Lore, New York, NY
Jawole Willa Jo Zollar, Urban Bush Women, New York, NY

I am also grateful for the assistance of many Rockefeller Foundation staff members in supporting a previous version of some of the material in this book, published in 2001 as *Creative Community: The Art of Cultural Development*. They include former Creativity & Culture (C&C) Senior Program Assistant Julie Bauer; former C&C Associate Director Tomás Ybarra-Frausto; and former Acting C&C Director Lynn Szwaja, Associate C&C Director Joan Shigekawa, C&C Program Associate Peter Helm, and C&C Program Assistants Michelle Hayes, Pam Johnson, Rose Marie Minore and Scott MacDougall. Thanks also to the Foundation's Records and Library Services Division staff including David Montes, Robert Bykofsky, Dottie Lopez and Elizabeth Peña, and Andre Oliver and Susan Muir of the Foundation's Communications office.

INDEX

action research, 64, 87–91, 233
activism and community cultural
 development, 20, 78–79, 102, 104, 221
Adams, Don, 26, 103, 128, 129, 165, 168,
 199, 210
Addams, Jane, 108
aesthetics: and community cultural
 development, 55–56
Africa, 106–107, 130
Alliance for Cultural Democracy, 210
Alternate ROOTS, 130, 210
Alvarez, Maribel, 81–82
American Artists' Congress, 109
animateurs, 21, 129, 158, 159
Appalachia, 18, 66–67, 177–179
Appalshop, 66–67, 177–179; Appalachian
 Media Institute, 66-67
Appiah, Kwame Anthony, 48
Art in the Public Interest, See Community
 Arts Network
Artists' Call for Cultural Policy, 193-196
artists' residencies, 67–69
artists' roles, 58–60, 103, 107, 147–148
arts in education, 62–63, 113, 195
ArtsChange, 79
Asian Dub Foundation, 80; ADFED,
 80–81
asset-based community development, 138
Assignment Theatre, 72
Australia, 17, 22, 26, 110, 131, 158, 160,
 163, 198

Baca, Judith F., 33, 126
Barefoot Artists, 66

Berger, John, 69
Berlin, Isaiah, 237–238
Bicentennial Arts Biweekly, 112, 124
Boal, Augusto, 53, 62, 72, 74, 118–120,
 161, 187
Bolivia, 32
Borrup, Tom, 229
Botswana, 123
Brazil, 117
Brecht, Bertolt, 47
Britain, 105, 110, 130, 159, 180, 204, 206
Building Movement Project, 169–170;
 Generational Leadership Listening
 Project, 169–170

Canada, 159
Center for Cultural Exchange, 151
Césaire, Aimé, 117
Clark, Mary Marshall, 126
Cocke, Dudley, 125–126, 176, 193
Cohen-Cruz, Jan, 149
Collective Encounters, 180–182, 186, 221
colonialism, 37, 103, 105–106, 115–117,
 129, 130
Community Arts Forum, 184
Community Arts Network, 171, 201, 210–
 211, 214, 215, 218; Art in the Public
 Interest, 210; *High Performance*, 211
community cultural development: and
 safe space, 150; and the "mainstream,"
 59; core beliefs, 142–144; definitions,
 20, 82, 140; influences on other fields,
 81–83; nomenclature, 20–22; unifying
 principles, 43

Community, Culture and Globalization,
 26, 28, 56, 122, 132
Comprehensive Employment and Training
 Act (CETA), 113, 123–125, 203
conflict and community cultural
 development, 146–147
Cornerstone Theater, 134–135, 218
Council of Europe, 158
Creative City Network, 159–160
Critical Response Process, See Lerman, Liz
cultural citizenship, 227–228, 233
cultural democracy, 127–131, 133, 158,
 165, 191, 196, 200, 226, 229, 237
cultural diversity, See diversity, racism
cultural exchange, 127–132, 195, 213
cultural identity, 32, 71–73, 105, 114–117,
 238
cultural indicators, 199, 231, 232
cultural planning, 226–227; approaches,
 228–235
cultural policy, 186, 189–196, 222; aims,
 198–199; Artists' Call for Cultural
 Policy, 193–196; cultural impact
 report, 199–200, 224; scope of,
 192–193
cultural rights, 32, 41, 50–51
culture: definition, 120–121
Culture Shapes Community, 226
Culturelink, 121

dance, 104, 136–138, 147, 212–213
Dance Exchange, 136–138, 139, 218
Davis, Dee, 38, 193
Davis, Stuart, 109, 125, 182
development, 37–38, 83, 120–123;
 definitions, 37; Human Development
 Index, 37
dialogue, 64, 118; and community
 cultural development, 52, 64, 185
digital media, 17, 46, 73, 179
diversity, 25–26, 31–32, 48, 63, 69, 71,
 73, 238
Documentary Project for Refugee Youth,
 77
Dubois, Rachel Davis, 128
DuBois, W.E.B., 117

Edell, Dana, 172–74
El Teatro Lucha por la Salud del Barrio,
 75–76, 221
elder projects, 64–65, 69, 140, 147
Elders Share the Arts (ESTA), 140
environment and cultural development,
 29–31, 199
Enzensberger, Hans Magnus, 46
Esperanza Peace and Justice Center,
 166–167
ethics, 150–152
Europe, 25, 67, 105, 130–131, 158, 159,
 164, 196, 204
evaluation, 153–516, 212
extension services, 113–115

Fanon, Frantz, 115–117
Feral Arts, 17
field infrastructure, 20, 102, 184, 213;
 recommendations, 113–114
Flanagan, Hallie, 112
Ford Foundation, 205; Animating
 Democracy Initiative, 205, 211
Forum Theatre, 53, 76, 118–120, 181, 221,
 234
France, 14, 25, 26
Frankenstein, Ellen, 70
freedom of expression, 35–36, 51, 166–167
Freire, Paulo, 22, 117–118, 215
Fringe Benefits Theatre, 62–63
Fuentes, Carlos, 32, 238
fundamentalism, 32–33
funding, 152–53, 163–166, 186–188,
 201–209; European Union, 131,
 161, 164, 180–84, 204; foundation,
 204–206; public, 131, 152–153, 179,
 186–188, 189–92; recommendations,
 206–209

Gard, Robert, 114
Ghana, 108
Gioia, Dana 197–198
Girard, Augustin, 144
globalization, 20, 39–42, 48, 239–240
Goffman, Erving, 147
Goodman, Paul, 44–45

Gould, Helen, 230
Gramsci, Antonio, 168
Graves, James Bau, 128, 133, 151

Harding, David 67
Harlan County Listening Project, 19
hate crimes, 31
Hawkes, Jon, 198–199
Heschel, Abraham Joshua, 134
High Performance, See Community Arts Network
Higginson, Henry Lee, 57
history-based projects, 69–71, 125–127; oral history, 18, 69–70, 125–127
Hoeane, Masitha, 122
Holler to the Hood, 177–179
Honduras, 26
Hurstel, Jean, 158
hybridity, 172–173, 211

immigration: as cultural issue, 28, 64–65, 80, 108–109
India, 27, 40; Narmada Dam project, 30, 199
International Monetary Fund, 37
Internet, 25, 36, 47, 81, 194

Kallen, Horace, 128
Kaplan, Mordechai, 152
Kerr, David, 123
Kharazzi, Lily, 212
Kirby, Amelia, 177–178
Knight, Keith, 21, 139
Koch, Frederick, 113–114
Kreidler, John, 124
Kurdistan, 47

Lacy, Suzanne, 78–79
Latin America, 105, 133
Lerman, Liz, 56, 104, 136, 139, 147, 162, 212, 218; Critical Response Process, 212
Lesotho, 122
liberating education, 117–118
Liberia, 26
Lila Wallace-Reader's Digest Fund, 204
Lovelace, Alice, 168

Lowe, Rick, 176
MacArthur Foundation, 162
Maheu, René, 50
Malawi, 123
Mascarones, 105–106, 132, 133
mass media, 25, 46, 157; and cultural development, 23–27, 45, 67; democratizing potential, 47
McGrath, John, 104–105, 181
Mercer, Colin, 199, 226, 227
Mesa-Bains, Amalia, 162
Mexico, 26, 33, 105, 132, 133
Mills, C. Wright, 41
Morris, William, 102–103
Mothers Against Senseless Killing, 17
music, 69, 79, 80, 125, 177

Nathan Cummings Foundation, 206
National Arts and Cultural Alliance, 22, 160
National Center for Creative Aging, 140
National Endowment for the Arts, 129, 131, 132, 164–165, 186, 194, 197–198, 204, 206
National Institute on Media and The Family, 45
National Performance Network, 168, 211
negritude, 117
Neighborhood Arts Programs National Organizing Committee (NAPNOC), 103, 129–130, 210
New Belfast Community Arts Initiative, 182–183
New Deal, 111–113, 124
New WORLD Theater, 63
Nicaragua, 26
Nigeria, 107
Northern Ireland, 182–184

O'Neal, John, 104
oral history, See history-based projects
orature, 106–107
Owusu, Kwesi, 106–107

participatory research, 63, 145, 233
Patten, Marjorie, 113–114

PETA (Philippine Educational Theater
 Association), 57–58, 213
Philippines, 27, 28–29, 47, 57–58, 213
Playback Theatre, 160, 213
Popular Front, 21, 110–111
Pottenger, Marty, 111
process vs. product, 54, 148–149, 179
professionalization, 158–162
Project Row Houses, 175–177, 218
public art, 18, 19, 33–34, 126–127
public awareness, 218–220;
 recommendations, 220–222
public service employment, 113, 123–125,
 195, 203

quality: and community cultural
 development, 54–57

racism: as cultural issue, 31–32, 49, 62–63,
 71, 114–117, 179
Ramirez Oropeza, Martha, 105, 132
Rebbe Nachman of Bratslov, 138
refugees and cultural development, 29, 77
Rich Mix, 80
Roadside Theater, 125–126, 178
Rockefeller Foundation, 114, 132,
 189, 205, 210, 219, 220; Multi-Arts
 Production Fund, 205; Partnerships
 Affirming Community Transformation
 (PACT), 205, 210
Rohd, Michael, 52, 139, 186
Roy, Arundhati, 42
rural issues, 18–19, 38–39, 73–74,
 113–114, 146
Rural Southern Voices for Peace, 19
Rwanda, 66

San Francisco Neighborhood Arts
 Program, 124
Schwarzman, Mat, 21, 139
Scotland, 67, 130
Sen, Amartya, 40
Sengendo, James, 122
Senghor, Leopold, 117
settlement houses, 108–109
Shigang Mama Theatre Troupe, 72

Smith, Ronald E., 72
social capital, 230
Sojourn Theatre, 52, 64, 139, 184–86,
 221; The War Project, 186; Witness
 Our Schools, 52, 64, 186
South Africa, 26, 116, 122
Southeast Kentucky Community and
 Technical College, 18
Space One Eleven, 75
SPARC, 33–36, 126–127
spirituality and cultural development,
 133–138
Stewart, Gary, 80
Sweden, 196, 199
Szuberla, Nick, 177–79

Taiwan, 72
TENAZ, 132
theater, 19, 53, 62–63, 64, 72, 73,
 104–105, 112, 114, 118–120, 121–123,
 125–126, 134–35, 160–161, 179, 180
Theatre for development, 121–23
Theatre of the Oppressed, 75–76, 118–120,
 160–161, 213 See Forum Theatre
Thomas, Chandra, 173
Thornton, Sarah, 180–182
Togo, 130
town artist, 67–68, 130; Harding, David,
 67
training, 156–158, 214–216; formal
 training, 156–158, 214–216;
 recommendations, 216–18

Ukiah Players Theatre, 73
UNESCO, 25, 26, 38, 39, 48–50, 120,
 130, 192, 197; Convention on the
 Protection and Promotion of the
 Diversity of Cultural Expressions, 25,
 26; Intergovernmental Conference on
 Cultural Policies for Development,
 192, 199
unions and cultural development, 68,
 110–111
Universal Declaration of Human Rights,
 36, 50
Universal Declaration on Cultural

Diversity, 48, 50
viBE Theater, 173–175
video and photography, 64, 66–67, 70, 77
Village of Arts and Humanities, 65
visual arts, 18, 33–34, 69, 74–75,
 126–127, 175–177

Wa Thiong'o, Ngugi, 116
War on Terror, 27, 35–35
Watts, Natasha, 67
Weber, John Pitman, 130
Welfare State International, 105
Wing Luke Asian Museum, 64–65
Workers' Art Clubs, 110–111
World Bank, 37–39, 123
World Commission on Culture and
 Development, 31
World Trade Organization, 41
WPA, See New Deal

YA/YA (Young Aspirations/Young
 Artists), 74–75
Yeh, Lily, 65
youth projects, 17, 61, 62–63, 66–67, 70,
 74–75, 77–79, 80, 150, 173–175
Yung, Rene, 69

Arlene Goldbard. Photo: Averie Cohen 2004

ABOUT THE AUTHOR

A provocative independent voice for our times, Arlene Goldbard is a writer, social activist, and consultant who works for justice, compassion and honor in every sphere, from the interpersonal to the transnational. Whether in her roles as commentator, teacher or consultant, a main focus of her work for nearly three decades has been community and cultural development. Community artists and their supporters value her vision, her proclivity for speaking truth to power, and her forthright and graceful prose.

Arlene's essays have appeared in such journals as *Art in America, The Independent, Theatre, High Performance* and *Tikkun*. Her books include *Crossroads: Reflections on the Politics of Culture; Creative Community: The Art of Cultural Development; Community, Culture and Globalization*; and her novel *Clarity*.

Arlene has helped countless organizations make plans and solve problems. They include nonprofits such as the Independent Television Service, the National Campaign for Freedom of Expression, and the New Museum of Contemporary Art; foundations such as the Rockefeller Foundation and the Paul Robeson Fund for Independent Media; a score of state arts agencies; and many others.

She has served as Vice Chair of the Board of ALEPH: Alliance for Jewish Renewal, and Tsofah/President of Congregation Eitz Or in Seattle. She is a member of the Board of Directors of The Shalom Center. She co-founded such activist groups as the San Francisco Artworkers' Coalition, the California Visual Artists Alliance, Bay Area Lawyers for the Arts and Draft Help.

Born in New York, Arlene grew up in the San Francisco Bay Area, where she and her husband now reside after extended sojourns in Sacramento, Washington DC, Baltimore, Mendocino County and Seattle.